W9-AED-214

CREATE
PERFECT
PAINTINGS

An Artist's Guide to Visual Thinking

NANCY REYNER

NORTH LIGHT BOOKS
CINCINNATI, OHIO
artistsnetwork.com

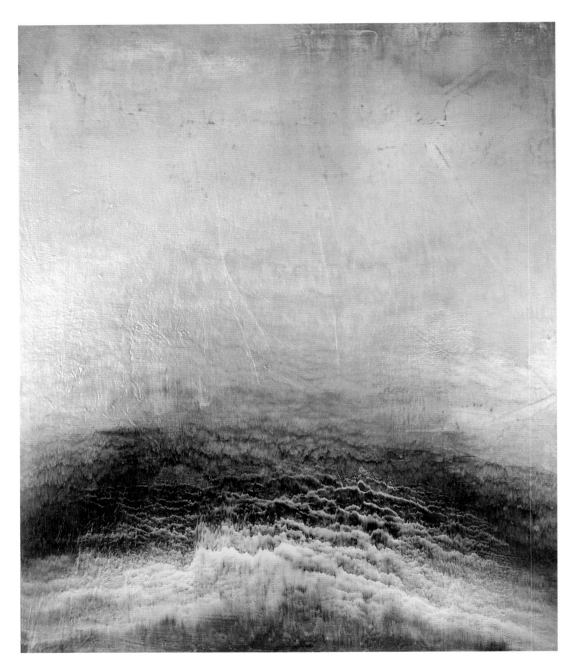

E-FIELD WITH OCEAN / Nancy Reyner / Acrylic on panel / 23" × 19" (58cm × 48cm)

"THE DIFFERENCE BETWEEN
PROFESSIONAL ARTISTS
AND AMATEURS LIES NOT
SO MUCH IN THE QUANTITY
OF TECHNIQUES AQUIRED
AS IN THE ABILITY TO SEE IN
A CERTAIN WAY."

CONTENTS

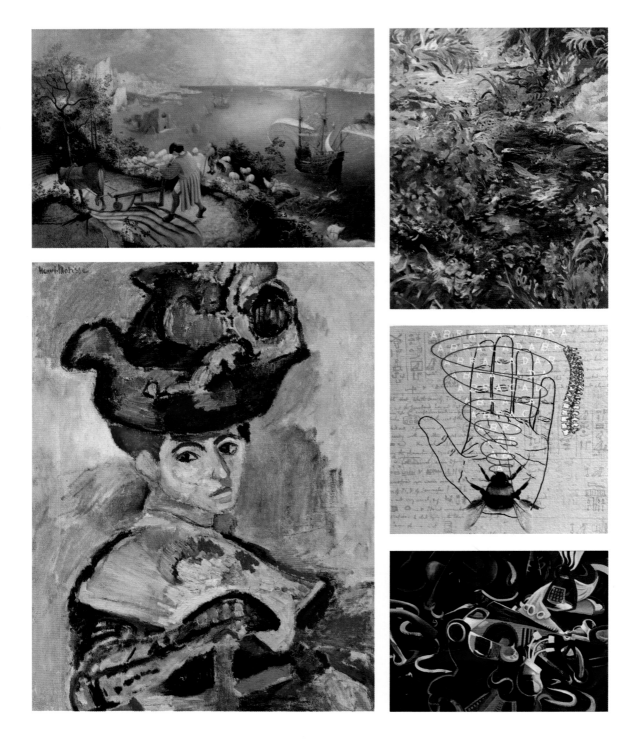

IMAGE DETAILS
CLOCKWISE FROM TOP LEFT:

Pieter Brueghel the Elder, page 23
Nancy Reyner, page 35
Vicki Teague-Cooper, page 80
Nancy Reyner, page 139
Henri Matisse, page 113

INTRODUCTION

Making art is exhilarating and also challenging. A work of art can be vital or lifeless, illuminating or confusing. Like humanity and our universe, it is a bundle of oppositions. As artists, we often have to fight to make room in our busy lives for making art. For those of us willing to take on the battle it can be very fulfilling, adding rich meaning to our lives. As painters we can enjoy the sensuous feel of applying paint, experience a thrill as an image emerges or get excited over happy accidents that seem to appear like magic.

Yet what about those times when playful fun starts to fade and frustration sets in? The ease and flow of painting comes to a halt. What to do? This is the all too frequent moment in a painter's process that gave birth to this book. When the "play phase" is ready to move into a "critique phase," having a set of guidelines can help push the image to better clarity and a more powerful effect. Starting on page 46, these guidelines are detailed as a complete critique method I call "The Viewing Game."

Critique is a way to analyze and edit your paintings to enhance the visual experience for those viewing your work. Editing your paintings also strengthens your eye-viewing muscles and enhances your ability to paint what you envision. Artists, in general, usually want to communicate something to others through their work. This desire brings about two goals. The first is to bring a viewer's attention to the painting. The second is to keep the viewer's attention on the work long enough for a quality viewing experience. Analyzing and editing the work is critical to reaching these goals.

The difference between professional artists and amateurs lies not so much in the quantity of technique acquired as in the ability to see in a certain way. The power to see an image deeply, to analyze it for its viewing effects and to make revisions and corrections as needed is key. After all, painting is really about choreographing eye movement. The Viewing Game's guidelines offer ways to strengthen your perception skills as well as new ways to self-critique and self-evaluate your work. Even though these guidelines spotlight painting as a discipline, the core concepts can be easily transferred to other disciplines as well. All painting techniques described here are broad in scope and can be utilized by any painting medium.

Oil, acrylic, watercolor, pastel—whatever your passion—this book offers abundant ideas to enhance your images. The scope is not limited to any particular style or to any level of experience. Art educators can easily add this vital content into curriculum materials. Additional sections offer help with material selection, process, exhibiting and even career aspects. From realists to minimal abstractionists, from pros to beginners, all are invited to read on and find new inspiration and tools to serve your artistic needs.

May this book increase your productivity, add ease and flow to your creative process, clarify your ideas, add nuance to your personal style, and most importantly, add joy to the miraculous act of painting.

Here's to your creative spirit!

Nancy Reyner

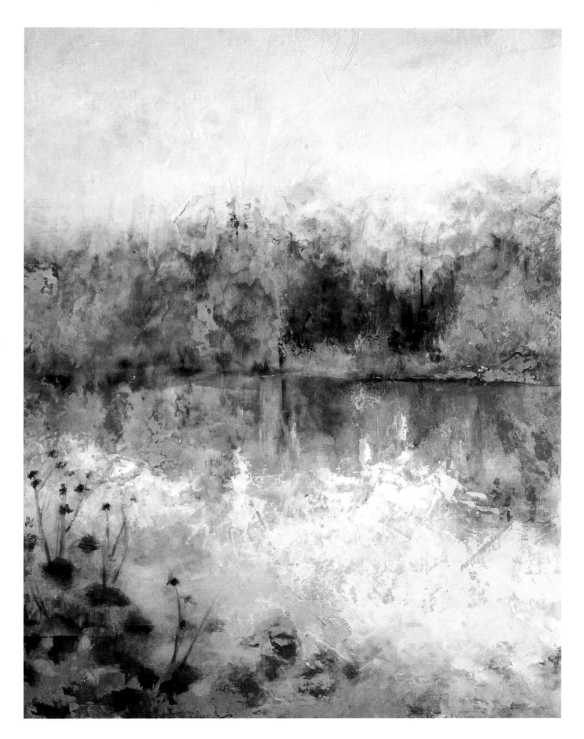

BOSQUE DEL APACHE / Nancy Reyner / Acrylic on canvas / 40" × 30" (102cm × 76cm)

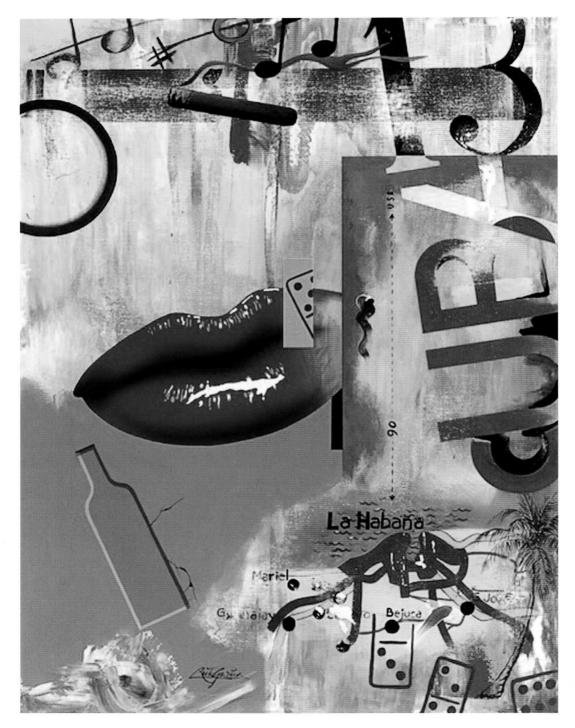

CUBA RUM / Rick Garcia / Acrylic on canvas / 40" × 30" (102cm × 76cm)

SECTION 1

ESSENTIALS

This book makes references to many well-used art terms and art concepts. For better comprehension, I have defined the terms right in the beginning to avoid possible confusion later when used in different contexts. For example, commonly used terms such as *realistic* or *abstract* may seem obvious at first but can mean different things to each of us. This section explores these terms and more with a broad lens and is divided into eight chapters, each focusing on a specific terminology or concept. Some chapters tackle more controversial notions such as what is good or bad art. By understanding these terms up front, you'll find that the remaining sections of the book can then be read with more clarity as we establish common semantic ground.

CONCEPT 1: UNDERSTANDING PAINTING

Let's begin our discussion on painting by looking at art in general. Definitions of beauty are often used as a way to judge art; however, definitions of beauty are subject to change. What was once considered good art later may be seen as bad. In his book *Bad Art*, English art historian Quentin Bell raises the point that tastes and styles change over time, going in and out of favor. Judgments that rely on current taste may be more about economics and politics than art. Bell writes, "The dealer has to satisfy a clientele which, unlike that of eighty years ago, is not frightened by incomprehensible 'modernity'—indeed, this is what it wants. The dealer therefore may look for some young man or woman who may or may not have talent but certainly has a gimmick, some amusing novelty which will please the elite." He continues, "But as our young artist grows older, he or she may not be able to find a new gimmick …. This is hard on the artists, but this is what the market is like."

Is judgment of a work of art then, impossible? Is beauty truly in the eye of the beholder? Can standards of beauty exist for artwork? Bell writes that good art is made from "significant form and plastic harmonies." John Ruskin, a leading English art critic of the Victorian era, wrote that the difference between great art and average art lies not in methods of handling, styles of representation or choices of subject, but in the "nobleness of the end" to which the effort of the painter is addressed.

But how can we obtain what Bell describes as "significant form and plastic harmonies"? How can we evaluate Ruskin's "nobleness of the end"? In this book I tackle how form and plastic or spatial harmony can be defined and handled. And as for Ruskin, I agree that an artist will get better results not by attempting to work from current trends, sales or popularity, but instead by aiming for more authenticity, revealing their unique self through the work. Art offers a means to communicate some message from artist to viewer. A work of art conveys the artist's message through three means: the idea, the artist's spirit or personality, and the voice of the medium. By making appropriate choices in all three areas, an artist has the potential to produce a work that is unique in idea, distinctive in personality, and expressive of the medium, and perhaps has never existed before.

From a wide variety of art forms, an artist can choose the one that best suits their intent. Painting, sculpture, video or performance—each offers its own unique qualities. Over time, painters continue to push the limits and the definition of painting. Contemporary painting has developed a variety of offshoot disciplines that go beyond the classic idea of painting. Contemporary art institutions and museums now include installations, temporal paintings (using fleeting materials like ice, wind, etc.) and new technologies incorporating computers and video.

For this book, I narrow the scope by focusing on the classic definition of *painting*: an image painted on a 2-D surface. This may seem an unusual choice for a contemporary book, but narrowing the field allows for a deeper exploration of concepts.

The classic or conventional notion of painting has a unique quality. It can play illusionary tricks with our eyes. On a two-dimensional (2-D) flat surface, we are deceived into an experience of three-dimensional (3-D) physical space. Here a painter can manipulate dimensionality, enticing the viewer's eyes to move back into spatial depths, dart across the front surface, or flicker back and forth between depth and surface. With this illusionary experience of space, a painter may point out something that already exists in such a skillful manner that the viewer sees it in a brand-new way. Thus, painting can alter the viewer's perception, launching them into an exploration of their own thoughts and beliefs.

Too often painters will impulsively label their own work as bad or unworthy and discard it, only to find the same issues crop up in the next painting. I believe every painting can be improved if time is taken to examine the work with a critical eye. To serve this purpose, painters need tangible ways to problem solve and self-analyze the work for potential improvement. The Viewing Game in Section 3 offers ways to objectively assess your work, identify possible issues and then resolve them, all without wasting time and energy by using ineffective judgments of good or bad. *Create Perfect Paintings* is about finding ways to make your painting perfect for *you*.

OPPOSITE:
PLAYA GORDITA / Nancy Reyner / Oil on five wood panels / 90" × 240" (229cm × 610cm)

FIELD OF POPPIES / Vezna Gottwald / Oil on canvas / 60" × 48" (152cm × 122cm)

CONCEPT 2: LEFT VS. RIGHT BRAIN THINKING

The two hemispheres of our brain—left and right—offer different perspectives in thought, capability and action. The left brain directs our critical and analytical thinking in tasks such as reading, speaking, writing, labeling, editing and judging. Our right brain is creative, spatial and timeless, giving us those "in the zone" moments.

The left side is mainly concerned with our safety. It sources from our earliest survival experiences, stored in the oldest part of our brain, and thinks like a dinosaur. It keeps us from lingering in activities that it might deem dangerous, encouraging minimal activity in tasks so that we can stay alert and are not distracted for any length of time. The left brain makes fast, on the spot decisions, allowing just enough time to label a situation as safe in order to quickly move on. As we walk down a garden path, for instance, tall and graceful trees lining the path are quickly labeled by the left brain as all straight. Our left side assesses that none of the trees are likely to fall on us and that we are safe to continue walking. Our right side, though, enjoys the variety and personality of the trees, and indulges in metaphors, making each one a beautiful dancer waving in the wind. Turning things into generalities is the left side's job; peering deeply at life's quirks and individuality is the job of the right side. In general we can call the left side our analyzer and the right our creator.

It's a popular notion that we need to create art from our right side. This makes sense, as the right is more observant to visual detail, movement, drama and the unusual. Painting from the left will ensure all the trees are painted straight and that objects are safely lined up and, unfortunately, boring. Our right side is also the better half for meditation techniques to subdue the "monkey mind"—continuous chatter of the left brain—bringing about a desired calm. In *The Natural Way to Draw*, Kimon Nicolaïdes notes that art made with our right side dominant allows for more creativity and less judgment. There are plenty of other books that focus on creating with our right side. Two of note are *Drawing on the Right Side of the Brain* by Betty Edwards and *Life, Paint and Passion* by Michele Cassou.

The Shift from Left to Right

Most of our daily activities are directed by the left. The left side likes control, so it will inevitably begin all tasks. The right side takes over when the left gets too frustrated to complete a particular task. As a painter, this means that when you first start painting, actions are initiated with the left. Remember, the left side is not happy about painting, and its dinosaur mentality perceives this as a dangerous activity. The left wants you to finish quickly and tries all kinds of manipulations and maneuvers to

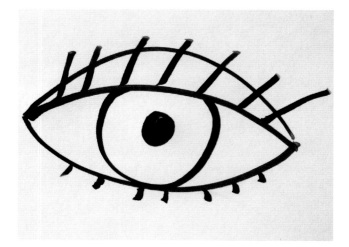

LEFT BRAIN REPRESENTATION
This drawing of an eye was created using the left brain, which uses general symbols and stereotypes as a substitute for engaged observation.

get you to stop painting. So when we paint, it's good to be aware that a shift from left brain to right will happen early on in our painting process. This shift usually occurs naturally, especially for experienced painters, but sometimes presents a challenge to beginners.

Creative blocks may occur during this shift from left to right as all kinds of unhelpful thoughts roll in: Am I using too much paint? I have more important things to do! I'm not good at this, and so on. As we gain experience, we learn to ignore this left brain attempt to stop us from painting. When you simply continue to paint, your left side will gradually realize that quitting is futile and will allow the right to take over. You have successfully allowed the shift!

While you continue to paint, the left side will intermittently check in to make sure you are not in danger. Once you're painting and on a roll, the side switching will have less of an impact on your ability to create. When you move between brain hemispheres, try to identify your left brain's fancy tricks. For more on maintaining right side dominance while painting, check out my tips on right brain painting starting on page 43.

Making the shift from left brain to right is not only important to artists in the act of painting but is equally important for the viewing audience. Viewers will gain a more meaningful gazing experience when they are encouraged to shift from their left side to right while viewing your work. This concept is at the heart of this book, forming the backbone of the process for evaluating and critiquing your images. By putting ourselves in the viewer's shoes (or eyes, in this case) we can employ the methods here to encourage the viewer to make the brain switch.

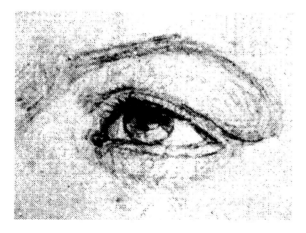 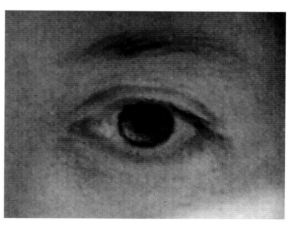

RIGHT BRAIN REPRESENTATION
Painting and drawing an eye from our right brain results in images with more detail and personality as shown in these painting details. On the left, William Blake; on the right, Élisabeth Vigée Le Brun.

<div style="text-align: center;">

EXERCISE

Learning How to Focus

This simple exercise demonstrates how our left and right brain hemispheres affect how we see. Read the instructions for steps 1 and 2 in full before beginning.

</div>

1 Stare at the picture of a hand on a colored background for about ten seconds. The left brain begins its standard task of applying a generalized descriptive label to the image in hope of a "quick exit" to keep your eyes on the move. The left brain will focus on the hand, while ignoring the background. Once labeled as a hand, the left brain will attempt to move your gaze elsewhere. See if you can become aware of any frustration that occurs when you force yourself to stare for the full ten seconds, longer than the left side wants you to.

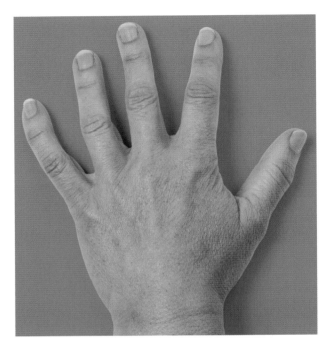

2 Gently turn your focus from the fingers (the positive spaces or forms) to the areas in between the fingers (the negative spaces or background). To keep focused on the negative spaces, ask yourself questions like "Which of the spaces is longest?" or "Which spaces are wider, narrower or more interesting in shape?" The left side is not so willing to label ambiguous forms such as negative spaces, and therefore allows the shift from left brain to right. You may feel an ease or release as your brain shifts.

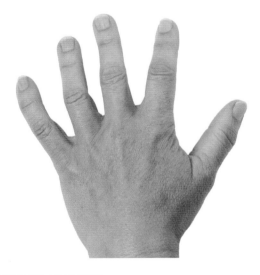

LEFT BRAIN VIEW
Forms are quickly defined with our left brain, while negative spaces are easily perceived by our right. Here the hand is isolated from the background, simulating what you might see while viewing with your left brain.

RIGHT BRAIN VIEW
Your right brain is more adept at viewing less identifiable shapes like these green background pieces.

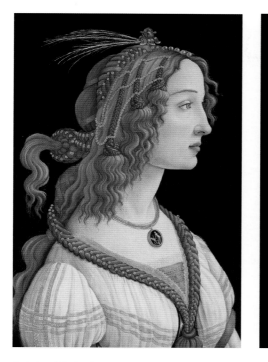

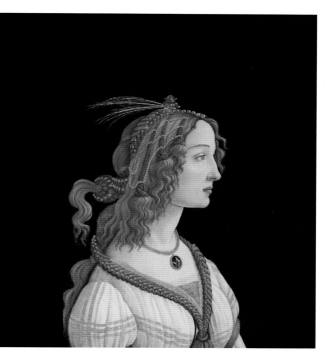

Original Painting **Altered Version**

ENVISIONING NEGATIVE SPACE

Compare the original Botticelli painting with the altered version that has an expanded background. In the original, notice the black shapes around the portrait. These background areas, or negative spaces, have been intentionally crafted, creating interesting shapes and adding a feeling of strength and importance to the woman. The expanded background, on the other hand, doesn't relate to the woman very much. It overwhelms her, making her seem small and insignificant.

IDEALIZED PORTRAIT OF A LADY (PORTRAIT OF SIMONETTA VESPUCCI AS NYMPH), CA 1475 / Sandro Botticelli / Tempera on wood (poplar) / 32" × 21" (82cm × 53cm) / Collection of Städel Museum

It is difficult, if not impossible, to see from both sides of our brain at the same time. Generally, one side is always dominant. Try taking a new look at the picture of the hand on the green background. Switch your gaze from fingers to spaces, then back again, giving at least ten seconds to focus before each shift. Notice how it feels while shifting. Even though one side takes precedence over the other depending on the task, keep in mind that both sides of our brain are continually engaged for all activities.

The Importance of Negative Space

Negative spaces are key to adding emotional and aesthetic support to the positive forms. For best results in both creating and critiquing your paintings, it is important to be able to view forms and spaces in your work separately, using the appropriate brain hemispheres.

CONCEPT 3: VISUAL TENSION

There are three aspects to consider when evaluating a painting: style preference, design issues and visual tension. To better understand these aspects, let's use the analogy of watching a movie.

Style Preference

Let's say your favorite film genre is the romantic comedy; this is your style preference. *Style preference* indicates what kind of subject matter or content you prefer. In painting, if you like the color blue, you are naturally attracted to blue paintings. Or maybe at an exhibition you gravitate to paintings that look super real or find yourself making a beeline toward minimal color field paintings. There's no need to discuss style preference in the course of evaluating paintings. You paint what you paint, attracting an audience with similar preferences to your chosen style.

Style preference can be problematic when mistakenly used for judgment. If you paint nature scenes but show your work to a gallery director who prefers geometric hard-edge abstraction, the director may reject your work based on differing style preference, which would not reflect the true quality and value of your work. If you are interested in shifting your painting style or genre, my book *Acrylic Innovation* is all about that topic.

Design Issues

Now let's look at design issues, still using the movie analogy. You find a movie to watch, but while watching you notice some technical difficulties. Too much static appears on the screen or the format won't show properly on your device. Design issues are built-in technical flaws that prevent you from watching the film (or viewing the painting) altogether. Design issues are fixable repairs that represent the main source for this book's painting critique. These problems, once identified and resolved, allow the painting to be viewed more fully. Section 3, starting on page 46, is devoted to design issues and their solutions.

Visual Tension

To watch a movie you search for your style preference, the romantic comedy category, find one and start watching.

"THE GREATER THE TENSION, THE GREATER THE POTENTIAL."

C.G. Jung.

If the movie you pick follows a common plot you've seen way too many times before, you'll stop watching to search for another with more of a plot twist. With no surprise element to anticipate, the level of visual tension of the first selection is too low to hold your interest. Visual tension is directly related to viewer expectations. The amount of surprise in an image determines the highs and lows of visual tension. The more variety and the more unexpected in a painting, the higher the tension. The more elements that match a viewer's expectations, the lower the visual tension. Low visual tension can therefore occur with images that have been overexposed to the public, for example, the *Mona Lisa*, or Warhol's soup cans.

Each of our five senses contains a natural attraction toward the unexpected. Surprise elements in hearing and taste are what make music and food more interesting. It's the same with our eyes. Carl Jung once said, "The greater the tension, the greater the potential." *Visual tension* is what engages viewers, enticing them to stay and view the work longer.

Look at a painting that attracts you and encompasses your style preference. How does it feel while you view it? This is visual tension. Are you relaxed and enjoying the image, or does it make you feel uncomfortable? If uncomfortable, are you compelled to stop viewing the work or does it entice you to look more deeply? These questions can shed some light on your own preferences for visual tension.

Being able to manipulate visual tension in a painting is a painter's number one tool for bringing attention to the work, and keeping the attention focused there to create a more meaningful experience for the viewer. Allow time to gaze at your own work. Keep looking until you are aware of how it makes you feel, to help determine its current level of tension. Then determine if the level will enhance the viewing experience or detract from it. It is important to understand that there is no fixed or correct level of visual tension for a painting. Preferred levels of visual tension comprise a range or window that differs for each of us based on the amount of time and experience viewing art and on our individual preferences.

PAINTINGS ARE NOT WALLPAPER

A painting is an image on a flat surface, sharing the same definition as wallpaper. Wallpaper designs are purposely created with low visual tension to avoid attracting attention, while the goal of the painter is the opposite for their work—to attract a viewer's attention and create the desired viewing experience.

Courtesy of Brewster Home Fashions

WALLPAPER EXAMPLE 1

Symmetric and repeated patterning in this fine example of wallpaper make this design well suited for a home environment, adding a touch of beauty and interest, while a low visual tension allows it to be peripheral to the furniture and art.

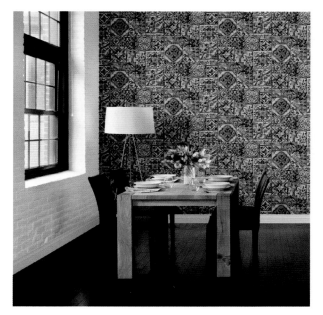

Courtesy of Brewster Home Fashions

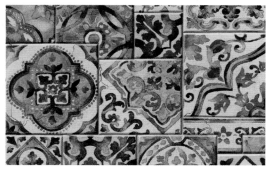

WALLPAPER EXAMPLE 2

Even a bold and varied pattern such as this one, when repeated on the wall, lowers the visual tension, allowing it to remain appropriate for its function and peripheral to the interior furnishings. High visual tension wallpaper may create discomfort if you are staying in the room for long lengths of time.

Develop Your Viewing Skills

Our eyes are in actuality "viewing muscles." In the same way we exercise our other muscles at the local gym, we can strengthen our eye muscles by viewing art more frequently.

The more we look at art, the more we increase our eyes' viewing muscle capacity, and the more visual tension we crave. Low visual tension can feel too safe and easy like elevator music, while visual tension that is too high can feel irritating like noisy, scratchy sounds. It is a quality we can control to give the right amount of edge to the work, attracting a viewing audience with windows of visual tension similar to our own.

To be appealing to a particular viewer, an image will have the appropriate style preference, a matching level of visual tension and no design issues. Levels of visual tension are not predetermined by any particular style. Both abstract or realistic paintings can contain high or low levels of visual tension. The determining factors depend on how much surprise or variety is present in an image for the viewer. Extreme levels of visual tension (too low or too high) as well as any design issues will instigate a quick exit from viewing. When a painting connects with a viewer, however, it will draw them in, and more importantly, keep their attention focused on the work.

VARY PATTERNS

When using patterns in a painting, allow enough repetition while also including enough variation to raise visual tension.

GARDEN OF THE KEYS / Nancy Reyner / Acrylic on canvas / 46" × 60" (117cm × 152cm).

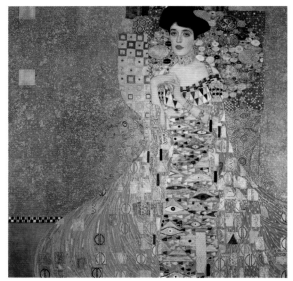

CONTRAST PATTERN WITH SIMPLIFIED AREAS

Position nonpatterned areas next to patterned areas for contrast, to add variety and to increase visual tension. In Gustav Klimt's painting, notice how the smoothly painted nonpatterned areas in the woman's face, hair, neck and hands, and the solid green in the bottom left provide an interesting contrast with the patterning in the gold leaf.

PORTRAIT OF ADELE, CA 1907 / Gustav Klimt / Oil, silver and gold on canvas / 54" × 54" (137cm × 137cm)

HOW CULTURE INFLUENCES VISUAL TENSION

Visual tension is also influenced by cultural tastes. Édouard Manet created an outrage at the 1865 Paris Salon with his painting *Olympia* depicting a nude woman in a confrontational gaze directed out toward the viewer. For its time, *Olympia* contained high visual tension and therefore created a scandal. In the twenty-first century, the visual tension of this same image might feel quite low to a contemporary museum goer, but high for someone with conservative ideas about nudity. Remember that visual tension is not fixed for any particular work of art but instead relies on the viewer's expectations and preferences.

OLYMPIA (DETAIL), CA 1863 / Édouard Manet / Oil on canvas / 51" × 75" (131cm × 190cm) / Collection of Musée d'Orsay, Paris

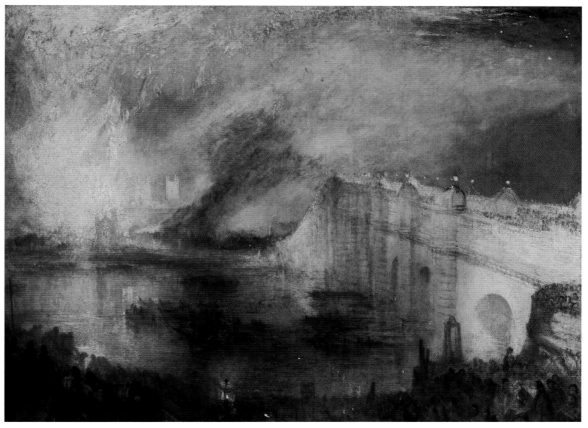

MAINTAIN YOUR ARTISTIC VISION

As English Romanticist landscape painter J.M.W. Turner's style evolved, his landscapes became moodier and more abstract, almost like color fields. These abstract works had a visual tension that was too high for most of his audience, and he received unfavorable criticism as a result. This did not keep Turner from painting this way, and perhaps it is the reason he has become somewhat of an artists' hero. It is easy to succumb to popular demand, yet important for artists to maintain their vision even when their work is not widely accepted.

THE BURNING OF THE HOUSES OF LORDS AND COMMONS, CA 1835 / J.M.W. Turner / Oil on canvas / 36" × 48" (91cm × 122cm)

CONCEPT 4: MEET YOUR AUDIENCE

Artists paint for an audience. It could be an audience of one—yourself! Or a larger audience of people you have never met, perhaps only connected by your art. Private or public, it's an artist's choice. Painting for yourself is similar to writing in a diary. You write to express yourself, to clarify your thinking or just for the pure pleasure. Your diary is not meant for others to read, so why edit for readability? For public writing, however, you would reread, rewrite, edit and proof your text. Similarly, a painter who wishes for the work to be seen by others will want to view, review, edit, tweak and repaint areas. Edit your painting to add "readability" and to clarify your intent in the work.

Your ideal viewing audience will have a matching or overlapping range of visual tension to yours. Understanding the connection between visual tension levels and your audience will make it easier to handle criticism and rejection, a natural part of any artistic pursuit. If you like to create edgy contemporary work and show it to a friend or relative who has minimal art experience, you are not likely to get a positive response. A rejection of your work may be due to differing windows of visual tension rather than a reflection of the inherent quality and value of the work. When you exhibit and market your work, knowing who your audience is will boost your efforts. Like Turner and Manet, referred to in Concept 3, paint the paintings you want to make rather than compromise your work for others. Make yourself happy first and always! Then the work will naturally find its appropriate audience.

Photo by Ryan McGuire

EDITING YOUR WORK

In Section 3, I introduce The Viewing Game, a method of critique that can benefit artists painting for either private or public viewing. Critique is an editing tool for painters. Editing your painting strengthens your eye-viewing muscles and enhances your ability to paint what you envision. Artists who intend for others to view their work will naturally want to communicate something through their work. This leads to two goals: to bring a viewer's attention to the painting and then to keep the viewer's attention on the work long enough for a quality viewing experience. Analyzing and editing the work is critical to reaching these goals.

CONCEPT 5: OPPOSITES ATTRACT

In *The Book of Tea*, Kakuzo Okakura writes, "Truth can be reached only through the comprehension of opposites." Our brains are hardwired to seek out pairs of opposites. When we see light, our eyes then search for dark. In a crowded room we seek empty space. Tasting something sweet, we crave something salty. The importance of opposites, and how they play a significant role in visual attraction, is used throughout this book and is the basis for critical analysis. To fully comprehend the extent of the role that opposites play in our vision and perception, try the following Red Square Game. It takes just 30 seconds, and the results may surprise you.

Paint with the Right Side, Critique with the Left

Our left brain balances sets of opposites to make things feel safe. When you paint dominantly with your left brain, it will result in safe, symmetrical, neutral images with low visual tension. For better results, paint primarily using your right brain and save your left side for the critique process.

EXERCISE

Red Square Game

Read the following instructions before proceeding. Cover this page with white paper so that only the white box and red square are visible. Set a timer for 30 seconds (or plan to count to thirty slowly on your own). Fix your gaze on the red square pictured here. Do not change your gaze for a full 30 seconds. You can blink, swallow and breathe, but do not look away or let your eyes wander. After 30 seconds, look immediately at the blank white space to the right of the red square and blink lightly a few times. Notice what happens. Were you surprised? A green square should have magically appeared on the white of the page. If you did not get this result, repeat the process, keeping your eyes more focused. Try not to let your eyes wander while staring at the red.

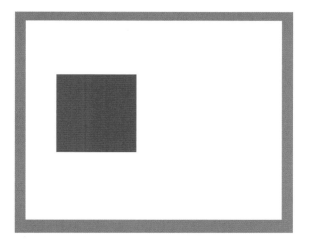

What Happened?

The natural reaction after staring at red for so long is for our eyes to seek out something green. By forcing our eyes to move immediately from red to white and stay there, the brain is forced instead to create green where it doesn't exist. Why did this happen? Red and green are color opposites, positioned across from each other on a standard color wheel. Mix them together in paint and the result is neutral or brown. Our left brain is primed to keep us safe and out of danger. It equates neutral, symmetrical and equal as safe, while any overstimulation is perceived as dangerous. So when you force yourself to stare at red longer than a normal glance, the retina becomes oversaturated and alerts the left brain to neutralize with green.

CONCEPT 6: THE 80:20 RULE

Successful painting relies on pairs of opposites such as light and dark, bright and dull, space and form. But how to best use them in paintings? Let's start by viewing the relationship between one element and its opposite as a ratio. For instance, if a painting contains a lot of red with no green at all, that is a 100:0 ratio (red to green), and a viewer will leave the painting very quickly to find green elsewhere.

To avoid these quick viewing exits, both parts of a pair must be present in the painting. However, if both are present in equal amounts (a 50:50 ratio), it will create boringly low visual tension as in wallpaper. The real secret to powerful painting lies in the use of unequal ratios, such as 80:20. Uneven ratios create more interest and higher levels of visual tension. Why is this?

Let's look at a typical art viewing experience. A viewer gets interested in a painting and goes in for a closer look. As is the norm, their left brain begins the viewing task looking for ways to cut viewing short.

Remember, our left brain perceives deep concentration as dangerous to our safety. Equality (a pair of opposites in a 50:50 ratio) is interpreted by the brain as safe, and if present in a painting will encourage the viewer to move on. If, however, enough pairs of opposites are presented in unequal ratios (80:20), the left brain will keep searching for a way to determine or label the viewing experience as safe, and when unable to do so, will eventually transfer the viewing task to the right brain. Success! Our viewer is now enticed into a longer gazing session with the possibility of a more meaningful viewing experience using their right brain to view.

EXCEPTIONS TO THE 80:20 RULE

Let your intent for your work guide how you use the principles in this book. There are always exceptions to the rules. For example, in this minimalist painting the artist intended to use only one color, yellow, for the work to have specific meditative qualities. Using the 80:20 rule as hard and fast would mean adding 20% of yellow's opposite, violet, into the image, therefore overriding the artist's intent. Instead, the artist could add violet outside the painting in a matte frame or paint the wall behind it violet to minimize any quick exits and enhance the viewer experience (see page 123 for an example of this). Remember to consider the 80:20 concept with an open mind, using it to your advantage without the need to compromise the work.

MER KA BAH / Marcia McCoy / Monoprint from *Sacred Geometry* series / 40" × 26" (102cm × 66cm)

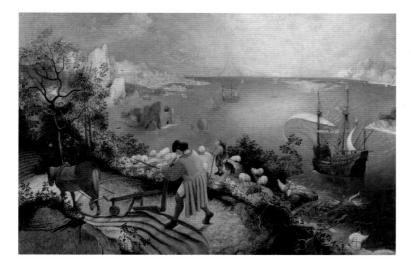

UNEQUAL COLOR RATIOS ATTRACT

This painting's green to red ratio is about 80:20 or maybe even 90:10, directing the focus swiftly toward the central red shirt and warm browns. An unequal relationship for a pair of opposites adds powerful attraction to the image.

LANDSCAPE WITH FALL OF ICARUS, CA 1560s / Pieter Brueghel the Elder / Oil on canvas / 29" × 44" (74cm × 112cm) / Collection of the Royal Museums of Fine Arts of Belgium

Original Painting

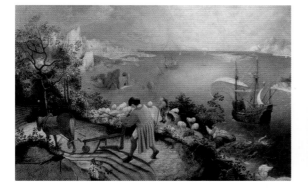

Altered Version 1

Photographically altering to remove all red (100:0 ratio green to red) creates an overly green experience, forcing eyes into a quick exit to search elsewhere outside the painting for red.

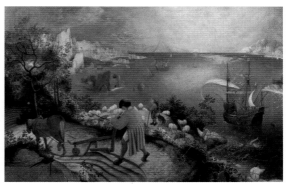

Altered Version 2

Photographically altering to remove all green (100:0 ratio red to green) creates the same viewing issue and quick exit. When only one of a pair of opposites is present, the image is unappealing. Avoid ratios of 100:0 with any pair of opposites in a painting.

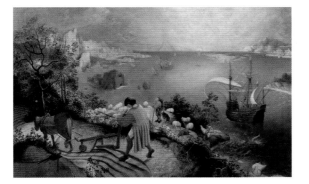

Altered Version 3

In this altered version, more red was added to the image to create a 50:50 green-to-red ratio. Avoid using both components of a pair of opposites in equal amounts. It can create too many focal points, adding confusion rather than more interest, or create an overall feeling like wallpaper.

CONCEPT 7: REALISM AND ABSTRACTION

Defining the well-used terms *realism* and *abstraction* can be a challenge. Numerous definitions are posted online and in art books, yet no absolute consensus seems to exist. The 1960s' painter Ad Reinhardt is best known for his minimalist black paintings. Art professor and author Irving Sandler felt these works of Reinhardt induced a contemplative state. One painting in particular, measuring five-foot (1.5 meters) square and all black, was divided into nine separate sections. Each section differed only slightly from the next using subtle changes of black coloring and brushwork texture. Reinhardt believed that any references to elements outside of a painting, including artists' emotions and feelings, detracted from the art. He said, "The only and one way to say what abstract art is, is to say what it is not…. Abstraction presents art as art, pure and emptier, more absolute, non-objective, non-representational, non-figurative, non-imagist, non-subjective, non-expressionist."

Abstraction includes, and often relies on, a viewer's personal interpretation. We like to interpret the world around us by our own experience. How many times do we look up at the sky and reinterpret the clouds into familiar shapes? This is one of abstraction's main appeals to its audience. The less detail, the more it becomes open to the viewer to add their own interpretation. In *The Book of Tea*, Kakuzo Okakura writes, "In leaving something unsaid, the beholder is given a chance to complete the idea and thus a great masterpiece irresistibly rivets your attention until you seem to become actually a part of it." This idea of viewer participation is one of the founding principles of modern and contemporary art.

GENERAL NOTIONS OF REALISM

Most viewers would define this painting as realistic. Realism strives to describe or reflect the world as it is. Realism often presents an objective view rather than a subjective one.

EVENING RAILYARDS / Bruce Cody / Oil on linen / 24" × 44" (61cm × 112cm) / Private collection

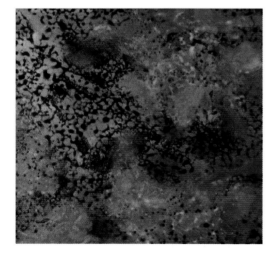

GENERAL NOTIONS OF ABSTRACTION

Most would define this as abstract. Commonly accepted qualities for abstraction are little or no horizon line, less detail, forms less recognizable and more ambiguous, and an emphasis on negative space and other atmospheric qualities.

MORNING COFFEE / Bonnie Teitelbaum / Acrylic on panel / 15" × 15" (38cm × 38cm)

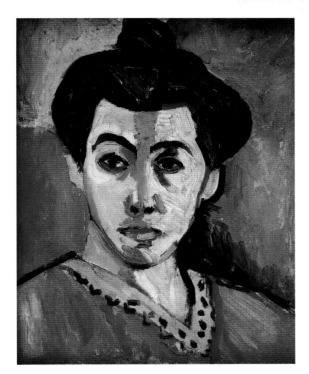

THE ARTIST'S INTENT AS A DEFINING QUALITY

Recognizable imagery in a painting does not automatically qualify it as realistic. A face is easy to recognize in this Matisse portrait, yet exaggerated colors and simplified shapes give it the feeling of abstraction. When an artist intends to leave interpretation open to the viewer, often by eliminating a certain amount of realistic detail, the work can be considered more abstract than realistic.

PORTRAIT OF MADAME MATISSE (GREEN STRIPE), CA 1905 / Henri Matisse / Oil on canvas / 16" × 13" (41cm × 33cm)

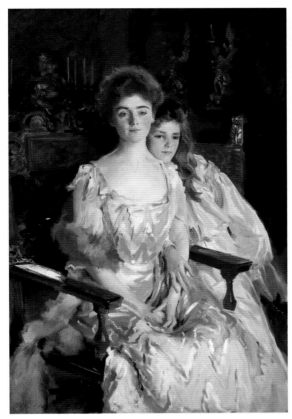

DEFINITIONS ARE NOT ALWAYS CLEAR CUT

The definitions of realism and abstraction are not always cut and dry. This above detail from an Old Master style painting could be viewed by itself as a contemporary abstract painting. This detail is from the bottom portion of the central figure's white skirt in the foreground.

MRS. FISKE WARREN (GRETCHEN OSGOOD) AND HER DAUGHTER RACHEL, CA 1903 / John Singer Sargent / Oil on canvas / 60" × 40" (152cm × 102cm)

Horizon Lines

A horizontal line in a painting that goes from one side of the image to the other, whether continuous or broken, is often interpreted as a *horizon line*. A horizon line is where land (or sea) and sky meet. In painting, the horizon line can be invisible and implied or visible and obvious, especially in landscape paintings. Horizon lines can be included in any painting, whether realistic or abstract, and they can be intentionally omitted to create a different type of spatial quality.

Choices to include or exclude horizon lines can significantly manipulate the image toward realism or abstraction. A painting with a distinct horizon line can be viewed with a certain amount of "safety" by dividing the image into what is perceived as "sky" and "ground." A viewer naturally transfers their innate experiences of being in the physical world, such as gravity, onto an image. A horizon line validates these expectations. When horizon lines are eliminated, it can often be interpreted as color field, and a viewer who prefers a lower or safer visual tension may feel disoriented. A more sophisticated viewer looks for the "edge" or added tension that may be enhanced by eliminating any hint of a horizon line.

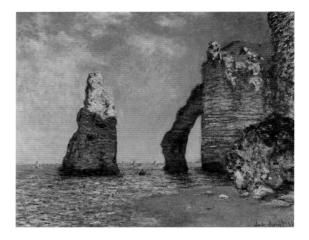

OBVIOUS HORIZON LINE
In this painting the horizon line visibly appears far in the distance, separating the sea from the sky.

THE CLIFFS AT ÉTRETAT, CA 1885 / Claude Monet / Oil on canvas / 26" × 32" (66cm × 81cm)

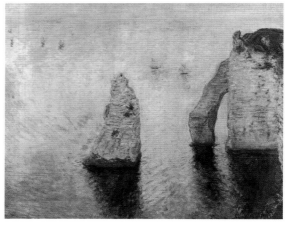

SUBTLE HORIZON LINE
Monet paints the same view with a subtle horizon line that all but disappears, appearing almost as a color field background. The treatment of the horizon line dramatically changes the feeling of the two compositions.

SAILBOATS BEHIND THE NEEDLE AT ÉTRETAT, 1885 / Claude Monet / Oil on canvas

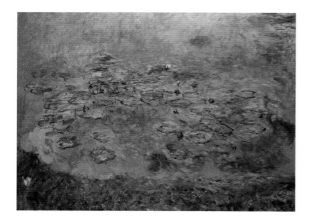

NO HORIZON LINE
Monet has completely eliminated any indication of a horizon line, making the image even more abstract like a modern color field painting.

NYMPHÉAS (WATERLILIES), CA 1917 / Claude Monet / Oil on canvas / 71" × 79" (180cm × 201cm)

CONCEPT 8: PAINTING PROCESSES

There are many ways to produce a painting. In this book I have divided the painting process into two distinct stages or phases.

Painting usually begins with a "play phase," which encompasses a variety of ways to start and to get an idea fleshed out. This phase is usually about having fun, using intuition, letting ideas flow and getting a variety of visual material initially onto the canvas. It's a great time to collaborate with materials and allow surprises. Critical thinking is best avoided during this phase.

The second phase is the "critique phase." This is the time for analysis to enhance the work, to better communicate ideas and to clarify the desired viewing experience for your particular audience.

While actively painting in the play phase, design issues are not always visible but they become more obvious during the critique phase, when brushes are put aside in favor of giving the work a good, hard look. Both phases require very different thinking, and use differing processes and techniques.

For this reason the two phases are handled separately in this book, comprising Sections 2 and 3, respectively. It is advisable to carry out each phase at separate times. It's not always easy to switch from one phase to the other in the same day. Each day tends to put forward a particular energy or focus better suited for one phase over the other.

Pay attention to how you feel just before starting to paint to decide which phase you prefer to work with that day. Choose to start new paintings when you feel in a playful mood, or continue on a work in progress while in a more intellectual mood. Choosing the phase that best matches your energy will enhance productivity and outcome. It helps when you are willing to have more than one painting in process at the same time. Paint at a time during the day when your energy and focus are at their highest. If your best energy is in the morning, get up early to paint before attending to other activities. If you are a night owl, save some energy for a work session later in the day.

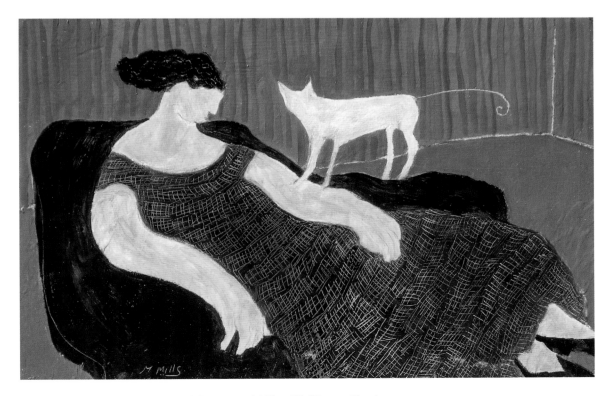

RECLINING WITH CAT / Gigi Mills / Oil on panel / 9" × 13" (23cm × 33cm)

THE TALISMAN, CA 1888 / Paul Sérusier / Oil on wood / 69" × 55" (175cm × 140cm) /
Collection of the Musée d'Orsay, Paris

SECTION 2

PLAY PHASE

This book divides the painting process into two distinct phases: the play phase explored in this section and the critique phase covered in the next section. Here you will find abundant ideas to keep the play phase as inventive as you like. Whether your paintings are humorous or serious, realistic or abstract, large or small, the creative act of playing is essential in the painting process. During play creative juices are fully active, and new ideas come bubbling up. Without play your work (and your spirit) can get dry, burnt out or bored.

Today's painters are fortunate to have numerous choices of readymade ingredients and materials. Paint comes in portable tubes, canvases are prestretched and even primed. With all the available choices, there's still a tendency for artists to fall into the habit of using the same materials over and over. We lay out our favorite paint colors on our usual size and type of surface. We have a routine to get our ideas onto the canvas. Habits are helpful, as familiar territory can get us moving quickly. However, there are times when those same habits can work against us, turning play into routine.

How do you choose your tools, materials, techniques and processes? What we select in the beginning can significantly affect the end result. Before the first brushstroke is even made, an emotional "content" is already added. The next time you start a painting, take time to ponder the ideas offered in this section. My hope is that you find something to shift your habits and perk up your process.

CONTROLLED PROCESSES

We are unique beings, and therefore we can find infinite ways to work through a painting from start to finish. In general, most painting processes fall into two categories based on the desired end result: control or surprise. If you have a specific vision in mind as to how your completed painting will appear, then the best process will be the one that offers methods of control. If you want more surprise, then flexibility is key for your process. Either way is valid. Acknowledging your choice in the beginning will cause less frustration later. Keep in mind that the choice of medium plays a big part in process decisions. For instance, watercolor is more well-suited for a controlled process, since changes needed mid-process may be limited.

Working from Models and References

Artists working with clients on custom commissions often need to submit proposals with multiple ideas. Making several small-scale, rough image layouts or models is one way to do this. Models can be made with mediums and surfaces that might differ from the final work. Images can be made from reference materials you find from your own archives or elsewhere. References can be photos, drawings, collages, postcards, or prints found in magazines, on artists' websites or through general Internet searches.

Once a model is selected by the client, there are several ways to transfer it onto a larger surface for the actual painting in a controlled manner. Here are two suggestions.

String Grid Method

My favorite grid technique uses string to form the gridlines on a painting surface. The string grid is quick and easy to create and leaves no trace in the final work. On the facing page I detail the string grid method in four easy steps.

FINISHED PAINTING
I used a gridding method with string to accurately transfer the image from the small oil pastel model to this finished acrylic painting.

FLORAL 1 / Nancy Reyner / Acrylic on canvas / 32" × 20" (81cm × 51cm) / Private collection

REFERENCE MODEL
This model measures only 6" × 4" (15cm × 10cm) and uses oil pastel on paper.

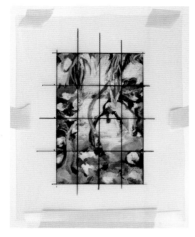
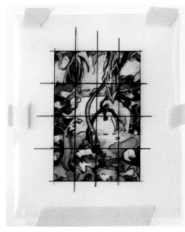
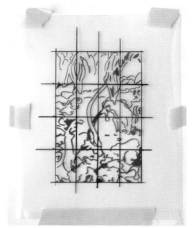

1 To transfer the image from the model onto a larger final surface, overlay a grid onto the model. Start by taping clear acetate over the model. Using a marker and ruler, divide each side in half, then half again, continuing to divide until grid sections are as small as you want, marking with a dot at each division. The more detail you have in your model that needs to be transferred, the smaller you need the grid sections to be. Now connect the dots to make the grid lines with a colored marker, seen here using blue.

2 Using a different color marker than the one used for the gridlines, trace over the image along general design lines. Here I used red.

3 Remove the acetate from the model, placing it over white paper to see the general design lines in red more clearly.

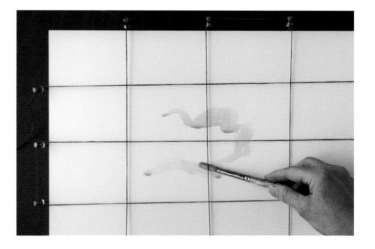

4 Grid your final painting surface. Using a ruler and pencil, divide the sides of your surface in half, then half again, marking the sides or edges with only a dot. This time, though, instead of connecting the dots with a marker to create colored lines directly onto the surface, use string to act as lines.

To create string lines, hammer extra long (⅝" [16mm]) metal pushpins along the sides of the painting surface and close to the top where each dot has been marked. Insert pushpins at a 45-degree angle to the surface so string lines will be raised up from the surface. If your surface does not have deep enough sides, drive the pushpins into the front face, close to the edges,

either through the canvas into the stretcher bars or directly into the wood if using a wood panel. Tie string around one of the pushpins nearest to a corner and continue to wrap the string around each pushpin until the grid is complete, securing it with a final knot around the last pushpin.

To begin the painting, dilute a light-colored paint and brush on your design using the model's general lines and grid as reference. The string will be slightly raised off the front surface, allowing enough room for your brush to freely paint underneath. When your wash sketch is complete, simply remove the pushpins and string. Continue painting without the grid until complete.

Direct Sketch

This painting began by sketching directly onto the canvas without gridding. Direct, loose sketching with paint and brush is a playful way to mark out a specific composition and preliminary color ideas. In the final painting the underlying composition has remained intact.

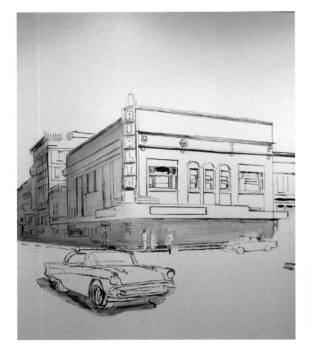

Initial Sketch

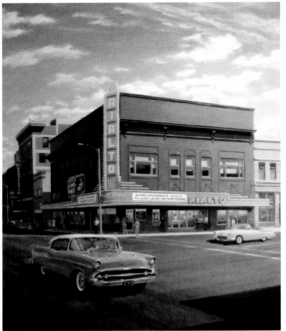

Finished Painting

RIALTO CORNER 1960 / Bruce Cody / Oil on linen / 30" × 26" (76cm × 66cm) / Private collection

Sketching Wet-Into-Wet

Transfer a model or design with more play and less control using this fun technique. First brush a clear medium (water for watercolor, oil mediums for oil paint, acrylic mediums for acrylic) onto your painting surface. While still wet, sketch your design into the medium with a light paint color like ochre. The wet medium allows for easy erasing using a rag. While painting you can keep changing it until you like it, until the medium starts to dry. Repeat the process until enough of an initial design is established for your needs.

FLEXIBLE PROCESSES

Cubist painter Juan Gris apparently preferred surprise endings when he said, "You are lost the moment you know what the result will be." Here are some ideas for starting a painting that allow for more changes during your process. Additional flexible processes are described in Section 5 on pages 130 and 131.

Dive In

Get something onto your canvas spontaneously with little or no preplanning about what you want to paint. Start with any color or colors you like, apply onto the canvas using any favorite tool, and work them into shapes or marks with no agenda.

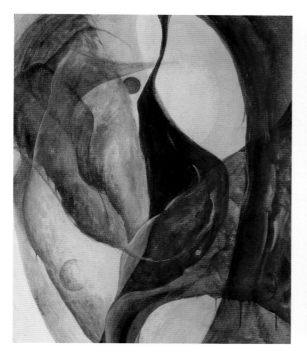

WORK IN PROGRESS
After starting with the spontaneous approach, Ragalyi got to this point, then evaluated the work, making decisions on how to progress.

FINISHED PAINTING
Ragalyi further defined the accidental shapes, added new shapes and applied an overall blue glaze, toning down the bright colors and integrating the overall color scheme.

VEILED LIGHT / Barbara Ragalyi / Acrylic on canvas / 46" × 36" (117cm × 91cm)

Happy Accidents

Play around with your paint to achieve happy accidents. Apply paint experimentally á la Jackson Pollock. Heavily dilute your paint and fling, pour, drip and drizzle it all over the surface or in selected places. When left to dry the resulting image can be interpreted into recognizable imagery or left as is for an abstraction. Overpaint and redefine the image to more fully express your newly interpreted vision.

WASHES ON ABSORBENT SURFACES

To create this Rorschach-type image, I diluted acrylic paint with lots of water and poured it onto an absorbent surface. (Similarly, you could use solvent to dilute oil paint.) This image could be used as a jumpstart or underpainting for a realistic or abstract painting. What type of imagery does it evoke for you? How might you add to it to make it more interesting, more realistic, or change it to something closer to your preference?

Thumbnail Sketches

Doodles based on simple designs—*thumbnail sketches*—can get your painting off to a quick start. Scribble a few ideas on paper, choose your favorite, then sketch onto a painting surface using pencil, charcoal or diluted paint and a brush. If using charcoal, seal it before painting by applying clear acrylic medium or fixative over the charcoal lines. Then overpaint using acrylic or oil.

PLAN YOUR COMPOSITIONS WITH THUMBNAILS

Thumbnail sketches can be very simple. The middle sketch of waves was used for this final painting.

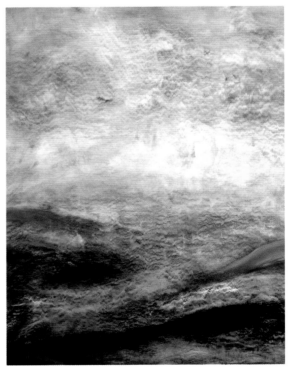

TURQUOISE SEA / Nancy Reyner / Acrylic on panel / 45" × 36" (114cm × 91cm)

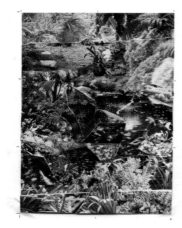

Photographs and Collage as Reference

Photographs make great painting references. Instead of copying from one single photograph, make the work and your process more exciting (and original) by combining multiple photographs.

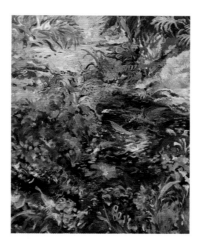

REFERENCE MODEL

This 6" × 4" (15cm × 10cm) model is made from no fewer than thirty separate pieces cut from photographs and glued collage-style onto cardboard. The buildup creates a dense image with lots of reference options to choose from.

FINISHED PAINTING

Compare the finished painting to the original model. The dramatic difference in size between the postcard-size model and the large canvas helped me shift the image while working.

KOI AND RIVER / Nancy Reyner / Acrylic on canvas / 60" × 46" (152cm × 117cm)

REFERENCE MODEL: COMPOSITION

I combined two photographs from magazines, securing them with a glue stick on paper, to create a new reference image. I cropped in on the desired composition with four strips of white paper taped together to form a window.

REFERENCE MODEL: COLOR SCHEME

Using the previous model as reference, I created another small-scale model using oil pastel on paper to establish the color scheme.

FINISHED PAINTING

I used both models as reference for the finished piece, combining both the composition and color schemes. No matter how attached you are to your models, always stay receptive to changes while a work is in process.

AQUA / Nancy Reyner / Acrylic on canvas / 48" × 36" (122cm × 91cm)

CHOOSING THE RIGHT MEDIUM

After deciding on a controlled or flexible process, it's time to choose a medium. Here are lists of pros and cons for most common painting mediums. In addition to those listed here, paintings can be made with many other mediums such as gouache, oil pastel, ink, pencil, markers, spray paint and silk screen among others. Experimenting with a new medium, even for a short period of time, can be fun and inspiring, and expand how you use your current medium once you return to it.

Oil

Pros: Oil paint is slow drying, allowing for more time to make changes and to blend colors. Oil refracts the color pigment in the paint for a beautiful, rich glowing color. Great for realism, blending and detail, oil can also be used for experimental and playful methods of abstraction

Cons: Working transparently (such as glazing) requires the use of oil mediums that often contain toxic solvents. Oil paint alone is not toxic, but some mediums used to extend oil paint are toxic. Reduce toxicity by using nontoxic mediums in the paint and baby oil to clean brushes.

Oil paint never fully cures even when dry to the touch, so correct care must be taken for handling and storage. The painting must not be shipped or varnished too soon. Layering requires correct chemistry so that a more flexible layer is always applied over a less flexible one.

Oil has the potential to crack, especially if used thickly. Most oils turn yellow over time, dramatically reducing luminosity in white and light value colors.

Acrylic

Pros: Acrylic paints, mediums and products are almost all nontoxic. Acrylic is known for its fast drying qualities but is also available in slow-drying forms. A wide variety of acrylic products are available to customize paint and to personalize preferences in surface absorbency, texture and sheen. Fast-drying acrylic paints are great for layering while slow-drying acrylics imitate the look and feel of oil.

Paints are available in varying consistencies (viscosity), so acrylics can imitate both watercolor and oil in look and feel. Acrylics can be as thin as ink or thick and heavy bodied for textural effects. Acrylic offers the widest range of possibilities and is now considered more archival than all other mediums. When used correctly it will not crack or yellow, and fully cures in about two weeks. Acrylic can be used in conjunction with many other mediums such as creating a fast-drying underpainting for use under oil paint.

Cons: Acrylic binders usually contain ammonia, and though considered nontoxic, can cause sensitivity with some people, especially when used without proper ventilation.

Watercolor

Pros: Watercolor naturally creates transparency, and its watersoluble nature allows for some changes even after it has dried.

Cons: Because watercolor is usually applied to paper, the paint will sink into and stain the surface, making the paint difficult to remove fully once dry.

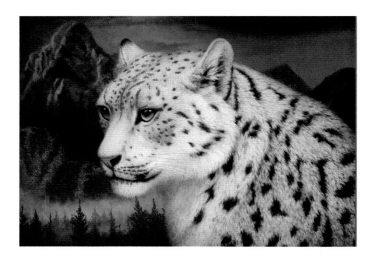

SELECTING MEDIUMS APPROPRIATE FOR YOUR STYLE
Here acrylic is used to get a fast overall underpainting, then oil is used for the final layers for detail and blending.

SNOW LEOPARD / Tom Palmore / Acrylic and oil on board / 18" × 24" (46cm × 61cm)

When finished, watercolor paintings need protection, such as being framed behind glass, due to paper being not as archival as panel or canvas as well as the non-permanent nature of the watercolor paint.

Chalk Pastel

Pros: Pastel is actually a drawing medium, but finished works in pastel are often referred to as paintings. Drying times are not an issue when working with pastel, making it portable and an excellent choice for working outdoors. Good quality pastels can produce a unique and luscious sheen in the final surface. Colors come in a wide range and can be blended and mixed directly onto the surface.

Cons: Pastel remains delicate on a surface and requires protection with glass and framing. Alternative protection, such as spray fixatives and sealers, will diminish pastel's color and sheen.

Mixed Media

Pros: Combining paint and painting mediums with other materials expands possibilities and adds an immediate contemporary appearance.

Cons: Non fine-art materials, such as those made for craft and commercial use, can fade over time with exposure to light and air, requiring UV or other types of protection such as sealing applications or framing with UV glass.

When one type of material is layered over a different one, it may need extra procedures for proper adhesion between them.

A Word About Mediums

The word medium *has different meanings depending on its context. It can designate a discipline such as oil or acrylic, or it can refer to an actual binder or extender used in the chemistry of that discipline. For example, linseed oil is a medium and is used with the medium of oil paint.*

USING NONTRADITIONAL MATERIALS
Mixed media combined with paint adds a contemporary feel and tactile surface interest in this painting.

DAISY MAO / Deborah Lewis / Mixed media (paper and acrylic) on wood / 30" × 40" (76cm × 102cm)

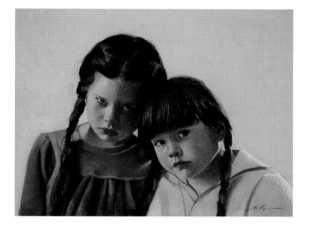

COMBINING FINE ART MEDIUMS
Reingold uses a combination of two fine art mediums. The oil paint washes create large areas of color and set up the composition and color scheme. Colored pencils, sharpened to a fine point, add fine detail over the washes.

SISTERS / Alan Reingold / Colored pencil and oil paint wash on board / 14" × 18" (36cm × 46cm)

CHOOSING THE RIGHT SURFACE

For painting, canvas and wood are two popular surface choices. Paper, plastic, metal, glass, ceramic, leather, vinyl and cardboard can also be used as surfaces for painting.

Canvas

Canvas comes in cotton duck or linen and has several advantages. It is lightweight, making it easy to handle for large sizes. Canvas has a lovely absorbency and texture in the weave, if that suits your style. It is obtainable already stretched and primed for immediate painting. Loose unstretched fabric is also available for you to stretch yourself using wooden stretcher bars, or it can be left unstretched to pin up on walls or drape loosely on floors for painting.

Take extra precautions when applying pressure to the stretched canvas such as sanding or pouring acrylic mediums onto the surface. These techniques are best accomplished using rigid wood panels since canvas will droop both from the pressure required to sand and the weight of poured mediums, which will require extra support underneath.

For those unsuccessful canvas paintings you are thinking of repainting, it is best not to overpaint. Instead, discard and replace the canvas while reusing the stretcher bars. Since canvas can only handle a certain amount of weight before it will stretch or develop defects, avoid applying excessively thick layers onto the canvas.

Wood Panels

Wood panels can be made with a variety of woods. They can be cradled to give some depth to the sides and can be purchased readymade as panels, with or without cradling. Hard and rigid, wood panels can be easily transported while layers are still wet, and they work well for sanding and pouring techniques. Panels last longer than canvas given similar environmental circumstances. They are cost efficient and can even cost less than stretched canvas. That is because canvas stretcher bars are crafted for reuse, while panels don't need this extra feature. This reduces manufacturing costs for panels. Hiring a carpenter for a bulk order, making several similar-sized custom wood panels at the same time, offers substantial cost savings to the artist. Carpenters will generally charge per hour plus cost of materials, while purchasing stretcher bars and canvas has additional retailer costs added into the final price. It is fairly easy to overpaint a former image on wood panel or sand off any texture from an old image for a fresh start on a new image.

Both wood and canvas should be sealed with a primer before painting with oil paint. Acrylic paintings require an additional stain sealer under the primer.

Hardboard

Hardboard, a type of wood panel formerly known as Masonite, is available as untempered (or standard) and tempered. A few decades ago, tempered hardboards

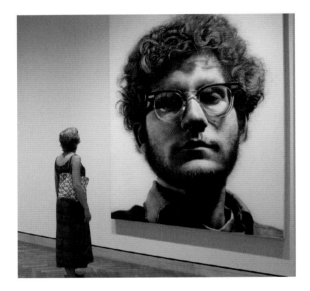

Photograph by Tim Wilson (everystockphoto.com)

LARGE-SCALE PAINTINGS
Artist Chuck Close paints portraits on a very large scale. The dynamic quality in his work is due in part to the unexpected combination of a face (which is intimate) with large scale (which is not). Chuck Close suffers from prosopagnosia, also known as face blindness, in which he is unable to recognize faces. He chose to paint portraits of people he knows as a way to help recognize and remember their faces.

FRANK / 1969 / Chuck Close / Acrylic on canvas / 108" × 84" × 3" (274cm × 213cm × 8cm) / Collection of the Minneapolis Institute of Art / Courtesy of Pace Gallery

resulted in delamination issues, though manufacturers have since resolved this. Now either type of hardboard can be used for archival painting surfaces. Tempered hardboard is a better choice as it resists warping and edges won't fray.

Surface Size

Typically, small paintings are categorized as those that are easy to hold with one hand and measure around 8" × 10" (20cm × 25cm) or smaller. Medium-sized paintings are those easily held with two hands, 11" × 14" (28cm × 36cm) to 36" × 48" (91cm × 122cm). Large-sized works usually measure from 40" × 50" (102cm × 127cm) on up. It is important to know that a painting's size will significantly affect how the image is perceived. Small, medium or large painting sizes will each create a different emotional effect when viewed, which can either change or reinforce your intent for the image you plan to paint on it. Small paintings appear to a viewer like gems or precious objects, encouraging close, intimate viewing. Medium sizes create the feeling one is looking in a mirror (especially if vertical) or out a window. Larger sizes, which approximate the size of human beings or bigger, can evoke a feeling of cosmic or universal grandeur. Small surfaces can sometimes be more challenging than larger ones. A large canvas is like writing a novel, with lots of space to weave your ideas, while small surfaces are like writing a haiku, often requiring precision with a simple and direct message.

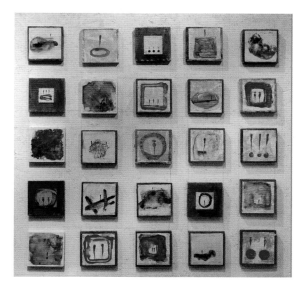

UNIFY MULTIPLE WORKS AS ONE
Create a larger statement using small-sized surfaces by displaying them in a tight group or installation to form the perception of one unified image.

UNINTERRUPTED / Larry McLaughlin / Ink and acrylic on paper and wood block / Installation of 25 pieces, each 6" × 6" (15cm × 15cm)

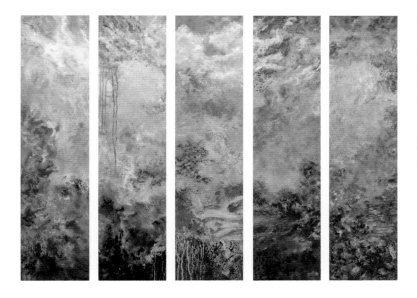

DIPTYCHS, TRIPTYCHS AND BEYOND
Combine multiple surfaces to form diptychs, triptychs, or in this case a quintych, by aligning them in a row.

ATMOSPHERIC DRIFT / Bonnie Teitelbaum / Acrylic on five panels / 48" × 60" (122cm × 152cm)

HOW TO MAXIMIZE VARIETY

Variety in a painting is key. It brings attention to the work, adds the element of surprise, enhances the spatial experience and increases visual tension. Variety here does not mean abundant, excessive or busy. Instead it signifies changes to avoid monotony and sameness. Gaze at a white interior wall that has been painted using the same white can of paint. Notice how the color varies naturally depending on how available light illuminates the wall. Variation in a painting indicates to our brain the existence, albeit illusionary, of space. This concept of creating the illusion of 3-D on a 2-D surface is part of painting's appeal.

I like to think of the play phase in painting as "advanced kindergarten" where I play with the intent to achieve variety. I use the most suitable setup to bring variety into the work right from the beginning of the play phase. Here are ways to maximize variety.

Color and Palette Selection

Start painting sessions with a full palette whenever possible. Use a warm and cool color choice for each of the three primaries (red, yellow and blue). Premix several light and dark values for a palette with a full tonal range as well as color. When heavily diluting paint (for washes or extra transparency) it is best to use modern colors as these maintain color intensity even when diluted. For more on modern colors and the full palette, see page 106.

Paints and Other Painting Products

Oil and acrylic paints are available in different consistencies or viscosities—thin or thick. Variations in oil paint viscosity will depend on the manufacturer or brand. Acrylic paints, however, are sold in difference consistencies as separate paint lines. They range from very thin, similar to ink, to very thick, known as heavy bodied. As an alternative to purchasing paint in your preferred consistency, you can customize acrylic paint to fit your preferences by adding mediums, gels, pastes or water. Oil paints can also be customized as well with mediums, wax and solvents.

For preliminary sketches or underpaintings, dilute your paint to make it thinner or into a wash, using the appropriate solvent or vehicle for your medium. To get the most variety in your dilutions avoid adding the vehicle directly into the paint on your palette as this limits your options for dilution. Instead, add the vehicle near the color on your palette or mixing surface, keeping the paint undiluted so you can simply drag the pure color into the vehicle to make it stronger or weaker as needed.

Opaque paint is great for hiding or covering previously painted areas, and for adding details and finishing techniques. Use the paint as is, without diluting it at all, or add small amounts of Titanium White. If using acrylic paints, you can also add white acrylic paste to increase color opacity. Acrylic gels and mediums are generally white when wet but dry clear, and can be added to acrylic paint color in large amounts to make the color more transparent. Add clear gels and mediums in smaller amounts to acrylic paint to change its consistency, using mediums to thin the paint or gels to thicken.

Please note that it is not recommended to add acrylic products to oil paint or oil products to acrylic in wet applications. However, oil and acrylic can be used together when acrylic is used as a dried layer underneath oil, but not the reverse.

Even more variety can be obtained by using mixed-media and/or drawing materials along with your paints. *Mixed-media* is a catchall phrase that signifies the use of nonpaint materials such as photographs, stamping, stencils, drawings, paper, collage material, fabric and objects. Drawing materials can include charcoal, marker, pencil, oil or chalk pastel, pen and ink, and Conté.

Palette Types

Select the palette that best suits the technique you are using. Techniques can change while you are still working on the same painting; therefore, you may need to change palettes mid-process for best results. For instance, if you are using washes, these thin diluted mixtures will be frustrating to work with as they flow uncontrollably all over a flat palette.

For thin paint, ice cube trays and plastic egg cartons have compartments that are perfect for diluted colors (although you will still need an additional flat palette to mix variations). Keep the trays in tightly sealed plastic

> **"VARIETY HERE DOES NOT MEAN ABUNDANT, EXCESSIVE, OR BUSY"**
>
> *Nancy Reyner*

bags while not in use, and the paint can stay wet for months. Alternatively, several disposable plastic plates can be laid out on your table as palettes for thin paint. Restrict each plate to only one or two paint colors to avoid crowding dilutions, which can mix together, creating one muddy mess.

For thick paint, some good options are sheets of glass, sealed wood or Plexiglas in large and small sizes (large for your tabletop, small to hand hold) and tablets of disposable palette paper. Tape a sheet of freezer paper (not waxed paper or parchment paper) onto a piece of heavy cardboard, wood or tabletop for an easy do-it-yourself version.

Brushes and Texture Tools

Probably the most familiar painter's tool is the brush. Expand your set of brushes to include a range of different sizes and shapes. Long handles are for painting while standing, and short handles work best while sitting. Bristles can be natural, synthetic or blends, and vary in shape from round or flat to a combination called *filbert*. Bristles can be long or short, stiff or soft, wide or narrow. In addition to brushes, experiment with alternatives such as knives, rags, refillables (empty containers with marking tips) and fingers. Textural tools sporting a variety of marking teeth, even knives and kitchen spatulas, can be found around the house or purchased from art stores. Additionally, try squeezing, pouring or dripping paints onto your surface directly from their original containers.

Application Techniques

Brush applications usually involve loading paint onto the brush, then unloading it while applying it to your surface. The reverse, called *subtractive technique*, involves applying paint to the surface, then removing from selected areas while wet. For removing paint, you can use stiff brushes, fingers, rags, knives, sandpaper or sanding equipment. Whether applying or subtracting paint, try to vary your wrist action and stroke direction.

5 Tips to Achieve Surface Variety

1. Apply the medium's appropriate solvent (for example, water for watercolor) using a brush or spray bottle directly to the dry surface. Pre-wet in some areas, keeping other areas dry. Paint changes in appearance as it is applied over wet or dry surface areas.

2. Remove some areas of paint as you apply it using a paper towel or rag to reveal the white of your surface and add lighter values back into the image.

3. Tilt your substrate at an angle while applying diluted paint to allow washes to move and drip.

4. Keep changing color, movement, brushwork and dilution as you paint.

5. Rotate your substrate at intervals to paint from different viewpoints.

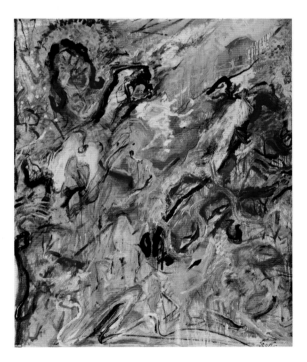

VARY YOUR PAINT APPLICATION
Exciting imagery is obtained here using a wide variety of paint applications.

ORCHESTRAL / Sam Scott / Acrylic on canvas / 80" × 66" (203cm × 168cm)

Customize Your Surface

Whatever substrate you decide to paint on, it will have a surface quality unique to the material used to produce it. For instance, unprimed canvas and wood naturally have an absorbent surface, while glass or metal are nonabsorbent. Nevertheless, you can change these qualities by applying acrylic binders to your substrate to create surface qualities that are very absorbent, moderately absorbent, of mixed absorbency, nonabsorbent, smooth or textured.

Acrylic binders come in three main forms: gels, mediums and pastes. Similar to substrates, each product has its own unique absorbency and textural quality. Apply these products onto any substrate in thick or thin layers, either textured or smooth, in any combination or mixture. For maximum variation use several different products together on the same surface. Once applied to your substrate, let dry a few days (or according to its label instructions), then paint your image using acrylic, oil or watercolor paints. Dilute paint with appropriate water or solvent to create a wash to best reveal surface qualities, and to offer the most potential for variety.

My favorite approach is to start with an absorbent product, then while wet or dry, apply nonabsorbent products on top, but only in some areas, leaving some of the absorbent products uncovered. When dry, due to the use of multiple products, the painting will have some glossy areas and some matte areas. As you overpaint with washes, the glossy areas will resist the paint color, while the matte areas will allow the paint color to apply evenly. The combination of effects creates an interesting variety.

Surface Quality Chart

CATEGORY 1
Absorbent (matte)

- light molding paste
- coarse molding paste
- fiber paste
- absorbent ground
- acrylic ground for pastels
- pumice gels
- crackle paste

CATEGORY 2
Mid-Range Absorbency

- molding paste
- glass bead gel
- micaceous iron oxide
- matte gels

CATEGORY 3
Nonabsorbent (glossy)

- polymer medium gloss
- clear tar gel
- gloss gels

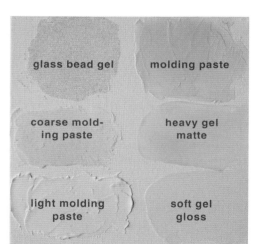

glass bead gel · molding paste · coarse molding paste · heavy gel matte · light molding paste · soft gel gloss

FIRST LAYER: APPLY PRODUCTS TO THE SURFACE
Here, a sampling of products have been applied to a canvas surface, changing the surface quality and subsequently the way the paint will appear.

SECOND LAYER: OVERPAINT USING WASHES
When the products dried, diluted paint (i.e., washes) was applied over the customized surface. Each area differs in appearance depending on the product underneath, creating a variety of color field effects. Use oil, acrylic or watercolor over your customized acrylic surfaces.

PAINTING WITH THE RIGHT BRAIN

Variety can be obtained using a range of tools and materials, yet our brain is also a tool that can be trained to maximize variety. Paint with your right brain dominant as much as possible since painting with your left brain will usually reduce variety.

Here are seven helpful suggestions to maintain right brain dominance while painting. As discussed on page 12 in Section 1, our brain naturally switches back and forth between both sides during all tasks. Being able to recognize when we switch and having some methods to control the switching can be advantageous.

1 Stay Playful

Remain in your play phase as long as possible. When your left brain starts to take over with its usual ploys of fear and judgment, take a moment to stop and change your thoughts to more positive ones. That's not so easy. Sometimes we think that the only road to creativity is through suffering, or even martyrdom, overworking ourselves in order to produce. The "no pain no gain" philosophy has its place but is absolutely not helpful for the play phase. Liz Gilbert, author of *Big Magic*, suggests staying playful and not reverting to seriousness. Gilbert advises to switch from being the martyr to being the trickster, suggesting that we dance with the trickster

and not let seriousness burden our experience. Put your ideas out there and see what happens. A painter's play phase is not about guilt, burden or fear, but about releasing. Instead of trying to conquer fear, invite it along to play in the creative act.

For example, while I am working on a painting, my left brain may start suggesting negative thoughts intending to get me to stop painting. Thoughts about whether the work will be sellable or not, or suggesting the work isn't very good. I treat my left brain, at times like this, as if it were a whining child, knowing it just wants to feel included, and this is the best it can do right now. I'll start a silent conversation with my left brain, telling it that all is well while I am painting, that I am in no danger, but thank you for watching out for me, and wanting to check in. I soothe it more by saying that I appreciate my wonderful left brain, that I will need its wisdom as soon as my painting session is over, and in the meantime please take a back seat so I can keep painting. It might sound silly, but somehow it works!

2 Avoid Autopilot

Autopilot is our left brain's favorite mode. While painting, try to be aware when the act of painting starts to feel repetitious and automatic. Notice if and when you start

Original Painting

Altered Version

TETON AUTUMN / Bruce Cody / Oil on linen / 26" × 56" (66cm × 142cm) / Private collection

THE RIGHT BRAIN INSPIRES VARIETY

Notice the depth of space and viewing interest in this landscape. Compare the distant mountains in the finished painting (above) with the mountain segment that has been photographically altered (below), simulating what might happen when painting with the left brain on autopilot. Even realism can turn into pattern when on autopilot, producing a quick viewing exit.

repeating anything—brushstrokes, direction, size, color. As soon as possible, stop actions that repeat painting the same thing three times in a row, do something the same all over, or cover exactly half your painting surface area. Once you notice any repetition, immediately fix it. Evenly applied patterns or too much symmetry will decrease the work's attention-getting power. Keep changing color, movement, brushwork, dilutions and shapes. Avoid bringing attention to corners, edges and sides, and the dead center. Don't hold your breath or tighten your jaw, and try to maintain a loose grip on your tools.

3 Alternate Eye Focus

As an exercise while painting, become aware of how your eye moves around your image. Are you looking at the whole image and the big picture or smaller sections of detail? Practice alternating your focus between the big picture and small detail by allowing your eyes to focus broadly, then narrowing in on detail, going back and forth several times during a standard painting session. This movement from big to small and its reverse keeps your right brain active. It also helps integrate parts of your image to the whole.

4 Exercise Your Brain

The original *Brain Gym* book was written for teachers to improve learning with youth in classrooms. It contains exercises for activating our right brain. The book has since been revised with several versions, but all contain great information and exercises regarding the right brain. Although the book was originally meant for children, I have used it in adult workshops with dramatic results. Learn more at braingym.org.

5 Frequently Restock Your Setup

Keep variety readily available by continuing to check your setup and refresh, resupply or reorganize as needed. Inadequate setups result when we take the lazy route and use whatever is left over, resulting in muddy colors among other issues. If variety isn't readily available in your setup, it usually won't get into your painting.

TABLEAU I, CA 1921 / Piet Mondrian / Oil on canvas / 41" × 39" (104cm × 99cm)

HARD-EDGE ABSTRACTION

Hard-edge abstraction is a painting style used by artists such as Piet Mondrian, Josef Albers, Agnes Martin, Kasimir Malevich and Frank Stella. This style is known for flat or shallow spatial depth, and geometric forms with distinct boundaries or edges. Hard-edge abstraction often contains pattern-like qualities, yet successful paintings in this genre will still contain enough variations in design and color to create interesting eye movement, as seen here.

6 Imagine Expansive Space

Try imagining that the image you plan to paint represents a very small fragment of a much larger space that exists outside the surface. This is similar to a snapshot photo taken from a more expansive landscape.

Practice the following exercise on an inexpensive surface to help you envision expansive space. Load your brush with paint, then place it well outside (at least 5" [13cm] or more) the edge of your surface. Position the brush loosely in your hand and angle it so both the brush head and handle are parallel to the surface. Begin moving the brush toward the surface as if you are applying paint in the air, continuing onto your surface where the paint is now visible, moving slowly while varying the line as much as possible. Avoid moving too quickly across in a straight line, into corners or riding along edges. Finish your stroke well outside the edges of the surface, again painting air.

7 Love Your Whole Brain

Make friends with your left brain by including it in your painting session. Learn how to work with your left and right sides together as a team. Our left brain can sometimes act like a spoiled child. It whines, judges, comes up with criticism and negativity, anything to get you to stop painting. Once you establish a good working relationship between your left and right sides, you will dramatically improve the level of ease and flow in your work. The goal is to feel like you are the observer (a term used in many meditation techniques) instead of identifying fully with the right or left sides. Being in observer mode is the most powerful tool you have. More on this topic is covered in Section 1 on page 12.

SIRENS SONG 5 / Willy Bo Richardson / Watercolor and gouache on paper / 21" × 26" (53cm × 66cm) / Photo by Kim Richardson

VARIETY ADDS APPEAL

In this abstract comparison both paintings make use of vertical stripes as an overall compositional theme. The top image has little variation in that each uniform stripe differs only in color from its neighbor. This overly repetitive quality is a common consequence when left brain dominates.

One might argue that by simply changing each stripe's color, one can create interest and a sense of space. Yet when it is compared to Richardson's painting below, we can see the difference that abundant variety can make. Here colors not only change with each stripe, but shift within the stripe itself. Edges overlap each other in great variety. The work readily reveals the artist's use of right brain dominant, producing a painting that has better attracting power and more intriguing spatial effects.

ADRIFT / Pat Bailey / Oil on canvas / 40" × 30" (102cm × 76cm)

"WE CANNOT SOLVE OUR PROBLEMS WITH THE SAME THINKING WE USED WHEN WE CREATED THEM." *Albert Einstein*

SECTION 3

CRITIQUE PHASE

The word *critique* can sound scary, overly serious or harsh to some artists, especially those of us who have had some past negative experiences with criticism of our artwork. I believe critique can be fun, enlightening and empowering. It is for me, at least, and I've found pleasure in sharing my system for analysis using somewhat of a game format.

What is critique? Critique is a way to analyze eye movement in a painting. Critique helps identify design problems and discover ways to resolve them. It is best to separate critique from the play phase. This new phase represents a time to think differently to further enhance your paintings.

I call the method of critique that I present here The Viewing Game. It is based on the assumption that your two main objectives as a painter are to draw the viewer to your work and to sustain the viewer's attention long enough to obtain a meaningful viewing experience. The success of both of these goals revolves around the quality of eye movement inherent in the work.

How The Viewing Game works. Our eyes perceive the world around us, and even though we have the ability to view using a variety of "perceptive lenses," we habitually use only one favored viewing mode. This underutilized viewing capability narrows our view. Imagine wearing a pair of sunglasses with pink lenses. The world around you all appears pink. Everything changes when you switch to a pair of glasses with green lenses. Optimal viewing would be obtained by taking time to switch lenses for a broader perspective. Critiquing our work is similar. By using only one favored lens to view and analyze our work, we blind ourselves to areas that might have issues or need attention. The Viewing Game consists of ten different "lenses" that I call *inquiries*. Each inquiry singles out a specific aspect of your painting, one at a time, for evaluation.

When you apply The Viewing Game to one of your paintings, make sure to read and follow all of the ten inquiries in the order presented, allowing time to contemplate after each one.

THE VIEWING GAME

My in-depth self-critique process—The Viewing Game—involves ten inquiries that allow you to recognize and resolve aesthetic and design issues in your paintings. You will be prompted after the first inquiry to determine if your painting is, in fact, at an appropriate point to continue with critique or instead needs to return to the play phase for further painting. If you know what your next course of action is, complete that task first before proceeding with this section's critique.

There are many advantages to self-critique. You can evaluate your work at the precise moment you need it, and improve your work without other people's input and sometimes distracting comments. The Viewing Game can also be used for group critiques (see page 135).

Two Ways the Eye Moves Through a Painting

PERPENDICULAR MOVEMENT

When the eye is encouraged to start in the foreground or bottom of the painting, and feel as if it moves perpendicular to the painting surface, it creates the illusion of deeper space. For more on this topic, see Inquiry 8 on page 84.

MORNING OVER A MOUNTAINOUS NORWEGIAN LANDSCAPE, 1846 / August Wilhelm Leu / Oil on canvas / 37" × 55" (94cm × 140cm)

PARALLEL MOVEMENT

When the viewer's eye moves in a direction parallel to the front surface (usually left to right or bottom to top), it can engage the eye in an exciting journey. This eye movement relies heavily on the relationships of positive and negative spaces in the image. Notice how pattern and graphic elements encourage the eye to move across the front painting surface here rather than recede into spatial depths. For more on this concept, see Inquiry 7 on page 78.

FULFILMENT, 1905 / Gustav Klimt / sketch on cardboard / 77" × 47" (196cm × 119cm) / Collection of the Museum of Applied Arts, Vienna

7 Helpful Tips for Self-Critiquing

For critique to be of benefit, your painting needs to be at an appropriate stage in its development. Critique is helpful when you don't know how to proceed, are at a crossroads with several options, have lost your flow or feel stuck, need to assess progress or are not sure if it is finished. When you find yourself asking "Now what?" that's a good indication that it's time to critique. Here are seven helpful tips to keep in mind when you are undergoing the self-critique process.

1. ***Always start with your intent.*** *Understand what your painting is about before starting the critique. What is your intent, point of view, content, psychology or philosophy? Imagine what you want the viewer to see and feel while viewing it. This will help determine the appropriate action, level of visual tension, and analysis needed for each particular painting. Remember, higher levels of visual tension are not always better. High tension means more visual action (for example, fast-paced eye choreography) which might not benefit meditative or peaceful imagery.*

2. ***Think with your eyes.*** *Intuitive reasoning in painting often comes from our eyes and not from our brain. The inquiries are meant to stir up a quick spontaneous answer. Don't overthink. Instead allow your eyes to present the answer. Train your eyes to gaze objectively and at length at your painting while asking the inquiry questions. Repeat the question, maintaining focus until you sense an answer. Often the answer comes in the form of a feeling in your body. You may be surprised at the wisdom and often underutilized abilities contained within your eye/body mechanism.*

3. ***Use contrast.*** *As a painter your most powerful tool is contrast. "All lies in the contrast," wrote Paul Cézanne. Contrast depends on a pair of opposites and how they relate to each other in a work. Each inquiry focuses on at least one particular pair of opposites to be singularly evaluated within the scope of your painting.*

4. ***Work with 80:20 ratios.*** *Pairs of opposites in unequal ratios create more viewing attraction and interest than when used in equal ratios. Unequal ratios create unexpected elements that jolt our left brain to shift to the right for viewing. A painting that encourages a viewer to shift viewing from left brain to right usually results in a deeper viewing experience. Avoid 100:0 ratios (where one component in a pair of opposites is missing) or 50:50 (both components of the pair are present in the work but in equal amounts). Both of these ratios cause the dreaded quick exit, whereby a viewer loses interest in your painting almost immediately. Ratios such as 90:10, 80:20 and 70:30 generate more dramatic contrast and more engaging imagery.*

5. ***There are no set rules.*** *Every image requires its own unique analysis. Take The Viewing Game's guidelines as suggestions and not as rules. To make the most appropriate decisions for your work, start every inquiry by first restating your intent and what you wish to communicate. Realistic or abstract, intellectual or emotional, it is best to personalize your choices. Always base decisions on your personal preferences, intuition and particular window of visual tension. For example, you may prefer utilizing a moderate 60:40 ratio for one particular pair of opposites while countering it with a more striking ratio using another pair in the same painting. Make your own decision about how to best use the critique concepts.*

6. ***Practice slow viewing.*** *When asked, "What do you do as a painter?" artist Pat Bailey replies, "I choreograph eye movement." The idea of eye movement provides the basis for almost all painting analysis. Set aside enough time to allow for deep contemplation of your work and for multiple viewings of each painting during the critique. Each question is like putting on a different viewing lens to reveal aspects that may not be visible through other lenses. Slow down and take your time to allow the viewing of a painting to unfold over time rather than attempt to see it quickly all at once.*

7. ***Use your gut response.*** *The most accurate answers usually come as a first response with a quick yes or no gut reaction. As an example, take the question, "Are there any light values in your painting?" If you have to think hard about it, then the light values are probably not visible enough. Let the answers come quickly, but slow down the viewing.*

INQUIRY 1: THE BIG THREE

Critique goal: Draw attention to your painting with important visual tools.

There's a lot of competition these days for viewing attention. Imagine your painting on display in a group exhibition. Will it stand out or be lost in the crowd? John Berger in his book *Ways of Seeing* says, "In no other form of society in history has there been such a concentration of images, such a density of visual messages."

Our culture presents a bombardment of images daily via ads, billboards, videos, computers, etc. According to recent studies from Microsoft Corporation, people spend an average of three seconds viewing each art piece in a museum. That's less than the attention span of a goldfish! Inquiry 1 is all about using the Big Three—value (light and dark), chroma (bright and neutral), hue (warm and cool)—to draw attention to your paintings.

| 1 | 2 | 3 | 4 | 5 | 6 | 7 | 8 | 9 | 10 |

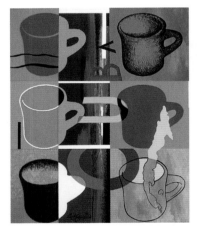 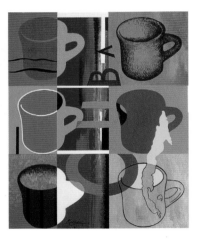

Altered Version **Original Painting**

FULL RANGE OF TONAL VALUES

A full range of values is used in this painting, including all tones from 1 (white) to 10 (black), as evident in the altered grayscale version on the left.

SIX CUPS / Rick Garcia / Acrylic on canvas / 20" × 16" (51cm × 41cm)

VALUE/TONAL QUALITY | Catch the viewer's eye with light and dark values.

High contrast in a painting is created when a pair of light and dark values or tones are positioned close together. This pair will almost always attract our attention. Ever find yourself walking along a beach scanning the sand for anything sparkly: a gem, luminous shells, a glowing stone? We like sparkle. In fact, our brains are hardwired for high contrast. Our anatomy is even constructed to encourage this preference. In the animal kingdom, human beings are considered hunters and therefore have eyes placed close together to focus for hunting. Rabbits, on the other hand, are considered prey, with eyes spread apart on either side of their heads to better identify movement in their surroundings for possible enemies. Our eyes search for eye gems, or high contrast, as if it were the glint in a rabbit's eyes while it hides in the grass.

This doesn't mean we have to add glitter to our paintings to draw attention to the work. It does mean that the placement, quantity and ratio of lights and darks in an image is important. To correctly analyze this aspect in our work we need the ability to translate color into value. Try the exercise on the following page to strengthen this ability. Take time to analyze the range of values present in your painting. A painting with a wide range of values means the image will include almost all value numbers from 1 to 10. A narrow range signifies a limited number (perhaps just 4 to 7). I use the terms *value* and *tone* interchangeably throughout.

NARROW TONAL RANGE

While viewing this painting, squint your eyes to help translate the subtle color palette into values. Here a narrow tonal range helps add a soft and subtle feel.

EMPEROR MINGHUANG'S JOURNEY TO SICHUAN (AFTER QIU YING) / Artist unknown / Wen Zhengming (calligrapher) / Ink and color on silk handscroll / 22" × 72" (56cm × 183cm) / Collection of the Freer and Sackler Galleries, Washington, D.C.

TONAL EXTREMES

When an image uses extreme ends of the tonal scale (1, 2, 9, 10), it skips the middle of the spectrum and is high contrast or graphic in quality. High-contrast images show up very well in photographs and for printing purposes. This was used for an album cover.

CHARLES MINGUS / Alan Reingold / Charcoal on textured paper / 14" × 11" (36cm × 28cm)

CHIAROSCURO USES HIGH CONTRAST

The word *chiaroscuro*, created during the Renaissance, is often used to describe strong contrasts of light and dark. Old Masters, known for their use of chiaroscuro, include Rembrandt, Georges de La Tour, Giovanni Baglione, Francisco Goya, Caravaggio, Diego Velázquez and Jan Vermeer.

SELF-PORTRAIT WITH PLUMED HAT / Rembrandt Harmenszoon van Rijn / Oil on oak panel / 35" × 29" (89cm × 74cm)

Training Your Eye to Identify Tonal Value

Our eyes are muscles, and we can exercise them to enhance their abilities to discern value. For this exercise refer to the gray value scale on page 50. With some practice you can learn to automatically read color as value without the need to match against a value scale.

1 To get started, collect a dozen or more paint chips from the paint department at your local home improvement store. You can also cut ½" (13mm) squares of uniform color from magazines, photos or printouts from online images. Place one color chip directly over black (10) on the grayscale. Stare for a minute or two until you can see an obvious difference between the black value on the scale and your color chip. Your color chip will likely be lighter than the scale's black.

2 Now move the same chip to white (1) on the scale, gazing until it becomes clearly apparent that your chip is darker. Next compare it to 9, then 2, then 8, then 3 until you find its corresponding value. Continue to move your chip along the gray scale, swinging left and right, alternating between the dark and light tones, making it easier to narrow the choices and find the tonal match for your chip. Leave the chip in place directly under its matching value. Repeat with your other color chips.

Tonal Value Exercise Tips

- Instead of using the grayscale on page 50, you can obtain your own high-quality version by printing one from the Internet or purchasing one from an art store. You can also create your own using Photoshop.

- While gazing, for the best read, your eyes should be focused right at the edge of the chip where it meets the tone on the scale. The edges of your color chip should be clean, without any ripped areas of white showing, to reduce distractions while comparing.

- Don't give up. If you can't determine a color's value right away, just keep staring. The longer you stare the better your eyes will discern differences to identify its value.

- Optionally, punch a hole using a hole punching tool in the center of each value on your grayscale. Place the color chip directly under the hole for easier matching.

- Check tonal ranges in your painting by photographing your work digitally, then use the camera or photo-editing software to convert it to gray tones. Try doing this at intervals during your painting's development to periodically check tone.

CHROMA | Achieve space and movement with bright and neutral colors.

Similar advantages obtained by strategically using lights and darks exist with chroma using brights and neutrals. Bright colors attract attention and often create the illusion they are moving forward towards the viewer, while neutrals tend to recede into the background.

Combinations of these two can create the illusion of spatial depth. See Inquiry 8 on page 84 for more on spatial depth. For tips on mixing bright and neutral colors, see Solution 4 starting on page 104.

EARLY AUTUMN GATHERING / Sam Scott / Oil on canvas / 42" × 54" (107cm × 137cm)

USING CHROMA FOR SPATIAL DEPTH

Here are three examples of images that use a combination of bright and neutral colors to suggest the illusion of spatial depth.

INTERIOR / Celia Drake / Acrylic on canvas / 12" × 12" (30cm × 30cm)

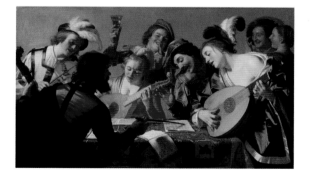

THE CONCERT / Gerard (Gerrit) van Honthorst / Oil on canvas / 48" × 81" (122cm × 206cm)

HUE | Enhance your images with warm and cool colors.

A color is considered warm if it looks close to red and cooler if it appears more blue. We intuitively interpret a "temperature" for a color, even though there are no set rules on what is warm or cool. Warm colors feel vivid and energetic and tend to come forward in space. Cool colors feel calm and soothing and tend to recede into space. White, black and gray are considered neutral. Try to get a general read on the feeling of warm and cool temperatures in your work.

WARM HUES
Most will agree that these colors feel warm.

COOL HUES
Most will agree that these colors feel cool.

COMPLEX HUES
Complex color mixtures such as tertiaries (a color mixture that contains all three primaries: red, yellow and blue) and neutral grays such as these may be more difficult to classify as warm or cool.

COMPLEMENTARY COLOR PAIRS

If using terms *warm* and *cool* gets confusing to you, think of the three complementary color pairs instead: red-green, blue-orange and violet-yellow. These colors exist opposite each other on a traditional color wheel, and each pair comprises a warm and cool component. The Red Square Game (see page 21) shows how our brains are especially hardwired for complementary pairs. For best results include at least one pair of complementary colors in your painting, remembering to use them in unequal ratios as discussed in Concept 6 on page 22.

Red-Green Complementary Pair

Blue-Orange Complementary Pair

Yellow-Violet Complementary Pair

THE MARRIAGE OF THE PRINCE, CA 1895 / Cesare
Auguste Detti / Oil on canvas / 26" × 21" (66cm × 53cm)

FLAMING SUN, FLOWERING YUCCA / Sam Scott / Oil
on canvas / 24" × 30" (61cm × 76cm)

USING ALL THREE COMPLEMENTARY PAIRS
These two paintings employ all three complementary
pairs of colors.

USING ONE COMPLEMEN-TARY PAIR
This painting successfully utilizes
only one complementary pair—
blue and orange. All three sets of
pairs do not need to be present in
a work.

HARMONIC REVERBERATIONS /
Barbara Ragalyi / Acrylic on canvas /
30" × 36" (76cm × 91cm)

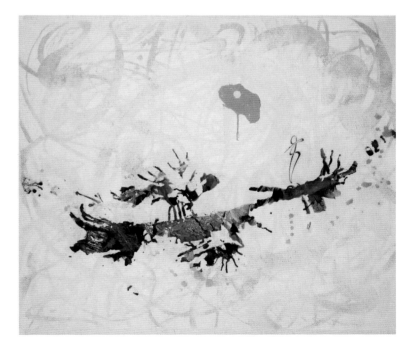

COMMON ISSUES OF THE BIG THREE

Your paintings benefit most when value, chroma and hue are used appropriately for the type of imagery and intent you have for that particular work. Consider the range of each of the Big Three in your painting to evaluate how to best use them. Ranges of value can be extreme to include high contrast, or narrow for a subtle feel.

Chroma can range from extreme, using bold brights and neutrals for a deep spatial effect to a more subtle range for a softer atmospheric appearance. Hue, using warms and cools, can include several complementary pairs for a wide color spectrum or only one selected pair for a narrower color palette.

ORIGINAL PAINTING

Here the image contains a wide range of values.

UNEARTHED / Nancy Reyner / Acrylic on canvas / 36" × 44" (91cm × 112cm)

ALTERED VERSION

The whites and blacks are removed, thereby eliminating contrast. By changing a wide range of values into a narrow one, this altered version has lost its eye-catching appeal as compared to the original.

ORIGINAL PAINTING

This painting contains an appropriate range of lights and darks, warms and cools, and brights and neutrals to create a feeling of spatial depth as well as visual interest and eye movement.

GRAND CANYON / Nancy Reyner / Oil pastel on paper / 9" × 12" (23cm × 30cm)

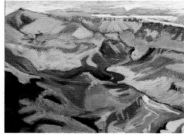

ALTERED VERSION 1

All the neutrals have been replaced with brights showing how a 100:0 ratio (bright to neutral) can weaken the spatial feel of an image. Since brights, in general, move toward the viewer, this version has a flat space with little spatial depth.

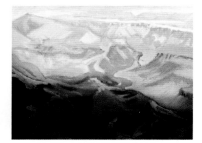

ALTERED VERSION 2

I have segregated the lights into a horizontal band across the top with the darks on the bottom. Separately, each band has a 100:0 ratio, reducing eye movement to a rapid sweep across the image and causing a quick viewing exit.

Critique Questions | The Big Three (Value/Chroma/Hue)

Starting with value, the first aspect of the Big Three, work through questions 1 through 9, then repeat all 9 questions for both chroma (substitute bright and neutral for light and dark) and hue (substitute warm and cool for light and dark).

1. *Does your painting have any light values? To help evaluate light values in the work, hold up something white (1 value) as a reference next to the work to compare. A light value is any color that registers 1 to 3 on the grayscale.*

2. *How many light values are in the work? If there are none or less than three, make a mental note and continue. Note: Yellow is not a light value, usually registering as a 4 or 5. If you observe that yellow is the lightest value in your work, refer to "Yellow Is Easily Overused" on page 113.*

3. *Where are the light values located? Light values usually act as important focal points, creating visual movement within the painting.*

4. *Are they in awkward places such as stuck in corners, smack in the center, sitting on an edge of the painting or filling an entire quadrant? If so, they may cause a quick exit, moving the viewer's gaze towards the painting's edges and subsequently away from the image itself. If needed, move light values to a better location—more centrally located or along desired movement paths you wish to create within the painting.*

5. *Does your use of light values best serve your intent for the work?*

6. *Is your use of light values interesting enough?*

7. *Repeat questions 1 to 6 for dark values: How many are there, and where are they located?*

8. *What is the relationship of light and dark values in your painting? Find where the lightest light values (1 to 3) actually touch edges with the darkest dark values (8 to 10). These are your high-contrast areas, the eye gems we seek, usually creating primary focal points (attention-getting areas) in the work. Additionally, notice where any low-contrast pairs exist. These are areas where midtone values (4 to 7) touch edges with other similar values, offering calming elements that can enhance neighboring busy or high contrast areas.*

9. *What is the ratio of high contrast areas to low? If the ratio is an even 50:50 (high to low), then consider if your work would improve if the ratio changed towards more high-contrast than low or the reverse. If so, make changes accordingly.*

Important Note!

Once you have completed the first Inquiry with your painting, this is the perfect time to assess if your painting is in fact ready to proceed with the critique's remaining nine Inquiries. Your painting should contain enough of the essential Big Three, in interesting ratios and in strategic places, to take you through the rest of the inquiries. If any of the Big Three are minimally represented or lacking in any way in your painting, head back to the play phase (see page 29).

Remember, the two most common reasons for Big Three insufficiencies are not using a full palette (see page 40), and painting with left side dominant resulting in the following issues: equal ratios (50:50) for pairs of opposites, leaving out one component of a pair entirely (100:0), lack of clean color and brights, minimal contrast, and awkward locations for focal points.

Still unsure? Jump to Inquiry 5 on page 70 and analyze the Big Three again for each suggested zone and quadrant.

Critique goal: Enhance the tactile quality in your paintings.

In general there are two ways for our eyes to perceive the world around us: optically and tactilely. We tend, though, to prefer one over the other and consequently are more attracted to images displaying our preferred type. When you next visit a gallery or museum, notice the type of artwork that gets your attention. If you are attracted to paintings with high contrast and striking color, your preference is optical. If you are attracted to images with interesting surfaces, sheens and texture, your preference is tactile.

Using both aspects in our painting, will therefore expand our potential audience, enabling the work to appeal to viewers with either viewing preference. Optical viewing potential in an image depends on how the Big Three have been utilized. If you are satisfied with your answers to the previous questions in Inquiry 1, then it is highly likely your work has sufficient optical qualities.

Since Inquiry 1 covers all that is required to enhance optical viewing, this inquiry focuses instead on surface qualities to enhance tactile viewing.

Tactile Qualities

Our eyes can tactilely perceive the world as if they are fingers touching all we see. High-relief texture, as in paintings by Vincent van Gogh, may first come to mind when thinking about a tactile surface. Yet tactile attractiveness can be obtained through a variety of paint qualities and applications regardless of whether the paint is lavishly applied in thick relief. When a painter is oblivious to tactile surface quality while painting, it can result in

THICK RELIEF TEXTURE
High-relief texture in this van Gogh offers a dramatic tactile experience and is one way to attract attention to the surface.

WHEATFIELD WITH CYPRESSES, CA 1889 / Vincent van Gogh / Oil on canvas / 29" × 37" (74cm × 94cm) / Collection of the Metropolitan Museum of Art, New York City

TACTILE MATERIALS
Unusual materials can add tactile interest. Here a painted image is overlaid with shattered glass, adding relief texture with reflective qualities.

SHATTERED V (FROM THE GRIEF AND PRAISE SERIES) / Diana Ingalls Leyba / Mixed media, acrylic and shattered glass on wood / 20" × 16" (51cm × 41cm)

a layer of paint applied thin and sparingly, similar to the surface quality of a print or photograph. Skimpy applications of paint, applied unintentionally, can suppress the voice of the medium, leaving little attraction for viewers with tactile preference.

Think of the surface of your painting as a "skin" with a palpable sensuousness to it, somewhat like our own living flesh. If you ever get the chance to see a painting in person by Georgia O'Keeffe, it is a real treat for tactile viewing. Her oil paintings often display a wide variety of paint qualities. Thin and thick applications of paint, along with lovingly applied brushstrokes, contrast areas where the canvas fabric weave is still noticeable. Tactile qualities in a painting are not always visible when photographed, and O'Keeffe's paintings look deceivingly smooth in photographic reproductions. Since artists often require photographic replications of their work for business and archival purposes, painters whose works rely on tactile qualities will greatly benefit when optical qualities are considered as well.

SHEEN VARIATION

Varying sheens using both gloss and matte in separate areas can also add surface interest. In this detail, glossy sheens contrast with matte areas using metal leaf, paint and glass beads.

RED SQUARE (DETAIL) / Nancy Reyner / Acrylic, glass beads and gold (metal) leaf on panel / 30" × 30" (76cm × 76cm)

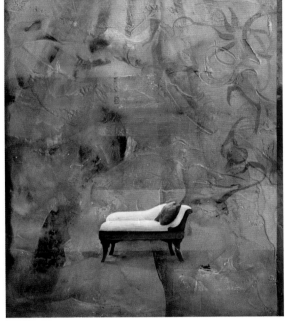

VARYING TEXTURE

This abstract background includes a variety of textures, providing contrast to the smoothly painted sofa.

SOFA DREAMING / Nancy Reyner / Acrylic on canvas / 26" × 22" (66cm × 56cm)

COMMON ISSUES OF TACTILE SURFACE QUALITY

Isolated Texture

Using texture for emphasis, focus and interest is fine, but if isolated by using it in only one area of a painting, it can stand apart from the image, becoming a distraction rather than an improvement.

Upstaging with Texture

Too much texture can overwhelm an image. If a viewer's first response upon seeing the work is technical in nature, such as "What is this material?" or "How did the artist do that?" it can sidetrack the viewer from a deeper viewing experience. Avoid overkill with texture by remembering that a good thing is only a good thing in the right balance.

Unintentional Sheens

Both oil and acrylic paint colors naturally vary in sheen according to the type of pigments used. Therefore, some paints will dry glossy while others dry matte. Adding mediums, extenders, solvents and varnishes into paint mixtures will also affect sheens. The final surface sheen of a painting will most likely contain both gloss and matte. Observe your work's sheen near its completion. If the resulting combination of matte and gloss areas enhance the work, then allow it to remain. If not, unify the sheen by applying final finishing coats of varnish in your choice of sheen.

Sprays offer thinner applications of a product than when applied by a brush. If you like your painting's final sheen, but still want to varnish it for protection without changing the sheen too much, spray lightly with one or two coats of gloss varnish for minimal changes to the sheen quality underneath.

ORIGINAL PAINTING
Here is the original image as van Gogh painted it.

STARRY NIGHT, CA 1889 / Vincent van Gogh / Oil on canvas / 29" × 36" (74cm × 91cm)

ALTERED VERSION
Van Gogh used texture over the entire surface of his painting *Starry Night*. In this altered version the texture has been removed from all areas except the stars to demonstrate how out of place texture can look when it is isolated and not integrated.

INTRIGUING SURFACE TEXTURE

Ragalyi's painting surface was initially texturized by applying acrylic gel, then pressing wrinkled plastic wrap over the gel while still wet, then removing the plastic to let the gel dry. Paint color sprayed over this textured surface further emphasized the relief texture. Paper cutouts and a plastic-netted produce bag were glued on to add focus and indicate a figure shape.

ESMERALDA / Barbara Ragalyi / Mixed media on canvas / 30" × 24" (76cm × 61cm)

Critique Questions | Tactile Surface Quality

Starting with tactile quality, work through questions 1 through 5, then repeat all five questions for optical qualities. Conclude with question 6 on the relationship between the two qualities.

1. *Are tactile qualities present in the painting?*

2. *What is in the work that adds a tactile quality? Have you used sheens, texture, brushstrokes or unusual materials? If surface qualities are insufficient for your preferences, turn to page 42 for ways to improve this for future work.*

3. *What percent of the surface displays these qualities?*

4. *Where are they located? Are they well distributed over the image or isolated in one area?*

5. *Is your use of tactile qualities best serving your intent for the work?*

6. *How do the optical and tactile qualities relate to each other in the painting?*

INQUIRY 3: FLIP 4

Critique goal: View your painting with objectivity.

As painters we typically spend long hours painting and staring at our work. It's easy to lose perspective while in the process of painting, making objective analysis sometimes difficult. To gain a fresh outlook on your image simply rotate your painting by a quarter turn and pause to view it at each rotation. Design problems and other issues may be more easily identified when viewed from different orientations. First, place your work on an easel or wall, surrounded by at least five feet (1.5m) of white or neutral coloring and away from clutter. Anything nearby that is interesting and eye catching such as bright aprons, patterned fabric, colored tape, etc., can reduce your ability to objectively view your work.

Flipping an abstract image by rotating it in all four orientations can bring new insights about your painting. It may also change your preference for the work to take on a completely new orientation. If at the end of this inquiry it encourages a switch in orientation from what you had originally planned, then change it to the new preference for the remaining Viewing Game inquiries. It is important to select the preferred orientation now as the entire critique will change accordingly.

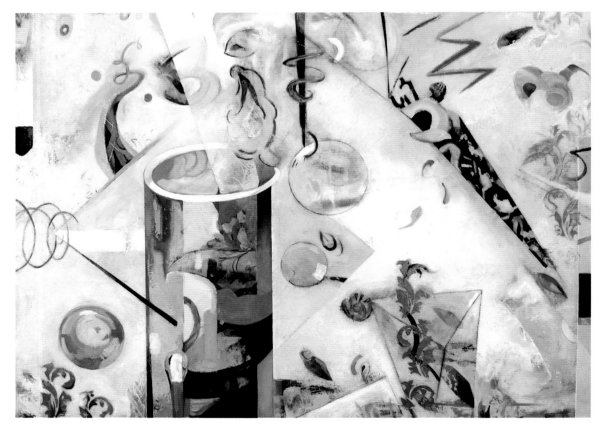

FINISHED PAINTING
Can you tell which orientation was selected to complete the finished painting shown here?

CANNED ART: NOW AVAILABLE IN SPRAY / Nancy Reyner / Acrylic with graphite, oil and paper on panel / 35" × 48" (89cm × 122cm)

SELECTING THE BEST ORIENTATION

Size and shape choices for a painting will evoke different emotions and expectations from a viewer. These aspects will therefore influence our orientation preferences. Rectangle, oval or square; large or small; vertical or horizontal are all choices that can each influence the way an image is perceived. The left side of a painting is key for entry points, as discussed in the following inquiry, and will also affect preferences. Flip a painting on its side and horizontal lines become vertical, eliminating any indication of a horizon line.

Look at the four orientations for this unfinished abstract painting. Which might you select as your favorite choice to continue the painting? Using this in workshops over the years, I found in almost all cases that each orientation has its own fan club. Rarely was there a majority vote for the same orientation for any particular abstract painting while still mid-process.

COMMON ISSUES OF FLIP 4

Visual Distractions

To create a neutral viewing space, avoid distractions in the periphery of your painting area. This can help avoid some common issues. For example, some artists will apply colored tape to the sides of a painting to keep them clean while painting. A neutral-colored tape is not distracting. A bright blue commercial painter's tape, however, is distracting and can cause a painter to think blue is in the painting itself, thereby inhibiting a painter from adding blue to the work even if it's needed. When the blue tape is removed at the end, any lack of blue in the work itself becomes obvious but at an inconvenient time in the process.

Physical Difficulties

If your painting is large in size, heavy in weight, or firmly attached to another support, turning it four ways for this inquiry may prove physically difficult. As an alternative, you can gain objectivity by looking at your painting in a mirror. Carry a mirror over to your work and view the work from a variety of different angles. Another idea is to photograph the painting in process. Transfer the image to your computer and print it out in a smaller size to easily flip the image.

Painting in Process

FLIP IT UPSIDE DOWN

Realistic imagery will have an obvious orientation established right at the start with little reason to change its orientation mid-stream. However, using this exercise still offers a way to experience a realistic image with fresh eyes. Forms and spaces easily recognizable when the painting is upright in its correct

Painting in Process, Flipped Upside Down

positioning can lose immediate recognition when the image is flipped, thus enabling new perspectives.

When I flipped *Abiquiu Dam* upside down, I noticed a heaviness in the red foreground, now that it was at the top, and corrected it in the final painting (shown on the facing page).

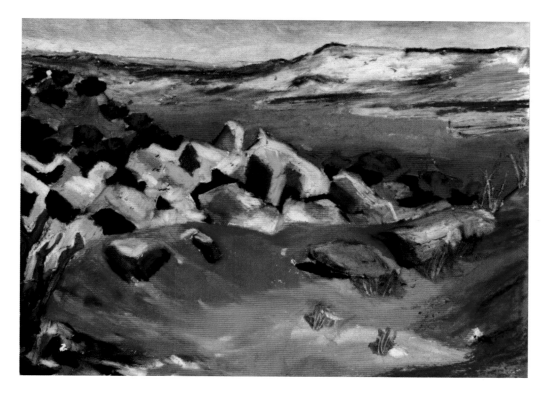

Finished Painting

ABIQUIU DAM / Nancy Reyner / Oil pastel on bristol paper / 9" × 12" (23cm × 30cm)

Critique Questions | Flip 4

An image can sometimes maintain its original intent in different orientations, while others may dramatically change. For a realistic image, once you've rotated it in all four orientations and analyzed it for issues, revert to its original orientation and make improvements as necessary. For images that can change orientations at this stage, if you find you prefer a new orientation, proceed with the analysis using the new orientation to identify further issues.

1. *Which of the four orientations feels the best to you? Avoid overthinking. This is not about which orientation has the fewest issues. At the stage where the painting is still in process, there will most likely be issues for all orientations. Just pick whichever appears the most interesting to you, even if it is a realistic image and the "correct" orientation is obvious. If after contemplating your image in different directions you still prefer its original orientation, then just flip it upside down for the next questions to be able to view your image in a different perspective.*

2. *What are some factors in the work that contribute to making this new orientation of interest? Is there a heavier area hugging one of the edges? If so, this will feel better positioned at the bottom.*

3. *Gaze at the painting while in the new orientation. While staring, see if something becomes more noticeable or surprising. Perhaps there is an unusual distribution of weight at the top or sides. Or maybe there is too much of the same color used overall. Notice shapes, colors, lines. Is anything stuck in the corner? Everything looks different when seen from new perspectives. Make corrections as needed.*

Critique goal: Make your painting more inviting.

This chapter examines elements in your painting that will invite a viewer into your work by way of visual entrances. Let's use an analogy of inviting guests to a party. As hosts we want our party guests to stay for awhile, enjoying themselves without leaving too quickly out of boredom. To that aim we would invite a variety of guests for a fun crowd, and provide a variety of refreshments. Drinks, food and seating would be strategically placed for ease of movement. Perhaps most basic to our party's success is how we style the entry. If there's no obvious entrance or door, if the porch light isn't on or if the front door is locked, guests will turn away before even entering and our party efforts will all be in vain.

Just like a party, a painting needs an entrance, enough aesthetic variety, uncluttered paths between attractions or focal points and even perhaps a memorable exit. With these in place, our viewing guests are most likely to party their way toward a fulfilling and memorable viewing experience with our painting. This inquiry specifically covers entrances and exits. Concepts relating to variety are scattered throughout this book, with special emphasis in Inquiries 1, 2 and 8. Inquiry 7 adds ways to improve your image's movement and flow "during the party"—between entrance and exit.

Types of Entrances

Viewing a painting does not happen all at once, in a brief instance. In fact we often view a painting linearly, just like watching a movie unfold. This viewing journey usually starts at a point along one of a painting's edges, then continues to move along lines, brushstrokes or areas of colors. The more we slow down our viewing process,

NAVAJO RUG, CA EARLY 20TH CENTURY / Artist unknown / Wool / 37" × 24" (94cm × 61cm) / Courtesy of the Division of Anthropology, American Museum of Natural History, New York (Catalog # 50.2/6854)

A UNIQUE TRADITION

Navajo textiles out of the American Southwest were traditionally woven without borders until the late nineteenth century as weavers began adding them when influenced by the Southwest trading posts. Wary of having their spirit trapped in the piece, the weavers added a small thread of opposing color that went from the interior design out through the border. These are called *spirit lines* to allow spirit an exit. Today, contemporary Navajo weaving encompasses many styles with some weavers continuing this tradition.

DETAIL

This detail shows the spirit line in the blanket's upper right corner—a dark dotted thread going from the gray interior and out through the border.

the easier we can identify the entrances as well as other issues described throughout this book. See page 122 for more tips on how to view paintings.

Westerners read text from left to right; therefore, entrances in western paintings are commonly found on the left side and sometimes, although less commonly, on the bottom. For cultures that read from right to left, entrances will be on the right. Either way, paintings are inviting when there is some entrance on the appropriate side of the painting. Entries are easily created using angles that start at an edge and move in toward the work's center but not parallel to any edge. Angles can be created using many painting techniques including the use of lighter values, a tree branch, a figure, an actual path, brushstroke—anything that moves diagonally against the straight edges of the painting's surface.

Ideas About Exits

Exits do not have to be as grandiose as entrances, but are still important to consider while analyzing the viewing movement in a work. Elements that work well for entrances will also work for exits.

ORIGINAL PAINTING

In this abstraction, angled lines and shifting values create ample entries that start on the left then move the eye into the image's interior.

FIGURE #8 / Nancy Reyner / Pastel, charcoal and graphite on paper / 38" × 50" (97cm × 127cm)

ALTERED VERSION 1
The image is altered to illustrate a blocked entry. The strong vertical orange column has been moved from center to the far left. This will add some frustration to a viewer's initial entry into the piece with the possibility they won't enter at all.

ALTERED VERSION 2
A dark column has been added that runs vertically along the left edge. It creates a blocked entry because it has no "buddy," meaning there is nothing in the image that it can easily relate to in either tone or shape. For more on this concept see page 74.

ALTERED VERSION 3
Instead of removing or changing the dark stripe to resolve the blocked entry, adding the other dark elements back into the work will redirect the eye toward the painting's interior. This is an example of using a buddy to resolve this issue.

COMMON ISSUES OF ENTRANCES AND EXITS

Blocked Entry

A shape or form that runs in a true vertical along or close to the left side of the painting may create a visual barrier or blocked entry. To resolve a blocked entry, repaint vertical forms so they are more angled, or move the shape farther to the right and into the painting. A solid or dense form with no angle can be broken up by softening some portions of the form's hard edges or by superimposing smaller shapes and diagonals over the form.

No Variation Between the Entrance and Exit

Some entrances encourage a quick exit by using a uniform horizontal sweep across the image with little variation toward the exit. This lack of variety will not engage the viewer for very long.

BEFORE: ENTRANCE AND EXIT ARE TOO SIMILAR
The lack of variety in these horizontal stripes pushes the eye too quickly from left to right, or entry to exit.

AFTER: ADD MORE VARIETY TO AVOID A QUICK EXIT
Using forms, lines and marks, I added more variety to slow down the eye movement for enhanced interest.

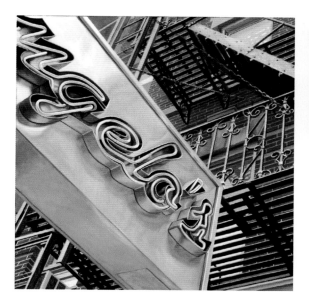

VERTICAL ENTRANCES

Strong verticals create dramatic entries. Any potential issues for an entry are avoided by angling the verticals slightly to encourage further eye movement into the image.

IN THE BERRY GLEN / Catherine Kernan / Woodcut monoprint on paper / 31½" × 72" (80cm × 183cm)

DIAGONAL ENTRANCES

A dramatic entry is created using strong diagonals starting on the left side and moving the eye inward toward the center.

LITTLE ITALY / Pat Bailey / Oil on canvas / 30" × 30" (76cm × 76cm)

Critique Questions | Entrances and Exits

As painters, we probably spend much more time gazing at our painting than any viewer will. We may therefore falsely assume the entry is issue-free. When evaluating the entry, avoid letting your eyes jump to something interesting in the interior of the work. Instead backtrack to see where your eyes actually start entering the image. You may need to take a visual break from the image if you've been recently working on it, then view it later with fresh eyes for analyzing entrances.

1. *Observe the left side of your painting. Are entrances visible? If not, are there entrances along other edges? And if so, what is the reason for using an uncommon edge for an entry?*

2. *Identify what elements are being used to create the entries in your painting? Are there diagonal lines, angled brushstrokes, light areas, etc.? If entrances are not easily visible, what elements might be causing a block to an easier entry?*

3. *What percent of the left side (or whichever side is used for entry) contains visible entrances?*

4. *Where along the edge are they located?*

5. *Do the qualities and types of entry points in the work best serve your image and intent?*

6. *Are they interesting enough?*

7. *Repeat the above, substituting exits for entrances. Where are they located? Of what type are they? Are they easily recognized?*

8. *How do your entrances and exits relate to each other in the painting?*

INQUIRY 5: ZONES AND QUADRANTS

Critique goal: Quickly uncover hidden design issues in your paintings.

At this point in The Viewing Game, we can assume you have taken your painting through the previous four inquiries. Perhaps you have found issues and made corrections or have not found any problems. In any case, this technique will readily reveal those elusive problems you may have missed, by viewing your painting in smaller isolated sections. This technique is an all-time favorite in my critique groups and workshops. Imagine your painting divided into four separate and equal quadrants: upper left, upper right, lower left and lower right. Cover the painting entirely, using sheets of paper or cardboard in white (or a neutral color) except to reveal one of the quadrants.

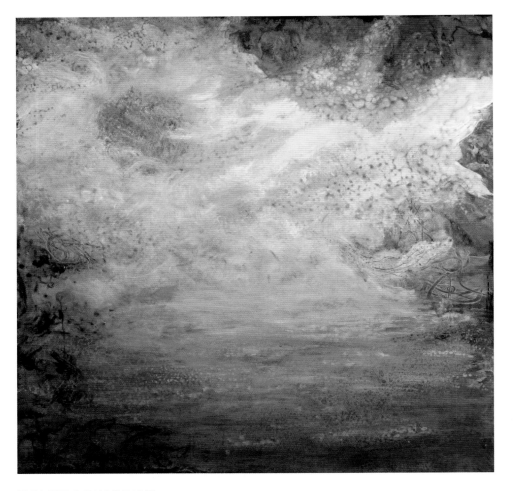

ISOLATE A QUADRANT

The isolation technique works well with realism or abstraction. Using strips of white paper, isolate the quadrants of Teitelbaum's painting directly on the page. You can easily see that each cropped section contains visual variety and interest.

SOLAR WINDS / Bonnie Teitelbaum / Acrylic on panel / 24" × 24" (61cm × 61cm)

Isolating Sections

Start with quadrants and observe each as if it were a complete painting on its own using pieces of white or neutral paper to crop or isolate the sections. Once isolated, view them through the lenses of the previous inquiries, paying special attention to pairs of opposites and their ratios. Each quadrant, once isolated, should hold its own for each of the Big Three in Inquiry 1. Additionally, check for entrances along the left side edges for each of these cropped quadrants.

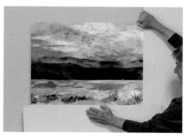

CROP THE LEFT QUADRANT
Use white paper to isolate each quadrant. Here is the upper left viewed by itself.

Troubleshooting

In addition to isolating quadrants, try isolating other zones or identifiable areas such as background, foreground, middle ground or landscape divisions of sky and ground. After isolating quadrants and zones, if you still feel there is an unidentified issue, try the following process: Find a part of the painting you like, and using paper or cardboard, isolate just that area, no matter what shape or size that area is, on all four of its boundaries. Slowly pull one of the pieces of paper outward while keeping the rest of the papers in place, revealing more and more of the painting until it starts to change to an area that you don't like. Notice the moment when it starts to change. This is the boundary between what is working and what is not. Repeat with the other sheets of paper until you know the exact boundaries of the area that works. Identify the qualities that exist in the area you like, and use these to extend the working area by painting them into the nonworking areas.

CROP THE CENTER
If all the quadrants look good, but the painting as a whole does not feel right, isolate the middle. Even though central areas of the painting are included within each of the four quadrants, it can be useful to view as a section by itself.

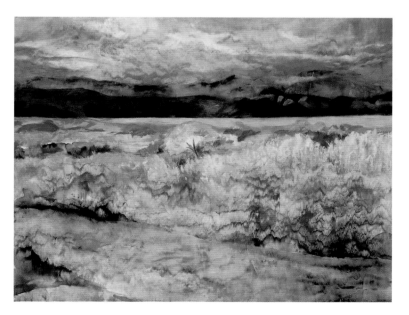

ORIGINAL PAINTING
Each quadrant and zone can stand on its own, while also working together for the painting as a whole.

BOSQUE LAKE / Nancy Reyner / Acrylic on canvas / 46" × 60" (117cm × 152cm)

COMMON ISSUES OF ZONES AND QUADRANTS

Sometimes one quadrant works well, but the rest do not. After determining what you like about the preferred quadrant, add some of those qualities to the others.

Dead Zones

I call a quadrant or any area that lacks visual interest a *dead zone*. Dead zones usually lack variety (all the same value, color with no variation, a 100:0 ratio of a pair of opposites, etc.). If you notice that you frequently create dead zones in the lower left quadrants of your paintings but paint more successfully in the upper right, periodi-cally rotate your canvas half a turn clockwise. This way the zone that usually goes dead is now in your best working range. Try to keep turning the painting while you work so all areas get your best working position.

Sometimes we can get enamored with an exciting area in the painting while ignoring the rest of it. This may unintentionally leave one or more quadrants barren or dead. Even if the painting does have some exciting parts, any dead area can detract from the total viewing experience.

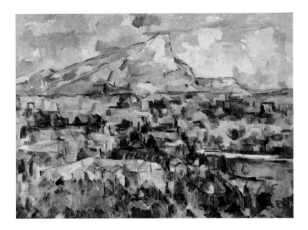

ORIGINAL PAINTING

This is the finished work as Cézanne painted it. Notice how the foreground, middle and background are handled. By having both warm and cool within each area in unequal ratios like 80:20 or 90:10, the painting feels integrated and visually exciting.

MONT-SAINTE-VICTOIRE / Paul Cézanne / Oil on canvas / 28" × 36" (71cm × 91cm)

ALTERED VERSION

Cézanne's painting has been altered so that warm and cool colors are segregated into sections. Each section has a 100:0 ratio—the sky and foreground are all cool while the middle is all warm—creating a monotonous viewing experience. When isolating areas, evaluate for any type of segregation like this.

THE TALKING HOUSE / Nancy Reyner / Acrylic on canvas with silver leaf / 24" × 36" / (61cm × 91cm)

PAINTING IN PROCESS

When I isolated the upper left quadrant of this image, it revealed a dead zone. If the upper left quadrant were a complete painting by itself, it would not hold much interest.

FINISHED PAINTING

I fixed the dead zone in the upper left quadrant by increasing its spatial depth, affecting the viewing experience of the whole image.

ALTERED VERSION

The focus and interest are contained in the center, resulting in a uniform and boring background with four dead quadrants. These overwhelm the central mandala design rather than support and relate to it.

ORIGINAL PAINTING

Two solutions can fix the issue. You can make the central design larger, moving it into other quadrant areas. Or you can add design elements from the central mandala design into the background to integrate them. The original mandala painting illustrates both solutions when compared to the altered version.

Critique Questions | Zones and Quadrants

Start with the quadrant in your painting that you like the best or one that seems to have the fewest issues. Isolate this quadrant using white or neutral-colored paper or cardboard. Proceed through the following questions.

1. *What is your first impression of this isolated section? Is it interesting enough to stand alone as a complete painting, or does it feel like a dead zone?*

2. *Identify one or more qualities that stand out the most (texture, contrast, forms, lines, color, busy or quiet, hard edged or soft, etc.). Make note of the opposites for each of these main qualities. What are the ratios for each of the pairs of opposites in this quadrant?*

3. *Even if the quadrant seems to work well, evaluate it further by going through the previous Inquiries 1 to 4, paying particular attention to the Big Three—light and dark, bright and neutral, warm and cool. If it has a dead zone, you will find what's missing and then make it more interesting. If it works very well, you will be*

clear on which aspects can assist other quadrants that might not work as well.

4. *Repeat the above questions for the remaining three quadrants and the center zone. If appropriate to the work, include other recognizable zones or divisions such as sky/ground, figure/background, etc. Summarize which quadrants and zones work the best and why, and which work the least and why.*

5. *How do the quadrants or zones relate to one another? Is one more prominent than another? Do the relationships benefit the work or can they be improved?*

6. *Are each of the zones and quadrants interesting enough?*

INQUIRY 6: FOCAL POINTS

Critique goal: Discover the best ways to direct eye movement.

What are focal points in painting? A frequently used term in art books and workshops, *focal points* are places the eye is attracted or pulled toward while viewing. Focal points are instrumental in bringing attention to the work and sustaining the viewing. Most common sources for focal points are high-contrasting pairs of light and dark values and bright colors, along with hard-edged forms. Focal points can also be created using the 80:20 rule (Concept 6). When using a pair of opposites, the lesser, or 20% component, often gets the spotlight for attention, and becomes a focal point. For example, revisit Brueghel's painting on page 23 and observe the centrally located red shirt. It is the minor component of two 80:20 ratios (green to red and neutral to bright), making that red shirt a very strong focal point.

Focal Points Need a Buddy

Imagine Shakespeare's play *Romeo and Juliet* but without Juliet. There would be no story. A *buddy* is created when a shape, form, line or area is related to another by sharing one or more noticeable qualities. When something stands out oddly in an image, with nothing to relate to, it appears to be alone with a missing buddy. Determine if your painting contains any loners and missing buddies by searching for 100:0 ratios. For help with this task, see page 103 for a list of useful painting pairs of opposites. When evaluating buddies in your work, make sure they are visible enough. If an element in the work has a buddy but the buddy is minimally present (for example, 99:1 ratio), it can still feel like it is missing. Another helpful tip is to make sure the form and its buddy aren't too similar. Some of their qualities need to be similar while others should be different. Remember, too much repetition can cause a quick exit.

Focal Point Placement

Focal points direct the eye. They can also affect levels of visual tension according to where they are placed.

AND LILACS SHALL BLOOM / Sam Scott / Oil on canvas / 42" × 54" (107cm × 137cm)

CONTROLLING VISUAL TENSION

The artist has placed focal points in all four corners of the painting. When attention is brought to corners and edges like this, a viewer becomes aware of not just the image painted on the surface, but on the actual surface itself. The painting can then be seen as an object rather than just a pictorial illusion of space. This creates a higher visual tension, requiring masterful painting skills to direct eye movement both inside the image as well as out. Here the eye is pulled from one corner to the next, avoiding a quick exit through rich relationships of form, color and line.

PAIRS OF OPPOSITES

In this painting, bright spots of color enveloped by neutral gray tones create exciting focal points.

BIRTHDAY MAKING PAPER HATS / Gigi Mills / Oil, paper, crayon and graphite on paper / 10" × 13" (25cm × 33cm)

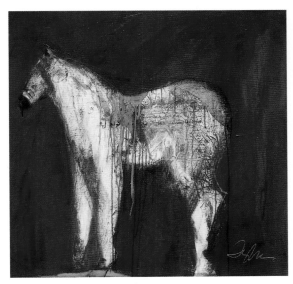

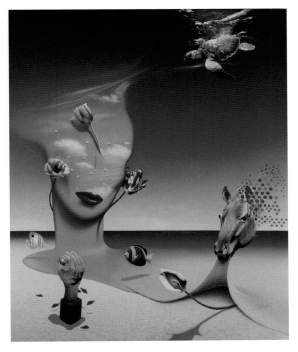

DIRECTING EYE MOVEMENT

The bright blue in this image represents two strong focal points: one on the horse's back and another along the bottom edge of the painting. Imagine if the blue on the horse's back were eliminated. This would leave only one blue focal point at the bottom edge. Without a buddy to bring the eye back into the image, the blue at the bottom would look like a mistake. Since the blue has a buddy, the eye can move from one focal point to the other, creating a more dynamic visual experience.

GRACE (BEDOUIN SERIES #3) / Kathy Taylor / Acrylic and mixed media on canvas / 36" × 36" (91cm × 91cm)

ENHANCE SPATIAL DEPTH

Unlike Kathy Taylor's painting to the left, this image would not benefit from focal points fixed along edges or in corners. Here the focal points are all well within the confines of the surface's edges to enhance the illusion of spatial depth.

RETURN TO TRANQUILITY / Rick Garcia / Acrylic on canvas / 48" × 36" (122cm × 91cm)

COMMON ISSUES OF FOCAL POINTS

Lacking Focal Points

Paintings that have no focal points risk becoming peripheral, looking like all background or wallpaper with very little visual tension. Even color field paintings need to have some type of focal points, even if subtle, such as an emphasis on an edge where color shifts. View your work frequently with fresh eyes as focal points added in the beginning may get lost during painting, requiring you to repaint them later.

A common pitfall, especially for abstract painters, happens when a new trick technique is used all over (for example, pouring or sanding). A new technique can be exciting to an artist using it but may trick us into thinking that the technique is enough by itself to create viewing interest.

Without additional painting, new tricks and techniques can appear as an overall pattern lacking focal points, looking like wallpaper, and boring to a viewer.

Too Many Focal Points

Eye-catching aspects such as high contrast, hard edges and bright colors, when used sparingly, create focal points. If overused, however, these risk adding confusion and chaos, feeling too busy to view for any length of time. This is illustrated in the altered version of Brueghel's *Landscape with Fall of Icarus* on page 23 where excessive amounts of red focal points were added to create a 50:50 ratio of red to green.

PAINTING IN PROCESS
This image was formed by sanding paint layers. The result felt so satisfying to me that I thought it was a finished painting. The small orange and black forms could be considered focal points, but after further consideration, didn't feel adequate. The image was further worked to become an underpainting for the finished painting *Canned Art: Now Available in Spray* on page 62.

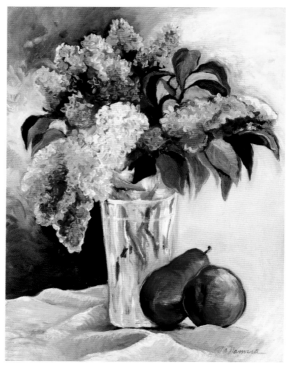

COMPLEMENTARY COLORS AS FOCAL POINTS
The focus is powerfully directed toward the still-life elements (vase, fruit and flowers) using pairs of complementary colors in unequal ratios of 80:20 (yellow to violet and green to red).

SPRING LILACS / Leslie McNamara / Oil on canvas / 18" × 14" (46cm × 36cm)

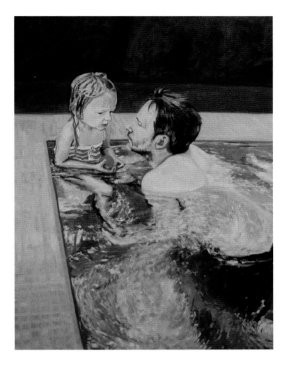

ENHANCE FOCAL MOVEMENT WITH LINES AND ANGLES

This painting also makes use of an 80:20 ratio (blue to orange), turning both father and child into focal points. The visual thrust towards their faces and upper torsos is further emphasized with strong linear angles made by the pool's corner.

FATHER AND CHILD IN THE POOL / Vezna Gottwald / Oil on canvas / 48" × 36" (122cm × 91cm)

Critique Questions | Focal Points

Focal points act like highlights in the work and will take on the role of "life of the party" in your painting. They should bring attention to the still-life objects in your still life, the figure in your portrait or critical forms in your abstraction. Their role is significant, so spend as much time as is necessary with this inquiry.

1. *Pick a time when your eyes are fresh and you haven't been staring at the work for a long time. Focal points do not have to be a literal geometric point but can be an area, edge, object or form. View the work and notice where your eyes are naturally directed. These will most likely be your focal points.*

2. *Look for major focal point players: high contrast, bright colors, hard-edged forms and minor elements of an 80:20 ratio in a pair of opposites. Does your painting have any of these aspects?*

3. *Do you see any focal points that differ from the aspects just listed? Identify the qualities that make them attracting as focal points.*

4. *How many focal points are in the work?*

5. *Where are your focal points located? Are they in places that help direct movement appropriately for your work, or do they work against your intent? If needed, move them to a better location along desired movement paths you wish to create within the painting.*

6. *How do your focal points relate to each other?*

7. *What is the ratio of focal points to the rest of the painting? Focal points are generally best showcased when they represent a minority of this ratio (for example, 80:20 background to focal points).*

8. *Does your use of focal points best serve your intent for this work?*

9. *Is the painting interesting enough with the focal points currently present in the work?*

Critique goal: Improve viewing potential using positive and negative spaces.

Design in painting is commonly referred to as *composition*, and influences how your eye moves around and within a painting. Western cultures read from left to right and tend to view images in that direction as well. This means most western paintings have entries that start on the left. Assuming any entry issues are now resolved, let's revert to the party analogy we began in Inquiry 4. Starting from your painting's entry, your viewer continues to move through the image, heading for whatever interests them most. As party hosts, our goal is to plan ahead for optimal flow and movement for our guests. Colors, forms, textures, high-contrast pairs, lines, spaces—all the qualities included in the work need to be considered in relation to each other to best direct and choreograph the eye movement of our viewing guests.

Positive and Negative Spaces

Think of *positive spaces* as the forms in a painting, while *negative spaces* are areas found in between those forms. Negative spaces are referred to as backgrounds, peripheral spaces or in abstract work, energized spaces or fields. The hand exercise (see page 14) showed the fingers as positive spaces while spaces in between the fingers were negative spaces. The exercise demonstrated that forms are recognized by our left brain while spaces are detected with our right. Therefore, it's ideal to take time while painting to consciously switch viewing between forms and spaces. M.C. Escher applied this

POSITIVE AND NEGATIVE SPACES IN ABSTRACTION

Each of us will identify positive and negative spaces differently especially in abstract work. Decide for yourself what you see as form and what you see as space. For instance, in *Traveler*, the colored squares in blue, red and dark purple could be seen as the forms, and the white area as space.

TRAVELER / Celia Drake / Acrylic on canvas / 24" × 24" (61cm × 61cm)

JOURNEY THROUGH NEGATIVE SPACES

Use this landscape to take a canoe ride with your eyes. Start your journey entering near the orange boat in the bottom left corner. Or start with the curving yellow and green bank that begins midway up the left side. Take a ride through the negative spaces, pictured here as water and air. As you move along notice the forms, such as boats, the moon, architecture and land. How do the spaces feel around and in between them?

MOONLIGHT ON THE YODO RIVER (YODOGAWA), CA 1833 / Katsushika Hokusai / Polychrome woodblock print; ink and color on paper / 10" × 15" (25cm × 38cm) / Henry L. Phillips Collection, Metropolitan Museum of Art, New York City

idea of switching brain sides to create optical tricks as the basis of his work.

A Canoe Ride for Your Eyes

Try this exercise that uses a canoe analogy to help identify and experience the negative spaces in your work. Start with an imaginary canoe to give your eyes a ride. The canoe, with your eyeballs in tow, puts down at an entry point (usually on the left side of the painting) to start your journey. You then maneuver your canoe through the negative spaces while your eyes notice the forms along the way. Your body is the canoe and your eyes are the riders. Slow down the ride to pay attention to how spaces feel.

Once the eye gains entry into a painting, it is directed toward focal points, and further continues toward any related buddies. Eye movement can be made more interesting by varying the negative spaces. The more the eye can travel, meandering through a painting, the longer the viewing time and the more potential for a fulfilling visual and aesthetic viewing experience.

Underlying Shapes

Imaginary shapes sometimes present themselves to a viewer while observing a painting. These shapes are not necessarily painted in the work but instead are conjured up by the viewer as the mind superimposes a shape or shapes onto the work through eye movements. These are underlying structural shapes. Of these, the largest perceived shape that covers a majority of the painting's surface can be called its *overriding shape*. This may then contain and hold together smaller subdivision shapes. While we are viewing negative spaces in the work, these underlying shapes emerge in our periphery and are not always visible at first. Geometric shapes such as diamonds, circles and squares are some common ones, along with other shapes such as S curves and pyramids. Even a minimal color field painting will evoke geometry while viewing. American minimalist Mark Rothko utilized squares within squares in many of his rectangular-shaped color field paintings.

Variety and Repetition

Choreographing eye movement depends on variety and repetition. Variety offers the unexpected, emphasizing differences between shapes and colors, while repetition adds the expected, emphasizing similarities. Too much variety is chaos, while too much repetition is wallpaper. Find the right balance of these for your work.

PARALLEL VS. PERPENDICULAR EYE MOVEMENT

These two types of eye movements are defined on page 48. This image directs the eye across (or parallel) to the surface using a flat space with almost no spatial depth. If the eyes were instead directed back into the illusion of depth (perpendicular) that would detract from its powerful graphic quality.

FOUR WAY LIPS / Rick Garcia / Acrylic on canvas / 30" × 40" (76cm × 102cm)

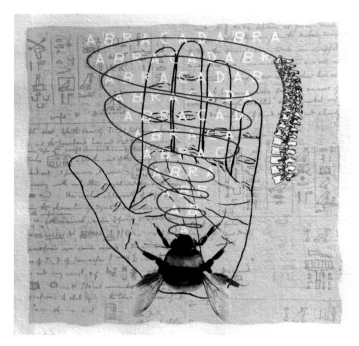

THE INFLUENCE OF A SURFACE'S SHAPE

This painting surface is square, which often evokes an underlying circle contained within its square shape.

ABRACADABRA: BABYLON CALL 1 / Vicki Teague-Cooper / Digital monoprint / 12" × 12" (30cm × 30cm)

Original Painting

THE PAINTER AND HIS PUG (SELF-PORTRAIT) / William Hogarth / Oil on canvas / 35" × 27" (89cm × 69cm)

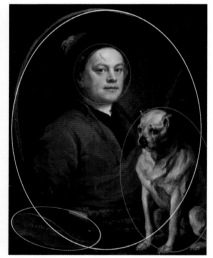

Altered Version with Line Overlays

EXISTING UNDERLYING SHAPES

The overriding shape in Hogarth's painting is a large oval that I've indicated in the altered version with a white line overlay. Notice how this imaginary oval follows the actual oval mirror at the top but extends much farther down toward the bottom of the painting. The subdivided shapes included within the larger oval are indicated by colored line overlays, encircling the man's face, the dog and the musical instrument. Some shapes stay within the painting's frame or edges, while some allude to moving beyond those borders.

BLUE DANUBE / Nancy Reyner / Acrylic and gold leaf on panel / 48" × 60" (122cm × 152cm)

S CURVES

British painter William Hogarth proposed that "the essence of beauty of line in painting, drawing, nature and design is not the simple geometry of a straight line or circle, but of curves that modulate like the S curve." He called the S curve "the line of beauty" and stated that it would excite viewer attention more than straight lines, parallel lines or right-angled intersecting lines, which he saw as static. He felt that the S curve is the basis of all great art.

Blue Danube makes use of an S curve for its overriding shape. Note that an overriding or underlying shape can be loosely ordered and does not have to be precise. The shape here is actually a Z, or a backward S, and moves outside the edges of the painting, indicated with a blue line overlay.

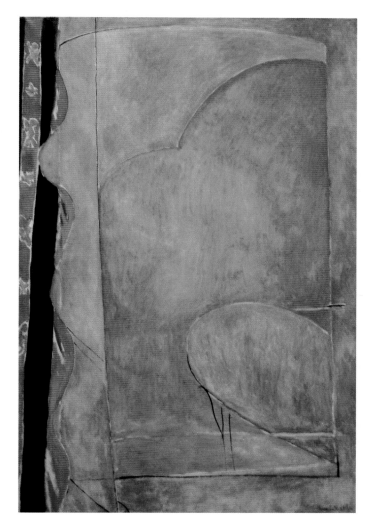

UNDERLYING SHAPES MADE VISIBLE

Underlying shapes can sometimes be more obvious in abstract images where geometric forms are visible, not imagined. What structural shapes can you find in this painting?

THE YELLOW CURTAIN, CA 1915 / Henri Matisse / Oil on canvas / 57" × 38" (145cm × 97cm)

COMMON ISSUES OF DESIGN AND MOVEMENT

Excessive Repetition

Keep the number three in mind when evaluating repetition. Whenever there are three or more aspects that repeat but do not differ, it may cause a quick exit.

Unexciting Ride

Avoid the one trick pony where only one main form is surrounded by a solid, even background. Too much background with little variety elsewhere creates a boring canoe ride. (See the altered mandala example on page 73.)

Clogged Arteries

Too many forms and not enough negative spaces can make an image feel crowded and overly busy. When passages are too narrow, they prevent your canoe from passing through. These spaces are like clogged arteries.

You can actually feel your body tighten and your breathing become restricted while traveling through tight negative spaces.

Combining Separate Panels

When grouping together separate smaller sizes into one unified image (diptychs, triptychs, etc.), consider the viewing movement between them. Focus at their edges where one panel meets the next. Where some aspects continue similarly from one panel to the next, there will be an ease to the eye movement. When aspects change between panels, the flow is interrupted. Visual tension increases with the interruptions and decreases with continuity. For your work, find the right balance between continuous and changing. Consider also whether the panels should be viewed with space in between them or close together.

Painting in Process
Finished Painting

THE KISS / Nancy Reyner / Oil pastel on paper / 10" × 12" (25cm × 30cm)

TOO LITTLE NEGATIVE SPACE

Using the canoe ride analogy, notice how it feels in the painting in process with little or no negative spaces to pass through, like clogged arteries. To correct, overpaint some forms to eliminate them altogether. Alternatively, overglaze some of the busy places, subduing, calming or pushing forms back in space until they create passable spaces.

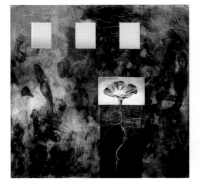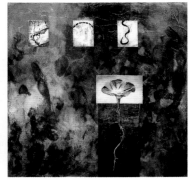

Painting in Process
Finished Painting

RUNE / Nancy Reyner / Acrylic on panel / 20" × 20" (51cm × 51cm)

MONOTONOUS ELEMENTS

Three yellow rectangles lined up along the top of the painting are all the same, creating monotony in the image. To resolve, the squares were varied so that some qualities remain the same (size and placement), while some aspects now vary with the addition of differing marks inside each rectangle.

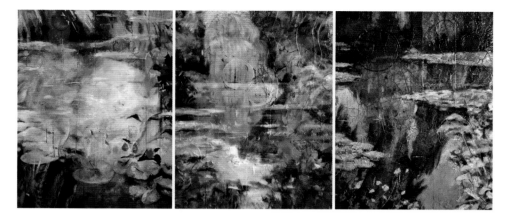

VARY MOVEMENT BETWEEN PANELS

In this triptych some elements are continuous, staying the same from one panel's edge leading into the next, while others are not.

MONET'S GARDEN / Nancy Reyner / Acrylic on three canvases / 48" × 108" (122cm × 274cm)

Critique Questions | Design and Movement

Evaluate positive and negative spaces in your work, for variety and repetition, to assess the quality of eye movement.

1. Using the canoe analogy, let your eyes go for a slow ride starting at an entry point (usually on the painting's left side), continuing through negative spaces in between forms. How does the ride feel? Is the ride exciting with a variety of passageways narrow and wide? Is it winding and full of surprises with alternating movements both quick and slow? Or is the ride over too quickly by directing the eyes immediately into a corner or opposite edge and exiting out? If needed, add more variety to the negative spaces that are too similar and unvaried.

2. Identify main elements in the work that create the most movement (diagonal lines, angled brushstrokes, light areas, etc.).

3. Are there any places during the canoe ride where spaces feel too narrow or tight? If so, make necessary corrections to widen them.

4. Analyze the positive spaces or forms and shapes in the painting for variety. Identify those that are the same and those that are different. For shapes that are too similar, write a list of all their adjectives describing color, value, edge, size and shape. Change some of these qualities so that they differ from each other, but keep others the same so they relate.

5. What is the ratio of varied forms to repeated forms? Does it best serve your intent?

6. What is the ratio of positive and negative spaces in your painting?

7. Is there a main overriding shape? If so, what is that shape?

8. Where and how is this shape identified? What elements or aspects encourage this shape to emerge in a viewer's imagination?

9. Does the overriding shape fit within the boundaries of the painting's edges or expand beyond?

10. Does the quality and type of overriding shape you have best serve your image and intent?

11. Are there any subdivision shapes? If so, how do they relate to the main overriding shape?

12. Observe the positive and negative spaces along with the relationship of variety and repetition in the work. Is it interesting enough?

INQUIRY 8: SPATIAL DEPTH

Critique goal: Master the illusion of spatial depth.

Most of the time, as we look at the world around us, forms of solid matter attract our immediate attention as we ignore the less noticeable spaces in between. The previous inquiry focused on movement traveling parallel to or across the painting's surface, using a canoe ride as an analogy, to place attention on both form (positive spaces) as well as the spaces in between (negative spaces). For this inquiry, movement travels perpendicular to the painting's surface so we will exchange the canoe for a spaceship to analyze the illusion of receding space.

Determining Spatial Depth

There are three aspects to analyzing your painting's spatial depth: How many spatial planes are represented in the image, what is the breadth encompassed by the planes and how far from the viewer does this breadth feel.

To determine how many planes are in your work, imagine you are in a spaceship traveling back into the image's depths. Starting with the viewer's position outside the painting as the launching point, the space-ship flies you toward the painting's surface and into its depths. As you continue to fly back toward the illusion of receding space the image conveys, determine which painted shape or form you will crash into first. In other words, which form, line or color in the image appears to be the closest to you? Then determine the next form you will hit after that one. Imagine that each object you crash through is on its own wall or plane parallel to the front of the painting surface. Count how many planes you crash through. There may be several objects that feel as though they sit together on the same plane. Count these as only one plane no matter how many forms are sitting on that same plane. This is not rocket science (pun intended), so just make it your best guess.

The capability of a painting on a 2-D surface to create the illusion of 3-D space is called *plastic space*, a term conceived by modern minimalist American painter Mark Rothko. This aspect has unique potential to shift a viewer's experience from the mundane to the divine, which can particularly benefit those artists who have romantic or spiritual intentions for their work. Once you estimate the number of planes, then determine whether the breadth or depth of field is broad or narrow.

MULTIPLE PLANES IN SPACE

This painting has many spatial planes. Starting with the largest and closest roof in the foreground as the first plane, each roof after that represents an additional plane. Its depth of field is broad, starting near to the viewer and receding back quite far for increased spatial depth.

FLORENCE ROOFTOPS / Pat Bailey / Oil on canvas / 48" × 60" (122cm × 152cm)

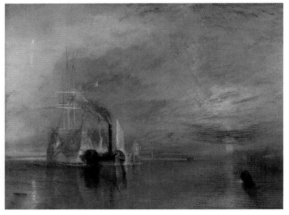

EMPHASIZING DEEP SPACE

When the illusion of deep space is emphasized along with a sense of mystery, soft energy and ethereal qualities, the resulting effect is sometimes referred to as atmospheric.

THE FIGHTING TEMERAIRE, CA 1839 / J.M.W. Turner / Oil on canvas / 36" × 48" (91cm × 122cm)

Depth of Field

Depth of field is a common term for photographers to indicate how much depth is in focus for a shot. For painting we can use it to judge how far apart the planes are from each other, or the total distance encompassed from the first plane to the last. For example, a painting with only three planes might have each of them very far apart from each other, creating a broad depth of field. If, however, the three planes feel very close to each other, it means a narrow depth of field. Once you determine where the planes are and how far they are from each other, observe how this depth of field feels in relation to you the viewer—near or far.

Types of Spatial Depths

Let's look at three types of illusionary spatial depth in a painting: deep space, flat space and a combination of the two.

Deep space: Illusionary space that is deep offers an expansive feeling, pulling the viewer back into the depths of the image. This concept was fully developed in the Renaissance where images had a discernible foreground, middle ground and background. The image was meant to trick a viewer into thinking they were looking at a scene not on a canvas but through a window.

Some modern artists continued to utilize this concept. Matisse once remarked that a successful painting makes a viewer forget that it is on a wall. Renaissance painting techniques to create depth included overlapping forms, varying sizes of forms, lines and forms on angles, colors that vary from bright to neutral (see Inquiry 1), and a combination of hard and soft edges.

Flat space: Spatial quality in a painting can be flat, focusing more on forms coming forward and less on spatial depth. Flat spaces feel confronting. Think of the

CERRO PEDERNAL / Lindsay Holt / Acrylic gouache on linen on panel / 63" × 33" (160cm × 84cm)

BROAD DEPTH OF FIELD

This contemporary landscape makes full use of spatial techniques to create the illusion of depth. There are multiple planes with a deep space starting close to the viewer at the rocks and bushes in the bottom foreground, receding in a zigzag along foliage and mountain lines.

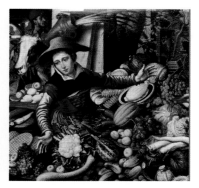

NARROW DEPTH OF FIELD

These images make good use of narrow depth of field as well as a flat spatial depth. The images rely more on design and the relationship of positive and negative spaces, to encourage eye movement to move around the front surface and not far back into illusionary spatial depths.

GRAFFITI HORSE #1 / Kathy Taylor / Acrylic and mixed media on board / 24" × 24" (61cm × 61cm)

THE VEGETABLE SELLER, CA 1567 / Pieter Aertsen / Oil on panel / 43" × 43" (109cm × 109cm)

many pop-art American paintings made in the 1960s and many contemporary graphic images that use hard edges, bright colors, and flat forms to produce a flat space. When using flat spaces, since your image offers a short spaceship ride, make sure to create a more adventurous ride in the canoe.

Combining deep and flat space: An image can incorporate both flat and deep space for a more dynamic viewing experience. When both types of space are included in an image, the eye is encouraged to alternate moving forward and backward in the work. This is called *push-pull*, a term coined by German abstract expressionist painter Hans Hofmann, and will usually increase visual tension.

In addition to the combination of flat and deep spaces, push-pull can also occur when attention is brought to the painting as an object as well as the feel of its surface. Methods to bring attention to the work as an object include placing forms along edges and into corners to emphasize the canvas (such as hot spots discussed on page 90). Bringing attention to the surface with texture or varying sheens will also pull the eye toward the top surface. The eye is pulled toward the painting as an object, then pushed back into the depths of spatial illusion. The eye alternates back and forth, creating a visual tension best suited for a sophisticated work and audience.

USE THE FRONT PLANE FOR A PUSH-PULL EFFECT

Abstract designs overlay this landscape image in a grid-like pattern. The pattern acknowledges the front plane and painting surface, while the landscape imagery and birds pull the eye back into spatial depths, creating a push-pull effect.

SAND HILL CRANES / Diana Ingalls Leyba / Mixed media and acrylic on canvas / 20" × 47" (51cm × 119cm)

HARD AND SOFT EDGES

On the left, observe the soft edge in the background (where the blue foreground meets the gold background). Compare it with the hard edge of the pepper. Hard edges tend to pull a form forward while soft edges feel as if they recede. Using different types of edges in an image can help forms to stand out from their background, creating more depth of space.

On the right, both the pepper and the background use soft edges so the pepper appears to melt into the background rather than come forward like the pepper on the left. This creates a softer feeling of space.

PEPPER 1 / Nancy Reyner / Acrylic on board / 10" × 8" (25cm × 20cm)

PEPPER 2 / Nancy Reyner / Acrylic on board / 10" × 8" (25cm × 20cm)

Eye Treasure

Most of us imagine that at the end of a rainbow lies a pot of gold. So, as our eye takes a journey into a painting's spatial depth, there's a natural expectation we will meet up with something exciting at the end. This could be something special, uplifting, surprising or different. It can be as subtle as a small highlight or shift in color, or more noticeable like a sun setting in the horizon, a bird in the sky or an interesting shape or line.

Edges Are Where the Magic Lies

An edge is defined here as the place where two forms touch, usually of two different colors, and are key to creating any type of space. Observe how edges are treated in your painting. There are four categories of edges: hard, soft, varying and uniform. A *soft edge* is created where two colors are blurred or smudged in some manner or are closely associated in hue or value. A *hard edge* is created where two colors meet clearly and sharply or where they noticeably contrast in hue or value. A form's edge varies when it contains both hard and soft edges, and this will most likely create a sense of volume and the illusion of 3-D. A uniform edge, like an outline, does not vary.

VARY EDGES TO ENHANCE ILLUSION OF SPACE

The varied edges on the peaches and other forms add volume, realism and believability.

THREE PEACHES ON A STONE LEDGE WITH A PAINTED LADY BUTTERFLY, CA 1695 / Adriaen Coorte / Oil on paper mounted on board / 12" × 9" (30cm × 23cm)

UNIFORM EDGES CREATE GRAPHIC APPEAL

An outline around forms will create a uniform edge. Outlines will flatten a form and are best used in graphic images and other types of images that use flat space such as this.

MEDIEVAL BEAST FROM ILLUMINATED MANUSCRIPT, CA 1230 (DETAIL) / Artist unknown (England) / Ink and gold leaf on vellum / 12" × 8" (30cm × 20cm)

COMMON ISSUES OF SPATIAL DEPTH

Confusing Forms

Outlining a form will decrease the illusion of volume and flatten the form. In a painting that is meant to express deep spatial depth, an outlined form can be confusing. It can pop out of the picture like a cutout, looking like it doesn't belong.

Shared or Overlapping Edges

Spatial confusion can also be caused when forms share a common edge even though they are meant to exist on separate planes in space. Improve upon this with overlapping edges to create two planes, giving the viewer a clue that one form is in front of the other.

Missing Treasure

Evaluate the direction of movement in your work to determine what lies at the end of your viewer's journey. When there is nothing to catch the eye, the viewer may be disappointed, like expecting a metaphorical pot of gold at the end of a rainbow.

ORIGINAL PAINTING

In Audubon's actual painting, the lower horizon line is unattached to the beak of the top bird. The second bird adds spatial depth and a buddy. More elements in the foreground enhance viewing movement.

ALTERED VERSION

The bird's beak shares the same line as the horizon line, breaking the illusion of space.

BLUE-WINGED TEAL (*ANAS DISCORS*), CA 1822 / John James Audubon / Watercolor, oil, pastel, black ink, and graphite with selective glazing on paper, laid on card / 20" × 29" (51cm × 74cm)

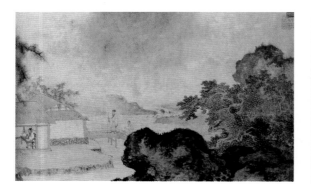

ALTERED VERSION

Move your eyes along the river from the bottom left to the middle of the painting. Without the clouds and variations in the sky, the eye comes to an abrupt end at the horizon line.

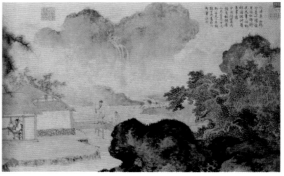

ORIGINAL PAINTING

In the original Chinese painting the viewer should feel visually rewarded rather than disappointed at the end of this visual journey.

MING DYNASTY LANDSCAPE, CA 14TH CENTURY / Tang Yin / Watercolor and ink

ALTERED VERSION

The eye starts on the left side with the child's hand, continues on a diagonal with her arm to the red flower on her chest, then farther along the diagonal toward the right edge of the painting where there is nothing to stop the eye from moving off and out of the painting altogether. This provides a quick exit and disappointment at the end of the journey.

ORIGINAL PAINTING

Here is the painting as the artist intended. More focal points make the journey more interesting such as the second red flower on the child's chest in the middle of the painting. The end-of-journey treasure here is a high-contrast edge on the far right where the dark shadowed tree meets the end of the building's wall.

BRETON GIRLS DANCING, PONT-AVEN, CA 1888 / Paul Gauguin / Oil on canvas / 34" × 42" (86cm × 107cm)

Critique Questions | Spatial Depth

Evaluate the spatial qualities of your painting's depths. For assistance in this exercise, review "Determining Spatial Depth" in the beginning of this inquiry on page 84.

1. *Take your eyes on a spaceship ride through your painting's depths. How does the space feel? What type of spatial depth works best for your work: flat, deep or a combination of both? If there is a combination of both, which feels more significant?*

2. *If your intent is for deep space, how many planes parallel to the viewer do you estimate exist in the work? Fewer than three planes may feel too narrow. Is the quantity of planes sufficient for your work?*

3. *Which forms, if any, feel as though they sit on the same spatial plane?*

4. *What aspects create the spatial depth in the work? Are there bright and neutral colors, hard edges, overlapping forms, variety in sizes of shapes, etc.?*

5. *Is the depth of field narrow or broad? And does this depth of field feel near or far to you?*

6. *Does the work create a push-pull effect? If so, what aspects pull the eye forward and which push it back?*

7. *Is there something of interest where the eye is led? Is there a shift in color or value, a form or bright spot, something unexpected, etc.?*

8. *What types of edges (hard, soft, varying, uniform) exist in the work? Is this range helpful for the spatial quality you want?*

9. *Is the overall spatial quality interesting enough?*

INQUIRY 9: HOT SPOTS

Critique goal: Use power areas in your painting to your advantage.

We tend to see things in our physical world as a reflection of ourselves. When we look at a painting, the different areas of its surface will be similarly interpreted. Gravity feels heavier closer to the ground, so we naturally expect the bottom of a painting to feel heavy too. Tops of paintings are interpreted as sky and expected to feel light. Areas such as these, which carry strong viewer expectations, I call *hot spots*. Chief hot spots involve areas close to the surface's edges (top, bottom, left and right), its four corners, dead center, the upper third portion considered as sky, and the lower third portion seen as ground. Understanding how hot spots affect viewing can help you to manipulate visual tension in your work. Aspects in an image that go along with the viewing expectations for each hot spot will lower visual tension, while aspects that oppose these expectations can increase visual tension.

How you treat hot spots can make or break the viewing power in your image. Eye movement directed into corners and along the edges can generate quick exits unless that movement is skillfully redirected. Excessive focus placed dead center can stop eye movement altogether unless a variety of focal buddies are included elsewhere.

Corners and Edges

If spatial depth is a significant aspect in your image, avoid drawing attention to corners and edges. Forms painted into corners and along edges can cause the viewer to focus on the painting's actual surface as an object instead of the image. To best use this concept, you need to have strong choreography around those hot spots, redirecting the eye back into the image.

Dead Center

The central area of your painting is a viewing "destination." When viewing square or rectangular surfaces, our eyes naturally move toward the center. This area was previously discussed as a special zone in Inquiry 5, but it is also an important hot spot. Emotionally, the center of a painting will reflect our hearts, both the painting's creator's as well as the viewer's.

Sky and Ground

Our experience with gravity equates heaviness and strength with the bottom portion of a painting. The bottom may also be conceived as a pedestal that holds up the perceived weight of the image, while the upper portions are expected to be light and airy.

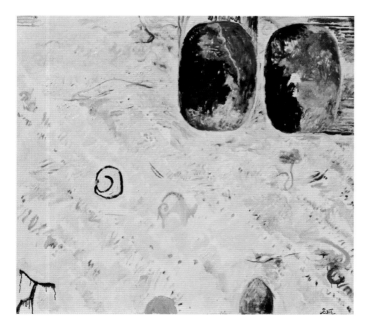

SKILLFUL USE OF CORNERS
A dramatic push-pull effect and higher visual tension is created by emphasizing the edges and corners, while using strong eye choreography within the image to avoid a quick viewing exit.

BRILLIANT CORNERS VI / Sam Scott / Oil on canvas / 54" × 60" (137cm × 152cm)

COMMON ISSUES OF HOT SPOTS

Our left brain likes hot spots. Remember, the left side likes form and is more comfortable dealing with the object you are painting on than the illusion of space you may be attempting to paint. If allowed to dominate painting activity, the left brain will not only place key aspects directly into hot spots but will not acknowledge them as possible distractions.

Locked in a Corner

Corners are eye magnets for a quick exit. If your intent is to emphasize the illusion of spatial depth, then forms placed directly into corners and along edges will look like mistakes, distracting the eye to move outside of the painting. Let's face it, the corners of your painting will almost always have something painted there. The idea is not to "lock" an object or form into the corner.

Riding an Edge

When a form is lined up along a painting's edge or runs perfectly parallel to it, an unconvincing space is created, looking like a mistake in an image using deep space.

HOW TO LOCK A FORM IN A CORNER

Here are three ways to lock a form into a corner:

1. If an imaginary axis can be drawn through the center of a form that leads directly into a corner.

2. If a form has edges that measure equal distance along both sides from the corner.

3. If lines are drawn directly into the corner.

UNLOCK THE FORMS FROM A CORNER

Make these simple adjustments to free a locked form from its corner:

1. Shift the form's angle so the axis points away from the corner.

2. Adjust edge lengths so they differ.

3. Move lines away from the corner.

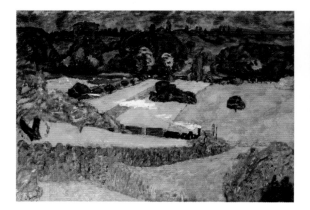

ALTERED VERSION

I moved the forms on the bottom right and left of Bonnard's painting more tightly into the corners. Compare this viewing experience with the original painting to see how corner hot spots can influence viewing.

ORIGINAL PAINTING

With nothing locked into the corners, the eye freely moves inward into the strong spatial depth of the original painting.

LANDSCAPE WITH FREIGHT TRAIN, CA 1909 / Pierre Bonnard / Oil on canvas / 43" × 30" (109cm × 76cm)

ALTERED VERSION

In this altered image the bottom portion of the white tablecloth and shadow underneath run exactly parallel to the painting's bottom edge, creating a distraction rather than reinforcing a believable space.

ORIGINAL PAINTING

The slightly curved table bottom along with variety in the placement of the figures' feet underneath is enough to entice the eye to move inward toward the rest of the image instead of quickly across from left to right as in the altered version.

THE LAST SUPPER, CA 1520 (AFTER LEONARDO DA VINCI) / Giampietrino / Oil on canvas / 117" × 303" (297cm × 770cm) / Collection of the Royal Academy of the Arts

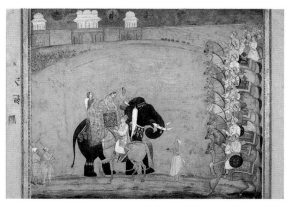

RIDE THE EDGE FOR VISUAL INTEREST

Notice the unusual ploy of lining up horses along the right edge of this painting. Since this graphic image uses an overall flat space, riding the edge feels intentional and creates interest and visual appeal.

PRINCESS ON ELEPHANT BACK WHO CROWNS THE WINNER, CA 1645 / Payag, Indian style / Ink, colors and gold on paper / 11" × 15¾" (28cm × 40cm)

THE SCREAM, CA 1910 / Edvard Munch / Tempera on cardboard / 33" × 26" (84cm × 66cm)

KEEP CORNERS FREE FOR SPATIAL DEPTH

The strong diagonals of the bridge go behind the main screaming figure, and disappear behind the two smaller figures near the left edge. Draw an imaginary axis or middle line through the bridge to see how it avoids locking into top left or bottom right corners, thus reinforcing the spatial depth, adding dramatic movement and avoiding a quick exit.

Critique Questions | Hot Spots

First evaluate whether your image uses the illusion of spatial depth or instead uses a flat, shallow or graphic space. To maintain the illusion of deep space, avoid drawing attention to hot spots that will work against this. For a shallow space decide whether you wish to refer to the painting as object and raise the visual tension. Then you would want to deliberately bring attention to corners and edges. These preliminary considerations allow you to make hot spots work best for your intent with the work.

1. *Are eye-catching elements or solid forms sitting in any corners, along edges or dead center? If so, do these enhance or detract from the image?*

2. *Analyze the central area of your work. Is there anything dead center? If so, consider moving it slightly off center to increase movement within the image.*

3. *If you are deliberately directing the eye to corners and edges, do you have enough alternate forces and movement vectors in the work to move the eye back and forth between these and the image's interior?*

4. *Are your treatments of corners, edges and dead center best serving your intent for the work? If your work uses a division of sky and ground, analyze them in terms of their perceived weight to see if they best suit your image's needs.*

INQUIRY 10: IS IT FINISHED?

Critique goal: Make that final decision with confidence.

The idea of finishing is often wrapped up with the idea of perfection. Perfectionism is the pursuit of an ideal and can kill creativity and sabotage your finale. If you want your painting to be ideally perfect, you may never finish. In fact, you may never even start! As artists, if we use the word *perfect* to mean finished or complete rather than someone else's version of *ideal*, this creates a positive goal out of a potential hindrance. The power of finishing comes from knowing that it doesn't have to be a masterpiece, just finished.

Take your painting through The Viewing Game, and analyze your work with honesty and patience. With each inquiry, identify and correct any issues you may find, always keeping in mind your intention for your work. Then you can be confident that your painting works. It may still call for some tweaking here and there, but these small changes would be based on your personal preferences, not on of any design flaws. It may not be your best painting, but it's finished. Now you can move on and start working on your next painting. This inquiry adds some further tips on knowing when the work is finished.

Fresh Eyes

Fresh eyes are needed to stay objective and ascertain if the work is truly finished. Some ways to keep your eyes fresh:

- Find two favorite paintings of yours that you know are finished. Hang or position your current painting between them. Leave them all on view for a few days so you see them frequently. Every time you view your newer painting, you will see it in relation to those you consider finished and can feel if it measures up to the others.

- Pretend it's finished. Paint the sides or loosely place a temporary frame over it and view it again. This suggests to your mind that it is finished, and you will more readily see if it rises to the occasion.

- Photograph it, then view it in your camera or transfer it to a computer screen. Viewing it in different modes and sizes helps to see it with new perspectives.

While on the computer, play around with the image by changing colors and contrasts, taking out shapes, etc. After playing, compare any changed images with the original digital image. Sometimes seeing the image go through changes can add confidence that the work is the best it can be or may help catch any elusive issue still needing correction.

- Resolve issues right away. If you see something that needs to be corrected but don't take action right away, you risk losing your objectivity. If you pass by an issue three times without fixing it, your mind will get tired of it. You will mentally edit it out and no longer see the issue.

Tweaking

Painting is really a process of problem solving. I like to use the analogy of a ladder where each step in the process of painting is like taking a step up the ladder. The top of the ladder is the finish line. The first step of the ladder is your first problem, which may be the simple notion that the blank canvas is too blank! From there you take action to resolve it. Once resolved you move on to the next step of the ladder to solve the next problem and so on, one step or problem to resolve at a time. The top of the ladder designates that there are no more problems to resolve, offering a sense of completion.

Sometimes you may find yourself at the top of the ladder (hopefully by means of the last nine inquiries) with no more problems but still feel inclined to make small changes. This is where tweaking comes in handy—when you make small preferential changes to the work without any major design shifts. Tweaking can be used to slightly shift visual tension or subtly change the choreography of eye movement. So even if you are officially finished, it's still valid to play around with small changes until you are totally satisfied.

What's Your Story?

An image usually presents a story. With narrative elements the story may be more literal, while an abstract painting might involve a story that is more open to interpretation. A story can be subtly constructed through relationships or placement of forms. For example, a grouping of fruit in a still life can speak of loneliness

by placing one fruit by itself away from the group. A similar story can be told through an abstract work using a solitary shape that sits apart from a grouping of other shapes. Objects in a still life can reveal many facts about its owner, adding to or creating the story. Portraits reveal the personality of the sitter through choices of clothing, jewelry, background setting, facial expression and possessions.

Your painting's story is closely related to your intent. Your story can be the same as your intent; if you have a more complex intent, the story may only be a small part. (See page 114 for more on clarifying intent.) Your story does not have to be blatant or easily comprehended by the viewer as in a book illustration. Instead it can be about your goals for how the work will be experienced when viewed.

To help decide whether your painting is complete, revisit your original intent, evaluate how much, if any, it has changed in the work's story, then determine if it is satisfactory.

Closing the Conversation

The act of painting is an active conversation between yourself, your idea and the paint. A good indication the painting is finished is when the conversation feels as though it has come to an end. Hang up the work where you can easily see it regularly in your day. As you walk by, do you feel there is still something unsaid? Is there something that makes you feel uneasy? Does your eye keep moving to an area that feels out of place? These are indications that the conversation is not finished. On the other hand, if you continue to walk by and there are no calls from the painting for changes, it is most likely finished. Maybe there's a silence, a feeling that it has, like Pinocchio, became something real, something living, all on its own, and it doesn't need you anymore.

GIRL / Celia Drake / Mixed media on canvas / 20" × 20" (51cm × 51cm)

CLARIFY YOUR STORY

The isolated and oversized head is unexpected and therefore attention getting, giving this image an uneasy feeling. The artist intended for the work to have an edgy quality, and that is part of her story. Another artist with a different intent might try to normalize this image by making the head smaller or attaching a body to it. That would change the image entirely. Always consider your intent in making decisions, and avoid mistakenly correcting what you may perceive as an issue but instead is a key element in the work.

COMMON ISSUES OF FINISHING A PAINTING

Unnecessary Limits

Here's a concept that may surprise you. You don't have to like your painting for it to be considered finished. A painting will likely change from its original plan during its development. Sometimes the change is slight and sometimes more dramatic. Perhaps you used a different color palette, included imagery you rarely use or made it more abstract than usual. A painting that is different from your usual style may feel uncomfortable. Since the painting no longer matches your original vision, you may feel the work is not yet done, even if it is truly complete. It's perfectly valid to make work you don't like as long as you've taken it to the top of the ladder with all problems resolved. Don't limit yourself and your work by always staying within the confines of your personal preferences. Your work might be from moving in a new direction that you are not yet ready to accept.

A student once asked me for help resolving a dilemma. She had finished a painting that she intended to be abstract, yet unintentionally it turned out realistic. She considered herself an abstract painter, so her question was how to correct it and turn the painting abstract. The painting at that point was so complete that attempts to turn it toward a different direction at that late stage would produce a crusty, overworked surface. My advice was to accept it for what it is and start a new painting. We can blind ourselves to new options by getting too attached to our initial intent. Some of our best work is created when we least expect it. Put the anomaly away, work on something else and look at it again after a length of time.

Reality Check

When inconsistencies occur between elements and its story, they can detract from the painting's appeal. For instance, imagine a still life with a vase of flowers where the flower stems don't look like they go into the vase. Check proportions and the placement of forms for believability.

Overcooked

The first painting I worked on after graduating from art school took me a full year to complete. When it was finished, I realized I had in actuality painted not just one painting, but ten different paintings all buried over each other on the same canvas. Every time I got a new idea, I would just overpaint the current one. If instead I had changed to a fresh canvas for each new idea, I would have had ten paintings instead of only one, which became so heavily worked, it was called "crusty" by one of my teachers. When a painting is finished, and you still have more to say, then congratulations! This means your ideas are overflowing. Start a new painting without over-cooking the one you just finished. Remember to leave some things unsaid for the viewer's imagination. As a Zen proverb states, "True beauty could be discovered only by one who mentally completed the incomplete."

Working on several separate paintings at the same time will also help avoid overworking or unnecessarily overpainting your work. Another tip if you tend to overwork paintings is to think of each layer of paint that you apply over another as transparent enough to reveal at least some of the layers underneath. As you build up layers, consider using color more transparently by adding mediums and avoiding heavy coverage. You should still be able to see a portion of each layer visible in the final work.

When All Else Fails

There may be times when you have gone through The Viewing Game with your painting, corrected and tweaked it, and you still feel apprehensive. Somehow the painting isn't quite finished, and you can't figure out why. More considerations are offered in the next sections.

> "SOME OF OUR BEST WORK IS CREATED WHEN WE LEAST EXPECT IT."

Nancy Reyner

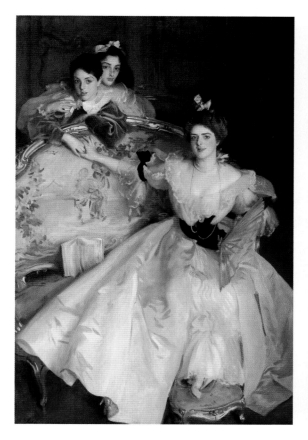

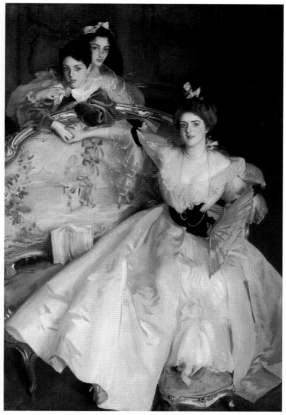

ORIGINAL PAINTING

MRS. CARL MEYER AND HER CHILDREN, CA 1896 /
John Singer Sargent / Oil on canvas / 79" × 53" (201cm
× 135cm)

ALTERED VERSION

Compare this version, altered in two places, with
Sargent's original painting. Can you spot the two
discrepancies? The mother's right arm cannot be
realistically attached to her body the way it is pic-
tured here, and the daughter's head is not believably
attached to her neck. These issues can detract from a
work's believable reality.

Critique Questions | Finishing

*Revisit your original intent, allow time to pass after your last brushstroke so you have fresh eyes to view, and commit to
being as honest with yourself as possible in answering the following questions:*

1. *How does your painting compare to your original idea? Has it changed? If so, how much? Is the change more
 interesting or less? What do you want to communicate through this work, and are you communicating it clearly?*

2. *What is the story that comes through this painting? Is it specific and narrative, or loose and more open ended? Are
 elements consistent enough to make the story believable (i.e., proportions, spatial arrangements)?*

3. *What type of viewer do you imagine would find it appealing?*

4. *Does this painting inspire you to create more like this? Or does it give you new ideas to change direction for your
 next one?*

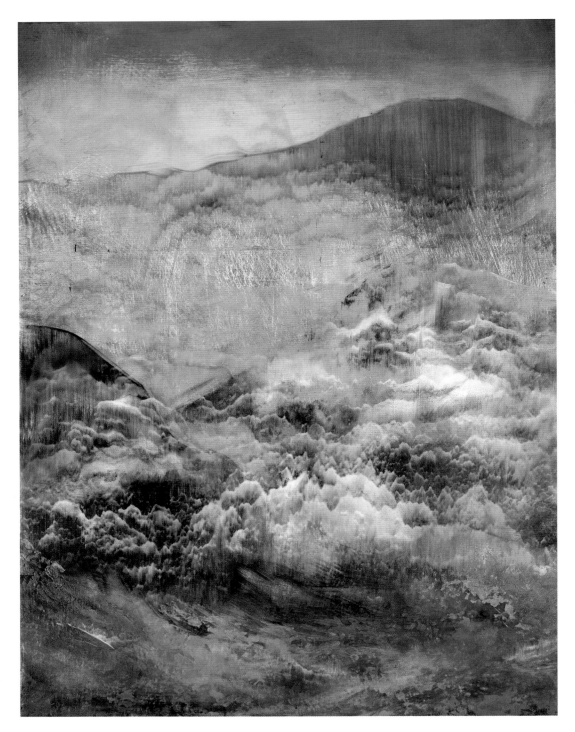

SKY MOUNTAIN / Nancy Reyner / Acrylic and gold leaf on panel / 16" × 12" (41cm × 30cm)

SECTION 4

HELPFUL PAINTING SOLUTIONS

The ten inquiries in the previous section provide a systematic way to discover visual and design issues in your work including a variety of options for fixing them. This section takes a further look at color, a painter's number one tool for resolving the most common painting issues. Inquiry 1 in The Viewing Game explored how color can enhance many aspects of a painting's visual experience. Here you will find even more ways to use color efficiently and with great success.

This section also includes shortcuts for streamlining The Viewing Game analysis detailed in Section 3. There may be times when you are in the painting zone, happily working away, wanting some direction without having to fully switch gears into a critique phase. These shortcuts provide a perfect mini-analysis for those times. This section also contains a handy list of pairs of opposites to further assist in analyzing your work.

SOLUTION 1: THE 4-STEP CRITIQUE SHORTCUT

You can use the ten inquiries in The Viewing Game to catch most design issues in your painting. After making any necessary corrections, if you still feel an issue exists, use this shortcut technique. It can also be useful while you are in the midst of painting but would rather not stop for a lengthy analysis.

This technique may sound very simple but is surprisingly potent. The technique has four steps:

First, look at your painting and find one descriptive term (an adjective) to finish the statement, "It's too _____." This is your issue.

Second, determine the adjective's opposite. This is the solution.

Third, select the most appropriate painting technique to add the solution's adjective into your painting.

And fourth, choose a strategy to ensure an unequal ratio between that pair of opposites. That's it!

Let's take a closer look at these four steps: statement, solution, technique, strategy.

Step 1: Statement
Finish the statement "It's too _____." Be spontaneous and immediately write down your first thought. Helpful words are descriptive adjectives such as busy, bright, dull, etc. Unhelpful words are more of an opinion or judgment such as bad, amateur, hopeless, uninteresting. Repeat the sentence "It's too _____" until you come up with a word, or several words, that feel true for the work at this stage. Let's continue using the arbitrary example "It's too dark" to define the current issue with the work.

Step 2: Solution
Determine the adjective's opposite. Using the example above—it's too dark—the opposite of dark is light. This means the painting does not have enough light values, and therefore the solution is to add more lights. If the opposite for your adjective is not as obvious as this example, see the reference list of adjectives and pairs of opposites in Solution 3 on page 103 for more ideas.

Step 3: Technique
Using the opposite adjective determined in step 2, select the best painting method to add aspects of it to the work. Continuing with our example, we would pick a technique that would best allow adding more light values and/or change one or more dark areas in the painting to a lighter value. For example, mix some of the colors that are currently in the work to a lighter version and repaint over them with opaque coverage.

Step 4: Strategy
Maintain an unequal ratio for the pair of opposites. This may be the trickiest step, and my best advice is to avoid implementing the corrections in step 3 with left brain dominant. Using our example, let's say we have mixed up a few lighter value colors and plan to overpaint some dark areas. If corrected using our left brain, we risk going on autopilot and overpainting not just some dark areas but all of them. Instead of solving our problem, we've just turned one problem into another. Next time we analyze it, we'll be saying "It's too light." Before corrective painting, make a strategy such as adding light values until an 80:20 dark to light ratio is obtained.

Painting in Process

ISSUE 1: DULL AND DARK

Suppose your intent is to get more richness, excitement and interest into your images, but somehow your paintings keep ending up too dull and dark like this one.

QUARK SPARKS / Nancy Reyner /Acrylic on canvas / 30" × 40" (76cm × 102cm)

Finished Painting

Step 1: Statement. "It's too dark and dull."

Step 2: Solution. The opposites of those two adjectives are light and bright. The solution is to add some of each of these opposites into the image.

Step 3: Technique. Introduce some new lines, shapes, forms and focal points using light and bright colors into the work.

Step 4: Strategy. Stop overpainting when the ratio becomes 80:20 (dark/dull to light/bright).

Realistic Painting

ISSUE 2: SWITCHING FROM REALISM TO ABSTRACTION

Suppose you are a realist painter and want to shift your work more toward abstraction. You paint an image with no design issues, yet you aren't satisfied because it doesn't reflect your new direction. This is not about issues, but about preferences. The best solution is to leave the painting as is and start a new one with this new intent.

BEACH BALLS #2 / Pat Bailey / Oil on canvas / 30" × 48" (76cm × 122cm)

A New, More Abstract Painting

Step 1: Statement. "It's too realistic."

Step 2: Solution. The opposite of realistic is abstract. According to this process, the solution would be to add abstract areas, or reduce realistic elements in the painting. However, this situation is about changing direction, not correcting issues. This painting is masterfully crafted, and so here it is best to leave the painting as is and start over on a fresh surface, using a different approach that steers the image towards abstraction.

Step 3: Technique. Create a new image utilizing abstract concepts right in the beginning, such as eliminating any horizon line, using minimal detail, keeping literal forms more ambiguous and placing an emphasis on negative space.

Step 4: Strategy. Continue to use preferred imagery and style, while introducing some abstract changes, using an 80:20 ratio (realistic to abstract).

BRITISH VIRGIN ISLANDS WATER / Pat Bailey / Oil on canvas / 18" × 60" (46cm × 152cm)

SOLUTION 2: CRITIQUE QUICK LIST

Here are the highlights of the ten inquiries in a nutshell for a handy, quick review. Use fresh eyes to gaze at your painting while asking the following questions.

1. What is your first impression, or how does the painting feel at first glance?

2. What aspect is most prominent in the work?

3. What is the opposite of this aspect?

4. What is the ratio for this pair of opposites?

5. Is this pair of opposites located in advantageous places?

6. Is this pair used in a way that is helpful for your intent?

7. Is it interesting enough?

8. Can either adjective in this pair be improved in any way for more variety, interest, placement or quantity, or have you maximized its potential contribution to your image?

9. Analyze these important pairs of opposites, one at a time, using questions 4 through 8:

 - lights and darks
 - brights and neutrals
 - warm and cool
 - Green-red
 - blue-orange
 - violet-yellow
 - tactile and optical qualities
 - hard and soft edges
 - form and space

10. Are there any pairs of opposites in the work in a 50:50 ratio?

11. Are there any pairs of opposites in the work in a 100:0 ratio?

12. How do entrances and exits feel?

13. How many main focal points exist and of what variety and location?

14. Do the negative spaces help the eye move from one focal point to the next across the painting surface?

15. Do the spatial qualities used in the work create an interesting movement receding into space?

16. How is the center of the painting handled?

17. Are each of the four quadrants of equal interest?

18. Are any lines, forms or other visual aspects unintentionally stuck in corners or sitting on edges?

19. Do the forms relate to each other in a logical way that make sense to the work's idea?

PAIRS OF OPPOSITES

This list of common painting adjectives and their opposites may be helpful for new painting ideas and evaluating your work. All adjectives have an opposite. If one of the adjectives listed below is in your work, its opposite should be in there, too. Remember, pairs are best utilized in unequal ratios. Many issues are easily revealed and resolved by noting an adjective that is missing its opposite (100:0) or too equal (50:50). Personalize this list by adding your own favorites.

bright	dull	detailed	hazy	polarized	nuanced		
light	dark	flat	spatial	sketchy	precise		
warm	cool	atmospheric	architectural	washy	solid		
red	green	confining	expansive	squiggly	straight		
blue	orange	rhythmic	still	angry	peaceful		
violet	yellow	transparent	opaque	linear	circular		
hard edge	soft edge	vulnerable	guarded	near	far		
edge	gradation	interior	exterior	mechanical	organic		
angular	curvy	figurative	abstract	confusing	clear		
realistic	abstract	interesting	boring	messy	clean		
forms	space	attracting	repelling	believable	unbelievable		
textural	smooth	clear	foggy	crafted	accidental		
busy	calm	day	night	tall	short		
color	gray toned	veiled	exposed	confronting	receding		
dynamic	static	gloss	matte	aggressive	meek		
full spectrum	monochromatic	solid	fragmented	open	closed		
bold	passive	symmetrical	asymmetrical	confined	expansive		
surprising	expected	alone	together	clear	confusing		
pleasing	disturbing	crisp	unclear	mysterious	recognizable		
seductive	repulsive	text	images	pattern	random		
specific	ambiguous	awkward	elegant	feminine	masculine		
thick	thin	weighted	light	historic	contemporary		
big	small	grounded	floating				

SOLUTION 4: MIXING THE PERFECT COLOR

Color is a painter's best tool. It may seem obvious that color is important in painting, but why should a painter care about matching a color exactly? Interior designers know that white-colored wall paint comes in thousands of variations of white. They also understand the importance of selecting the perfect color for a particular room. It is the same for your artwork. Here are several examples of why exact color matching is very important to the success of your painting.

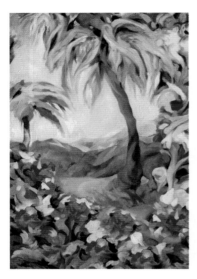

Painting in Process

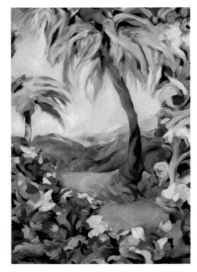

Finished Painting

COLOR MATCHING ALLOWS FOR EASY CHANGES

Mixing and matching colors skillfully enables easy editing and removal of elements in your painting. This image had too many repetitive red flowers in the foreground, lending the work a wallpaper feel. The solution? Remove some to give the remaining flowers more visual punch. I achieved this by matching the background colors to paint over several red flowers in the foreground. Without so much repetition, the composition is more inviting.

FLORAL #2 / Nancy Reyner / Acrylic on canvas / 32" × 20" (81cm × 51cm)

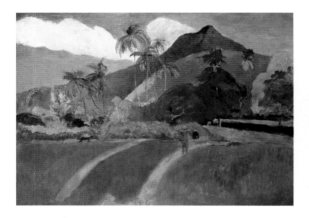

Altered Version

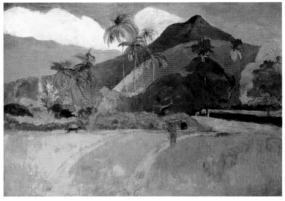

Original Painting

COLOR MIXING IMPROVES COLOR VARIETY

Create variety in a painting by mixing and matching to vary color. Compare the green grass in the foreground in the altered version, simulating what often happens when only one green color is used to paint a field of green grass. In the original work Gauguin used a wide variety of colors in the foreground, creating strong spatial depth and interest.

TAHITIAN LANDSCAPE, CA 1891 / Paul Gauguin / Oil on canvas / 27" × 36" (69cm × 91cm) / Collection of the Minneapolis Institute of Art

PREPARING YOUR PAINTING PALETTE

Essential Colors

There are hundreds of paint colors available for a painter to choose from. However, you need only six specific colors plus white to be able to mix any color you want. For ease and success in mixing and matching colors, start each painting session using what's called a full palette (a warm and cool of each of the three primaries) plus white. Though optional, I like to add black, too. When the colors are properly selected, you will be able to mix any color perfectly (including black) using only these paint colors.

It may be of help to know that inexpensive or student-grade paints include added fillers with low-quality pigments. This means those paints may not produce accurate results when mixing true, clean colors.

Choosing Primary Colors

Primary colors are those colors that theoretically can't be obtained through combinations of other colors. There are three primary colors: red, yellow and blue. They are your baseline colors, the three colors that you must start with on your palette. With these you should ideally be able to mix any color using them, as long as they are "perfect." So what are the most perfect primary color choices? Here is the central color problem for painters. There are no perfect primary paint colors that exist in physical form. To get as close as we can to this perfect but nonexisting ideal, we can instead select two of each primary, one a little warmer in color and one a little cooler than their conceptual ideal. A red that is a bit warmer leans towards the yellow (picture a tomato), while a red that is a bit cooler leans towards the blue (picture bing cherries). If we use Cadmium Red Light as our warm red and Quinacridone Magenta as our cool red, the unobtainable ideal would exist somewhere between these two. Having both warm and cool versions of our three primary colors allows us to mix any color we choose.

PRIMARY COLORS

A warm red leans toward its neighbor yellow, and a cool red leans toward the other neighboring primary, blue. Each of the other two primaries work this way as well. Using the terms warm and cool can be confusing. Most agree that yellow and red are warm while blue is cool. Therefore, distinguishing between the two blues—which is warm and which is cool—is more difficult. In this case it's easier to use the concept of leaning. One blue clearly leans more toward red and is more blue-violet, while the other leans toward yellow and is more blue-green.

cool yellow / warm yellow

warm red / cool red

blue leaning red / blue leaning yellow

A Word About Palettes

The word palette *has two different meanings. It can mean the surface used to hold paint and can also mean the arrangement and selection of colors you choose for that surface.*

Arrange Paint in an Arc

Squeeze out some of each of the paint colors from the six primary tubes plus black and white. Add colors moving in an arc as close to the outer edges of your palette as possible. Start and end the arc a few inches (several centimeters) from the bottom edge, and add space between colors, leaving room for other mixtures to be added in later during the painting process. The arc arrangement allows space in the center for mixing. Leave the bottom edge, closest to you, free from paint to enable range of arm motion while mixing and to avoid dragging your sleeve through the paint.

Mineral and Modern Pigments

Most pigments can be divided into two categories: modern (paint made from organic pigments) and mineral (using inorganic pigments).

Modern and mineral colors differ greatly in their tints. Create a visible notation of this on your palette by dragging a small amount of each squeezed out color, extending onto the palette, looking like a tail. Add a very small amount of white into each tail, mixing it well to indicate the color's tinting strength. Mineral colors will have tails that tint lighter while also looking chalky or duller. The tails on modern colors will also look lighter but tint brighter instead of duller. I therefore call tints of modern colors "popped" to distinguish a modern tint from a mineral tint.

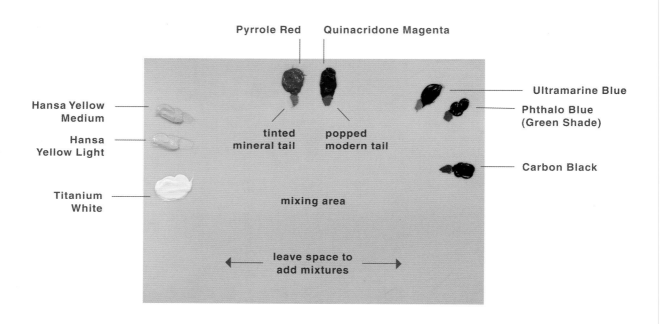

BEST FULL PALETTE FOR SLOW-DRYING PAINTS

Palettes for oil paint can be glass, wood or plexi. For acrylic paint, avoid wood palettes unless they are well-sealed so you can easily clean the acrylic off the palette. You can also make your own palette for either medium by taping freezer paper to a board or table. Readymade palette pads are available containing disposable nonstick paper. Gray-colored palette paper will best show color.

This full palette requires a minimum of seven paint colors: two of each of the three primaries

plus white. Add as many additional colors as you want—here I also added Carbon Black. The colors shown above are optimal choices for color mixing. Use the chart on the facing page for alternatives and optional colors you may prefer to add. Make sure to use a palette large enough to display all the colors along with extra room to make mixtures; I prefer a minimum size of 20" × 24" (51cm × 61cm). Combine two palettes in smaller sizes together if a larger size is not available.

BEST PALETTE METHODS FOR FAST-DRYING ACRYLIC

The full palette described on page 106 works best for oil and slow-drying acrylic paints such as Golden OPEN Acrylics. Most acrylic paints, however, dry fast. Once you squeeze them out, they may dry on your palette before you have time to mix and use them.

To avoid wasting time and paint, squeeze faster-drying acrylics into a jar with a lid. Apply a small amount of the color onto the lid thickly (to see the color's masstone), thinly (to see its undertone) and adding white to see its tint. When the color on the lid dries, it will offer an accurate visual reference of the

paint's color, since acrylic paints are lighter in color when wet. Keep lidded until ready to paint. Optionally add up to 20 percent water and/or slow-drying medium, customizing the mixture's consistency and drying time for your needs. Use the smallest jars you can—the less air in the jar, the longer the paint in it will last.

COLOR	MINERAL	MODERN
warm red	*Choose any one of these three: Cadmium Red (Light or Medium) • Pyrrole Red (Light or Medium) • Naphthol Red (Light or Medium)	Quinacridone Burnt Orange
cool red	Alizarin Crimson	Quinacridone Crimson • *Quinacridone Magenta
warm yellow	*Choose one of these three: Cadmium Yellow Medium • Hansa Yellow Medium • Primary Yellow	Nickel Azo Yellow • Quinacridone Nickel Azo Gold
cool yellow	*Choose any one of these three: Hansa Yellow Light • Lemon Yellow • Cadmium Yellow Light	Green Gold
warm blue (toward red or violet)	*Ultramarine Blue • Cobalt Blue	Phthalo Blue (Red Shade) • Anthraquinone Blue
cool blue (toward yellow or green)	Primary Cyan • Manganese Blue • Cerulean Blue • Teal	*Phthalo Blue (Green Shade)
white	*Titanium White	none
black	Carbon Black	Combine these three into one mixture: Phthalo Blue • Quinacridone Magenta • Nickel Azo Yellow

REFERENCE CHART FOR COLOR CHOICES

This chart shows paint colors divided into modern and mineral categories. The astericks indicate my recommendations for a full palette. The others are optional additions.

MIXING COLORS TO MATCH

Here are three exercises aimed at strengthening your color matching skills. To get started, gather some paint chips in various colors that you want to practice matching with paint. These are usually available for free from your local hardware store. Commercial paint chips work best because the color is uniformly applied.

To follow along with the examples you will need purple, red and khaki color paint chips in any sheen—

gloss, matte or semigloss. Have extra paint chips on hand for the color you are matching in case you run out of room. Make sure to get a few extra of each color you want to match. Obtain a knife with a stepped handle for color mixing so your hand doesn't drag through the paint while mixing, and prepare your full palette as detailed on pages 106–107. Before swatching your card, mix your color well and with a clean knife to get a clean swatch.

<div style="text-align:center">

COLOR MATCH #1

Purple | A Secondary Color

</div>

A secondary color is made from two primary colors. For example, orange colors are made from combining yellow and red, greens are made from blue and yellow, and purples are made from blue and red. This demonstration shows how to match a particular purple color exactly, but these instructions can be used for any secondary color. To match a color from a photograph in a book or any image you do not want to ruin with paint, use a plain white index card to swatch, and hold close to the color you are trying to match for comparisons.

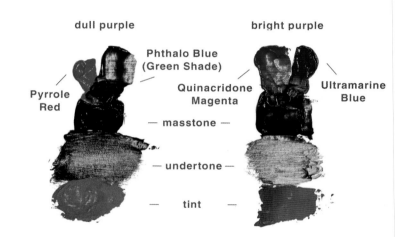

dull purple bright purple

Phthalo Blue (Green Shade)

Pyrrole Red Quinacridone Magenta Ultramarine Blue

— masstone —

— undertone —

— tint —

1 Start with the Brightest Version

When mixing and matching a color, it is easiest to start by making the brightest version of that color first, progressively making it duller to match as necessary. Changing mixtures from dull to bright is more difficult. Purple is made from mixing two primaries, a red and a blue. However, our full palette has two reds and two blues, giving us a total of four possible choices for starting combinations. Which combination when mixed together will produce the brightest purple?

To select the best combination, we need to determine what will dull the purple color so we can avoid adding that into the mixture. What is the one primary color not included in purple? The answer is yellow since purple is made from blue and red. Any amount of yellow, even a very small amount added to purple

will dull the color. So to make the brightest purple, we need to avoid adding any yellow into our mixture by keeping our knife clean and away from the yellow paints on the palette. However, we also need to avoid choosing the blue and red colors that are warmer, or lean toward yellow—Phthalo Blue (Green Shade) and Pyrrole Red—which will result in a dull purple mixture. The blue and red colors that are cooler, or lean toward each other (Ultramarine Blue and Quinacridone Magenta), will mix the brightest purple.

When a mixture uses one or more modern colors, as is the case with the bright purple, it will initially mix very dark, as black. Add a small amount of white right away to pop the color mixture for a more accurate feel for its hue.

2 Mix and Test the Mixture

Apply moderate amounts of Ultramarine Blue and Quinacridone Magenta to a spacious area in the middle of your palette and mix it well. Using a clean knife, apply a small amount of the mixture along the edge of your purple paint chip. Apply smoothly so texture is not a distraction. For exact color matches using acrylic, use a hair dryer to quickly dry the swatches on the chip since acrylic dries a bit darker. Stare at your swatch on the paint chip until you can discern the color difference between the swatch and the chip. Here you can see the swatch is darker than the chip.

3 Change the Mixture Accordingly

Add more white to your mixture on the palette. Mix well. Repeat as before, applying a new swatch onto the paint chip, close to but not touching the previous swatch. Stare until you can discern a difference. Now the swatch color is lighter and closer in value to the chip. We can also see the swatch is warmer or redder than the chip. The solution is to add more Ultramarine Blue to your mixture.

4 Repeat Until Perfectly Matched

In the upper right the color is finally matched to perfection after many attempts and almost seems to disappear into the chip. Notice how the swatches on the paint chip start to disappear as the color gets closer to the perfect match. Remember, contrast creates space! The more colors resemble each other, the less illusion of space between them.

Each time you change your mixture, make sure to add a new swatch of it directly next to the previous one. In this way your eye can learn to discern faster and with better accuracy. There is no award for fast color mixing. Take your time and enjoy the process. Remember, our eyes are muscles that can be trained. For every color you want to match, follow this practice, and your eyes will get sharper and wiser.

Six Ways a Secondary Color Can Differ While Matching

Check the VALUE:

- Too dark? Add white.
- Too light? Add more of its initial two components. For purple: Ultramarine Blue and Quinacridone Magenta.

Check the HUE:

- Too cool or blue? Add the warmer component. For purple: Quinacridone Magenta.
- Too warm or red? Add the cooler component. For purple: Ultramarine Blue.

Check the CHROMA:

- Too bright? Add very small amounts of its complement. For purple, use any yellow or black.
- Too dull? Add more of its initial two components. For purple: Ultramarine Blue and Quinacridone Magenta.

Red | A Primary Color

To mix a primary color such as red, begin with an initial mixture of the brightest red. For the purple we had several choices for starting combinations, but since red is a primary color and is not made from other colors (theoretically, that is), we have only two choices to start our red mixture: a warm red (Pyrrole Red) or a cool red (Quinacridone Magenta). Which one will give us the best or brightest start? The answer may be surprising. Instead of choosing between them, use both! Your first mixture will use a combination of the two reds. This mixture does not need an initial pop by adding white because the mineral red will brighten up or pop the modern red enough to discern the mixture's resultant hue.

1 Start with the Brightest Version

When swatched, this initial red mixture combining Pyrrole Red and Quinacridone Magenta looks darker compared to the paint chip. To correct, gradually add white, continuing to swatch and discern until the mixture's value matches the value of the chip. When matching any color, it's typically best to start by matching tonal value before trying to match hue or chroma.

perfect match

2 Repeat Until Perfectly Matched

After a series of corrective mixture changes, the last swatch seems to disappear on the chip, showing the mixture is matched to perfection. Avoid trying to match a color by just looking at the mixture on the palette without swatching the chip. It will be more difficult to discern color differences with accuracy from the palette.

Six Ways a Primary Color Can Differ While Matching

Check the VALUE:

- Too dark? Add white.

- Too light? Add more of its initial two components. For red: Pyrrole Red and Quinacridone Magenta.

Check the HUE:

- Too cool or blue? Add the warmer component. For red: Pyrrole Red.

- Too warm or orange? Add the cooler component. For red: Quinacridone Magenta.

Check the CHROMA:

- Too bright? Add very small amounts of its complement. For red, use any green or black.

- Too dull? Add more of its initial two components. For red: Pyrrole Red and Quinacridone Magenta.

Khaki | A Tertiary Color

A tertiary color is made from a combination of all three primaries. Tertiaries are grays, neutrals and other colors that are harder to identify. The previous two matches started by making the brightest versions of the colors, but since khaki is anything but bright, we will use the reverse combination to give us the dullest mixture. Caution! Only start with the dullest mixture if the color you want to match is a neutral or gray color, not a secondary or primary one. It's easier to go from bright to dull than the reverse. For a neutral tertiary, such as the khaki we will mix, it doesn't matter what combination you start with as long as you include any red, yellow and blue together in the mixture. You can even use a little of all six colors from your palette, and if you wish, add white and black. Since my color in this exercise looks a bit green-ish in hue, let's start with the dullest green combination, using a blue and yellow that both lean toward red.

1 Start with the Dullest Version

Create a dull green mixture from Hansa Yellow Medium and Ultramarine Blue. Following the steps on pages 108 to 109, swatch the chip, discern their differences and change the mixture as many times as necessary until correctly matched.

2 Repeat Until Perfectly Matched

1. Too dark, added white.
2. Too yellow, added blue.
3. Still too yellow, added more blue.
4. Too dark, added white.
5. Too yellow, added blue.
6. Too bright, added red.
7. Still too bright, added more red.
8. Too dark, added white.
9. Too yellow, added blue.
10. Too bright, added white and black.
11. Too green, added red.
12. Perfect match!

Six Ways a Tertiary/Neutral Color Can Differ While Matching

Check the VALUE:

- Too dark? Add white.

- Too light? Add any red or blue because yellow will make it lighter, or add black.

Check the HUE:

- Too cool or blue? Add any red, yellow or orange.

- Too warm, red or yellow? Add any blue or green.

Check the CHROMA:

- Too bright? Discern the closest color your mixture appears to be and add that color's complement or add black.

- Too dull? Though it is rare for a neutral color to be too dull, if you find that to be the case, add any bright primary color.

THE ENHANCED FULL PALETTE

The full palette previously mentioned works fine for matching colors. However, for painting purposes, your palette can be improved even more by adding some additional items. First add some type of clear medium in the center of your palette. This is useful for adding to mixtures while painting to make the colors more transparent, when needed. Optional additions to the arc of colors on the palette are favorite colors you have purchased or mixed, or the three secondary colors (orange, purple, green).

Most importantly, make painting easier and more successful by adding custom mixtures with very light and dark values. Instead of using only white and black as your extreme light and dark, having a variety of light and dark mixtures, available and ready to use, will add interest and variety to almost any painting.

Mixing Lights

Light mixtures are in the 1 to 3 value range and include both warm and cool choices.

Add very small amounts of any red color to Titanium White (1:99 ratio). Mix well. This warm white is still a 1 in value. Move some of that mixture over to the right, adding a bit more red, mixing to create a 2 value. Repeat again to the right to create a 3 value. Repeat the entire process adding a small amount of any yellow to white, then again adding a small amount of any blue to white.

Mixing Darks

Dark mixtures are in the 8 to 10 value range and include both warm and cool choices.

Combine a red, yellow and blue, making sure at least two of the three colors are modern (see page 107). By using them in differing proportions you can create a variety of cool and warm darks. Remember to add tint tails to reveal their hue.

Cadmium Orange

Dioxazine Purple

Green Gold

Permanent
Green
Light

a clear medium

light
mixtures

dark
mixtures

ADDITIONS FOR AN ENHANCED FULL PALETTE
Start with the full palette described on page 106 or 107 using a warm and cool of each primary plus black and white. Then add light and dark value mixtures, a clear medium, secondary colors and any other favorite paint color or mixture you prefer as shown here. Note that I added Green Gold for a cool modern yellow.

ACHIEVE A FULL VALUE RANGE WITH CUSTOM MIXTURES
Purchased paints are usually primary and secondary colors. Unmixed and straight out of the tube, these will translate into mid-range values. On a scale from 1 to 10, where 1 is white and 10 is black, mid-range values are 4 through 7. Other than white, the lightest value pictured here is yellow, which is a 3 or 4 value. This means very light (1 and 2) and very dark values will be missing from the palette and therefore your painting. Fill these color gaps in your palette's value range by adding custom mixtures.

Color Matching Varies with Application

When mixing a color to match, think ahead about how the paint will be applied onto the painting. There are basically four ways to use paint: transparent, opaque, glazes or washes. Each of these applications will change how a color you mix will appear in the painting. The color mixing techniques described previously are meant for opaque mixtures that will be applied slightly thickly onto the painting. The colors should look very close, if not exactly the same, as how the swatch color looked on the paint chip while matching. If, however, you plan on heavily diluting the color to make a wash or adding mediums for a glaze, you need to test the swatches accordingly so the test matches the application. For example, let's say your painting has a yellow area that you want to turn greener by applying a transparent blue glaze over the yellow. Obtain or make a paint chip that is the same as your painting's yellow color. Add enough medium to your blue color mixture to make a glaze, applying your swatches thinly over the chip to test how the color will appear as a glaze.

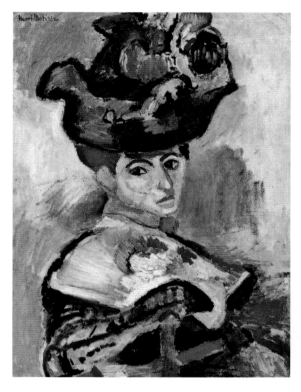

Original Painting

YELLOW IS EASILY OVERUSED

If your palette includes only white and yellow as light value choices, it is easy to overuse yellow. By premixing the custom mixtures just described, your work will include a variety of whites, enhancing contrast and interest in the work.

WOMAN WITH A HAT, CA 1905 / Henri Matisse / Oil on canvas / 31¾" × 23½" (81cm × 60cm) / Collection of the San Francisco Museum of Modern Art

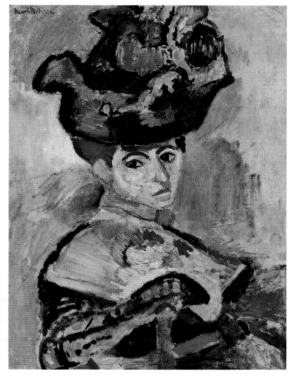

Altered Version

This painting is altered to illustrate an image with an overuse of yellow. This can easily occur by using a palette with minimal light value choices. Compare this to the original painting where a variety of light values make a more exciting image.

SOLUTION 5: CONVEYING YOUR PAINTING'S MESSAGE

This solution considers how to visualize and define what you are painting and how to best communicate your desired message. Your painting will communicate to a viewer in three ways: through your idea, through the medium and through yourself. For example, your idea or intent could be a landscape, a portrait, whatever you want to create. Once that's established, the choice of medium and how it is handled becomes crucial. The medium has a voice and this voice must be visible in the work. The third key element in painting is you—your inner spirit or personality. Your intent is a conscious idea while your inner spirit stems from a more subconscious influence. If you don't allow your inner self to come through, the painting may seem superficial. Too much emphasis on one aspect over the other can reduce the power of the work. The goal is to have each of the three aspects integrated in your work in such a way that they form one unified viewing experience.

CLARIFY YOUR INTENT

Your intent for your work can be as simple as a single idea to get a painting started or more complex, such as creating a prevailing mission for your life's work. It can be your point of view, your content, psychology or philosophy. It can be based on emotion, intellect, spirituality or experimentation. It can be a specific vision, such as painting a landscape or color field, or open ended and left hidden in our psyche to convey a collective unconscious or spiritual quality. An artist can have several compatible overriding intentions. For example, one intention can be for the work itself, another one regarding the relationship of the work to career, while another can be about prioritizing, for example, to help determine how much time and importance painting plays in your life. An artist's intent is as personal as the work itself. Artistic intentions can change for each new work, each new series, or over a longer course of time, marking important life changes.

Take the necessary time out from painting to periodically think about and clarify your intentions. It can help keep you on your path and improve your ability to articulate about yourself and your paintings to potential galleries or clients who may show, sell or purchase your work. Clarifying your intent can help with writing tasks such as updating text for your artist statement, résumé, portfolio, blog or website. Even if you are a mature professional painter, setting up a regular practice of clarifying your intent can improve your attitude and progress. If your intent is unclear or you are in between ideas, don't rush clarifying and jump to something definitive too soon. Allow a gradual process to formulate them using the suggestions in this solution. Here are some tips on pondering and writing about what you are painting and why.

Make a Personal Word List

Cut out images from magazines and browse through favorite art books or online art sites to find pictures you like and/or feel are compatible with your work. While looking at them, write down any words that come to mind without judging or overthinking. Try to include as many adjectives as possible. Keep at it until you have a long list of words that might describe your inclination, preferences and artwork. For mature artists, hang or place as much of your work around you as the space can hold. Include both current and past artworks. Write your list of words while observing your work. However, it may still be helpful to use found images from outside sources to see what pictures inspire you now.

Write an Artist's Statement

The process of writing can assist to clarify your ideas. Even if you already have an artist's statement, it is best to rewrite new ones from scratch every so often. There are two ways to approach writing your artist statement. A standard method begins with an outline using your main ideas to be organized before you begin to write. The method listed here is a bit unorthodox and uses an intuitive approach. Start by making a list of contemporary artists whose work you admire. Then go online and search for artist's statements from their websites, catalogs or gallery sites. Select keywords from their statements you feel an affinity with, and add them to your word list. Then juggle and combine your word list until

phrases and eventually sentences start to emerge. For more phrase ideas, go back to the images used previously and describe them in writing as if you were an art critic, friend or fan.

Here are a few phrase suggestions to complete:

- I like pictures about …

- I enjoy painting because …

- I want my paintings to affect people by …

- Painting is important to our culture because …

- Painting is important to me because …

- When someone views my painting I want them to say/to feel/to imagine/to ask/to enjoy/to notice …

Once you have assembled several phrases or sentences, organize and regroup them by ideas to form paragraphs. For instance, group all the phrases together that describe technique. Another paragraph can be based on concepts, and another on your background and experience. Don't try to make your statement perfect; just getting one started is a big achievement. Remember, painters like to communicate with visuals rather than text. Yet by struggling with words we can gain self-knowledge. Your artist statement can describe your style, the types of imagery you use, your medium of choice, special techniques you employ, sizes you prefer, and most importantly, any way to identify your work or anything about your work that is unique to you.

Using your statement as it is at this point, create two separate versions, one that is consistently speaking from the first person and one from the third person. A first-person statement uses "I"—*I like to paint landscapes to convey* … The third-person statement sounds like someone else is writing about you—*(insert your name) uses landscape imagery to convey* … Professional artist's statements are usually in first person, but writing an additional version in third person may enable you to reflect differently on the text and ideas you are trying to express. Third-person statements are used for press, PR and bios.

When to Change Gears

Having consistency throughout our work is important, yet when our images become too repetitive, we do not grow as artists and the work can weaken. It was said that Robert Rauschenberg created something odd and extraordinary nearly every day for sixty years. Extreme diversity such as that would require a lot of energy and drive, only suitable for a select few. Conversely, if we are too intent on variety and never willing to repeat an idea, we may be missing an opportunity to take our concept to a deeper, more personal and more meaningful level.

How do we know when to stick with a concept and when to move on? As artists we need to constantly balance commitment with change. Pay attention to how you feel. As our needs change, our feelings let us know. Sometimes we may need variety and experimentation to take us out of a rut and reenergize our work. At other times we may hit on something that really gets us excited, and we want to explore it more deeply. Taking time to evaluate our evolution and to write about it will help us to know which way our path is taking us.

LET YOUR MEDIUM INSPIRE YOU

Choosing unusual nontraditional materials, such as this metal truck hood, starts the ideas flowing for Lewis and assists in her intent to create nontraditional imagery.

CERULEAN BLUE HOOD / Deborah Lewis / Reclaimed metal truck hood with ceramic tiles and cement / 24" × 42" (61cm × 107cm)

THE VOICE OF YOUR MEDIUM

Your choice of medium plays a significant role in your work. Whether it be watercolor, drawing materials, oil or acrylic, the medium's personality should be clearly visible. The more mastery you have over your medium, the more its presence can be included. Mastering a medium requires time and practice. At a mastery level you feel a connection with your medium, a familiarity with the way it moves, mixes, dries and influences your decisions.

Getting to mastery level is a worthwhile goal. In his book *Outliers*, Malcolm Gladwell theorizes that any field, task, hobby or career requires 10,000 hours of practice to reach mastery level. We don't all have the good fortune to be at that stage, yet the idea of collaborating with our materials can still be part of your practice. Collaborating with your medium is like allowing it to master you, instead of trying to master it. By being more of a servant to the medium, you can pay appropriate homage to its voice in your work. As an example, Jackson Pollock allowed his paint to pour and drip, and collaborated with his medium (car paint) to such an extent it became his signature style. He got out of its way to allow the paint its optimal voice.

Collaborating with your medium is similar to having coffee with a friend. Think of painting as a collaborative conversation. Show up to your painting sessions willing to let the paint have some say in the process and let go of having too much control. Play with this idea to see how it can work with your current process and style.

Mechanical or commercial surfaces, such as an overall grid from a canvas weave, reveal an equal pattern under thin paint. With no hint of a brushstroke anywhere, it can look like a digital print on canvas. Thinly applied paint may be suitable for watercolor, where the paint is often applied onto a high-quality paper or other absorbent surface, but it's not the same with oil or acrylic. Diluted oil and acrylic paints can make great underpaintings or first layers. But left as is, uniformly thin all over with no other paint layers or applications added, the medium's voice may feel weak and unappealing.

Some abstract expressionist painters such as Helen Frankenthaler and Morris Louis used diluted paint on raw canvas. However, they further expressed the paint's personality by pouring multiple layers of paint to create variations in the paint quality and add tactile qualities to the painting surface. Parts of the raw canvas remained unpainted, expressing the personality and surface quality of the canvas itself.

ALLOW MEDIUMS THEIR FULL RANGE

Franz is playfully collaborating with watercolor, allowing the voice of the medium to have a strong and visible presence. You can actually feel the watery quality in the rippling edges of forms.

MORNING GLOW / Ming Franz / Watercolor on paper / 14" × 11" (36cm × 28cm)

YOUR INNER SPIRIT

Our paintings naturally contain messages from our inner self. Our inner state of being, attitude, personality or spirit appears in the work whether we are conscious of this taking place or not. These messages can be blatant or subtle and help to attract a viewer and extend viewing time toward a deeper experience. The idea of revealing our true selves in the work can be scary, yet is the magic ingredient that allows a viewer to connect to us through the work. Recognizing this fear can release it and help to keep us from hiding our true selves. Create work without trying to hide or veil your inner self for fear of being exposed. Make a conscious effort to bring your inner spirit into the painting's content, to strengthen your message and give the work a stronger presence.

I heard an interesting theory that the backgrounds in paintings express the painter's inner self, while the forms or foreground (for example, objects in a still life, brushmarks and gestures in an abstraction) symbolize the painter's outward personality. This can prove to be a helpful concept to analyze unconscious intentions and hidden stories in a work. Try this for yourself. Observe your work for the relationship of forms to background space. Which are more prominent? How are you portraying your personality through the forms and your more private inner self in the background?

In 1942 Hans Hofmann was introduced to Jackson Pollock. While in Pollock's studio, Hofmann looked around, and noting there were no still lifes or models that Pollock was using for reference, expressed dismay that Pollock was instead working from his heart, not from nature. To which Pollock responded, "I am nature." I like to use this story as a reminder that our inner self is

ORCHESTRATING COLOR AS MUSIC

Kandinsky felt that color, just by itself, can hold emotional and spiritual meaning. He associated color with sounds and music. For him, blue was a low bass note while yellow sounded like a shrill canary. He felt these sounds could shift depending on what shape contained the color. For instance, a shrill yellow sound will soften when used in a circle, while becoming even more shrill when used in an angular triangle.

YELLOW-RED-BLUE, CA 1925 / Wassily Kandinsky / Oil on canvas / 50" × 79" (127cm × 201cm) / Collection of the Museé National d'Art Moderne, Paris

naturally incorporated in our work. Pollock, while painting, attempted to completely let go of control, becoming more of a conduit, allowing spirit to flow through him, his tools, his paint, and ultimately expressing this idea of nature or inner spirit in the finished work.

The idea of spirituality in art was built into early concepts of modernism and abstraction. Considered the father of modernism, Russian-born painter and art theorist Wassily Kandinsky said, "The artist must train not only his eye but also his soul." I agree. No matter how technically proficient and skilled your painting becomes, no matter how innovative and original your ideas are, if your own individuality—your soul and spirit—are not included, the work will feel deficient. Kandinsky's book *Concerning the Spiritual in Art*, written in 1912, was influential to many artists at that time and still to this day. This book may have been one of the first to attempt a theory on spirituality and its relationship to abstract painting.

Some contemporary artists—as well as practitioners in other arts such as yoga and meditation—continue this notion of encouraging a connection to a higher self, place or source. As painters we can choose whether or not to emphasize or overlook the idea of spirituality in our work.

Contemporary artist Sam Scott nurtures spiritual qualities in his paintings. He sees painting as a tangible expression of the painter as a sentient being and so takes measures to be in a certain meditative state or frame of mind to paint. Inspired by Scott, I have also acquired some painting habits that help establish a meditative quality in my work. When I paint I see the canvas as a doorway, and with the image I paint on it, the painting can become an entry or portal for the viewer, with the potential to offer a transformative experience. I believe that encouraging a stillness, a time away from the normal reality viewing of our physical world, can propel the viewer into an alternate reality. While evaluating my work during the critical phase, I make a point of identifying qualities of stillness in the work to ensure these get enhanced and are not neglected.

EMPHASIZING THE VOICE OF YOUR MATERIALS
Gold metal, applied to the surface before painting, is left unpainted in areas, allowing the metal's unique quality and personality to shine through unchanged in places.

STONES OF FIRE #2 / Nancy Reyner / Acrylic and gold leaf on panel / 23" × 41" (58cm × 104cm)

Strengthen Your Spiritual Presence

Our disposition, thoughts, spirit and attitude all make up our essence, or individuality. While painting, if our mind is on autopilot or monkey mind (a cacophony of busy thoughts), our spirit's voice may get muffled. Find a practice, routine or ritual that allows you to get into the zone, a state of mind that is free from everyday concerns to paint. Have your setup organized, clear the space around your painting area except for current inspiration and reference materials, turn off phones and other distractions, and lock your door to avoid interruptions.

Stay centered throughout the day, even when not painting. Meditate, journal, walk or do any practice that helps you to get centered and calm. All those nonpainting tasks, such as a day job, child care, household chores, computer correspondence, business details and errands can be accomplished with focus, and good-natured intention. This helps prepare us and can make the most out of a specified painting time.

Painting in the zone allows your spirit to flow more easily into your brushwork, painting choices, ideas and process. Being in the zone enhances your passion and focus, while encouraging the presence of inner spirit in your work. When we are obsessed in the making, we gift a piece of ourselves in the artwork.

Embrace Your Imperfections

As painters we often struggle in the process of making a painting. This struggle can show up as imperfections like erasures, mistakes, etc. If we try to prettify and cover over these struggle areas, we may be missing an opportunity to reveal something interesting about ourselves. In Kimon Nicolaïdes's book, *The Natural Way to Draw*, he instructs students to draw a perfect circle, and he notes that wherever imperfections do appear, this is where our personality shows through. Initially set intentions for perfection, and do your best. Then let go, knowing that any so-called mistakes, as opposed to design issues discovered by critique, may well be seen by the viewer as creative originality.

REVEAL YOUR INNER SPIRIT
Painting can offer a snapshot of another reality. The more we allow our inner self to be included in the work, the more imaginative the work can be.

DRAGONFLY / Stephanie Law / Watercolor, silver and gold leaf on paper / 10" × 10" (25cm × 25cm)

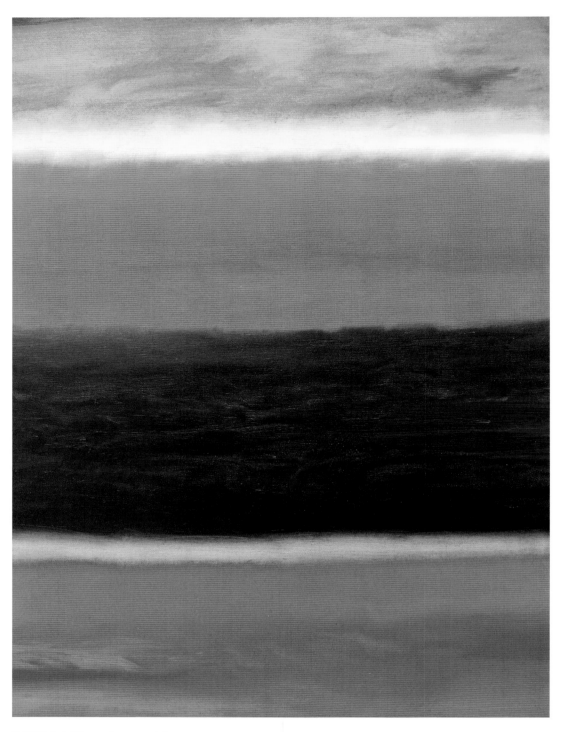

MANTRA 4 / Vezna Gottwald / Oil on canvas / 28" × 22" (71cm × 56cm)

SECTION 5

BONUS TOPICS FOR ARTISTS

The previous section offered ways to resolve issues directly in the work itself. It also provided additional methods of critique to complement and highlight the analysis process of The Viewing Game. As painters there are times when issues arise that are not directly related to a particular painting. We may crave new ideas or alternative ways to think about why we paint. This bonus section provides additional information for artists' needs such as career aspects, creative blocks, displaying work, clarifying ideas and even ways to think out of the box for new inspiration.

VIEWING, DISPLAY AND FRAMING

Did you know that viewing paintings can make us happy and has healing benefits? According to Dr. John Diamond in his book *Your Body Doesn't Lie*, looking at a landscape painting raises our levels of well-being, balances right and left brain hemispheres and increases vitality. Interestingly, Dr. Diamond's findings conclude that the benefits are highest when viewing landscape paintings as opposed to landscape photographs or other types of painting imagery.

Spend time viewing art by others for an uplifting experience, to get new ideas and to gain insight into your own work. Playing The Viewing Game with other artists' work will strengthen your critical thinking and perception, and you may notice that your preferences for visual tension change as well.

How to View Art

While watching a film or listening to music, these works of art unfold to our eye or ear in a linear fashion. Both movies and music performances require a fixed amount of time to watch or hear them from start to finish. With a painting one might falsely assume the image is viewed differently by absorbing it all at once. On the contrary, a painting requires a similar linear process to view the work completely. The average time a person looks at a painting is three seconds. A careful, thoughtful viewing should take much longer. By slowing down the viewing process, it is possible to feel as though our eyes move through the work like they're on a road trip.

In a museum, my energy for viewing lasts for only about one and a half hours. After that everything is a blur with little brain space left to soak in more. I often begin my museum adventure by quickly scanning the entire show, searching for the one painting that most gets my attention. While my energy is still fresh I remain in front of that painting for a long period of time, sometimes twenty minutes or more, to soak it in on an emotional level. Museums often curate a show with specific educational messages written on display cards, which I save for after viewing to avoid too many influences.

In a museum or gallery you may discover work you dislike. It may feel unfinished, unattractive or of little significance. Simply being framed and on display in a public venue does not mean a painting is of high quality. People are diverse and so are paintings. There will be some art we prefer and others we don't. If you don't like it, just move along until you find a piece that gets your attention. It's more fun to keep searching for work that interests us than to spend time with ones that don't.

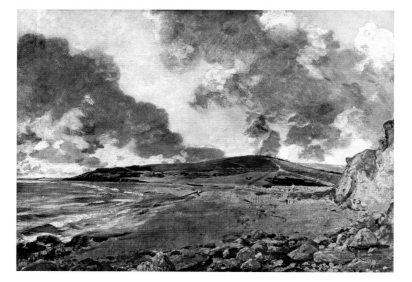

VIEWING WORK BY GREAT MASTERS

When looking at historic work it is good to remember that a really great work of art will usually transcend time and connect to our human spirit in some way.

WEYMOUTH BAY, CA 1816 / John Constable / Oil on canvas / 21" × 29" (53cm × 74cm)

On the other hand, there are times when it pays to investigate art you dislike. While viewing an historic master's work with contemporary eyes it may not reveal what made it great in its day, unless we are well read, or have donned a pair of headphones (one of the many benefits of educational museums). Art museums, in general, collect art within a specified mission, and in some cases, a particular historic period. Museums may only have the resources to purchase lesser quality works by a master artist they want to exhibit. Great masters, like most artists, created a wide variety of works in a lifetime. It may be hard to believe that an artwork by a designated "master" is not a masterpiece. Matisse kept only one drawing out of every one hundred drawings he made, throwing the rest away. Thanks to museums and their continued mission to collect art and educate the public, we are able to view a wide range of art and gain new knowledge about our culture, art and history.

Optimal Display

As painters we can make the best work possible, yet it is up to the viewer to receive any benefits from viewing. A viewer can be more encouraged to put in the necessary viewing time and effort when display conditions are optimal. Here are some ideas to facilitate this.

Evaluate your paintings up close as well as from a distance to see if and how the viewing experience changes. When a painting encourages a viewer to move around, back and forth, to view the image from different angles and perspectives, it can encourage the viewer to gaze longer. Some artists, like Chuck Close, purposely use this aspect as a significant part of their work. Perhaps this may be something to consider for your work.

As you view your painting from difference distances, measure its optimal viewing distance, where you feel your image will be seen at its best advantage. If possible, place seating furniture at that location, facing your

DISPLAY YOUR WORK FOR OPTIMAL VIEWING
A meditative and subtle painting such as McCoy's is best viewed on an uncrowded, uncluttered, neutral-colored wall with extra space between it and other art or objects, and illuminated with strong and direct-focused light. Having ample space around the work will help set it apart, bring focused attention to the work and allow its meditative quality to be optimally experienced.

TWO VORTEXES (FROM SACRED GEOMETRY SERIES) / Marcia McCoy / Oil on paper (monoprint) / 40" × 26" (102cm × 66cm)

CREATIVE DISPLAYS
Thinking outside the box (literally), this unusual and creative display changes the viewing experience dramatically. Together the painting and chair can be considered an installation.

ANIMA MUNDI: PRIMORDIUM / Vicki Teague-Cooper / Encaustic and oil on linen over panel, and gilded wooden child's chair / 25" × 14" × 13" (64cm × 36cm × 33cm)

work in the exhibition space. Georgia O'Keeffe certainly recognized the importance of how work is displayed when she mixed her own custom gray color for walls where her work was hung in Alfred Stieglitz's New York gallery.

Framing Tips

A finished painting may or may not need a frame. Framing acts as a segue between the image and the style of the room where it is hung. A frame can change visual tension. For example, traditional imagery can be reinforced with a traditional frame or made more contemporary without a frame.

Contemporary paintings often look better without frames but can still benefit from creating a finished look

by painting the sides. As a viewer approaches a painting hanging in a gallery or museum, they will most likely see the painting's sides before viewing the image on the front. The sides will create a foreshadowing, preparing the viewer in advance for the impact of the picture's image. Therefore, if painting the sides, avoid using a color that is dramatically different from any color in the image. For example, if a painting is very subtle in color palette and the sides are painted stark black or bright red, it will give the viewer an abrupt jolt to the viewing experience that may take away from the artist's desired effect. Paint the sides with a color that is harmonious to the image's overall color scheme. It's best to wait until

THE TRANSITIONAL EFFECT OF FRAMES

Frames offer an aesthetic segue from the work to its display space. Here, religious icon paintings each depicting a saint are custom framed in a way that unites them with the church environment where they have been installed.

FOUNDERS SHRINE / Leslie McNamara / Acrylic on panel with wood frame / 8' × 35' (2m × 10m)

SPACING INFLUENCES VIEWING

These blue squares illustrate how different spacing between paintings can influence viewing. The two middle squares will be viewed as a diptych because of their close spacing, while the squares on the far left and right appear independent.

In the second example the three green squares are spaced far enough apart to be viewed as separate works.

the painting is complete before contemplating the best approach to painting the sides.

Some painters "wrap the image" by continuing the painting's color and imagery along the sides. This can cause the painting to look as though it is a box wrapped in wrapping paper, and may spoil the impact of any spatial effects within the image.

The best way to paint the sides of a painting is to first select a predominant color in the painting. Then mix a duller version of it by adding about 20 percent black and 30 percent white paint into the color and using this to paint the sides.

Signing Your Work

Signing is a very personal choice. Some painters use full signatures, others use initials, while some create a graphic symbol. For minimal or color field paintings, it may be best to sign on the back to avoid competing visuals. When signing on the front, place the signature carefully to avoid changing visual movement and use a color that is not brighter or bolder than anything used in the work itself. Some painters choose to make their signature the most prominent aspect of the image, which I feel can be annoying to the viewer.

Hanging Tips

Standard hanging height for paintings measures 57 inches (145cm) from the floor to the center of the painting. Use this as a starting point and not a rule. For instance, hanging a painting in a space with high ceilings and sparse furniture, often common in gallery settings, may require a higher hanging height, while a room with low ceilings may necessitate a lower hanging height. Paintings hung on a wall in a row should have some relationship to each other. For example, the bottoms or tops could line up with each other. Avoid hanging paintings too close to visual distractions such as light switches, signs, lights, etc. Experiment with spacing, ensuring that each painting has appropriate space or breathing room. If there is too much space around a painting, it may feel lost or as if it is floating on the wall. Too little space can feel cramped.

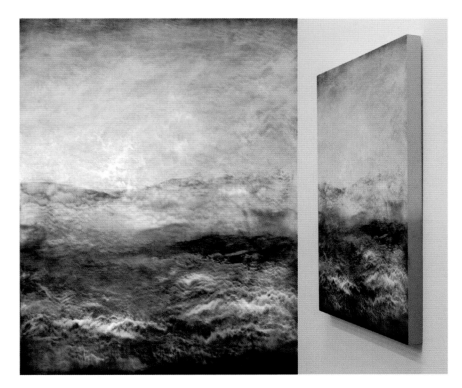

PAINTING THE CANVAS SIDES

This painting changes in value from the light sky at the top to the dark ocean at the bottom. I remixed three predominant colors for each section, muted them with white and black, and used them to paint the sides with subtly blended gradation. Without including all the detail from the front image on the sides, the wrapping issue is successfully avoided.

BRONZE OCEAN / Nancy Reyner / Acrylic on panel / 40" × 30" (102cm × 76cm)

TOPIC 2: FREEING A CREATIVE BLOCK

If you find yourself stuck and not able to work productively, you may be experiencing a creative block. We all encounter these pitfalls along the creative path. Creative blocks are triggered by a variety of causes producing an inability to take action. Our creative energy is like a moving river that flows through our mind, heart, body and soul, corresponding to our mental, emotional, physical and spiritual centers. Each center occupies its own space with connecting paths to each of the others. Just as fallen trees or boulders can jam up a river's path, our creative flow can get stuck with too much inner clutter. Fears and insecurities sustain old patterns and beliefs that may no longer serve us, creating inner clutter not at all helpful for creativity.

There's a myth among some non-artists that making art is all fun and fluff. Not true! Alone in the studio, immersed with your inner thoughts, making art can be uncomfortable, challenging, intense, exhausting and frightening. Making art often entails inner discoveries, digging up past hurtful issues and facing the fear of the unknown. Georgia O'Keeffe once said, "I've been absolutely terrified every moment of my life— and I've never let it keep me from doing a single thing I wanted to do." Like Georgia, we can move forward by being brave, setting intentions and soothing fears to unclutter our vital centers.

Inaction results from two opposing thoughts active in our mind simultaneously. One thought may be telling you what you really want to do, while the other speaks to you from past experience or past fears and wants to stop you. Usually one thought is conscious and the other unconscious (the outer voice as opposed to an inner one). If both voices are strong on the same topic in question, a contradiction between them causes our brain to take an inactive stance.

"I'VE BEEN ABSOLUTELY TERRIFIED EVERY MOMENT OF MY LIFE—AND I'VE NEVER LET IT KEEP ME FROM DOING A SINGLE THING I WANTED TO DO"

Georgia O'Keeffe

Here are a few ideas to help with some common types of creative blocks. When the need strikes, try whatever feels right for you.

The first exercise allows us to reconnect with our inner voice called "first thoughts." It may take several attempts of this exercise to begin to hear our inner voice again and even more time to start taking action on it. Once we start taking action on our first thoughts, we break the habit of contradicting our true motivation. Most worthwhile remedies are about breaking the spell of inaction.

Tap Into First Thoughts

This exercise takes approximately twenty minutes and is based on Natalie Goldberg's *Writing Down the Bones*, written for writers, encouraging stream of consciousness, and is here adapted for painters. Do this once a day for ten days in a row.

Obtain ten inexpensive painting surfaces such as scraps of canvas, sheets of paper or cardboard. Prepare the day before by gathering all the supplies. Set up one of the surfaces so it is ready for painting. Do not preplan what you will paint. The next day, begin the exercise by standing in front of your materials and surface, and ask yourself the question, "What do I want to do first?" Take a moment and pay close attention to the first answer that comes up. This is your first thought. The question asks only for one simple action. Do not try to think any further or plan ahead for any final outcome or results. Stay open and receptive. Take immediate action once you get your answer, no matter what it is. Your first thought might sound silly and childlike, as in "I want to splash bright orange paint all over." Do it anyway.

Your first thought presents your true preference and inner voice, which tells you what you really want to do. After this first action is completed, continue asking the same question, looking at the exercise in process and

attempting to catch your first thought before the louder, more controlling "parent" or second thought takes over. We get so accustomed to ignoring our first thought, and instead we listen to and take action on the advice from our second. The second voice says things like "Are you out of your mind? That orange paint is expensive, and that sounds like a stupid idea. How about a nice landscape using green instead?" Our second voice is good at judging, denying and objecting.

After twenty minutes, move the painting exercise away and out of sight to avoid influencing any other painting work you do that day. You do not need to look at the exercise, or analyze it. It's only an exercise, not for critiquing. Leave it alone and proceed with your regular studio work, forgetting all about the exercise.

Repeat this each day. As you progress, keep piling up the exercises one after another without reviewing them. The exercises themselves aren't meant to create great masterpieces but to strengthen your ability to make clear painting decisions among other benefits, often including an increase in production and less frustration. After ten days you can throw them all away or cut them up for collage pieces. It is not a waste of materials and time to

work through issues, change habits, renew your process and heal your creative block. This exercise will bring new awareness to your inner voice and intuition.

For extra credit, while doing this exercise notice any mind tricks that come up. Mind tricks are thoughts designed by your brain to keep you from painting. Common mind tricks for this exercise are "What should I paint?" or "I have more important things to do" or "I'm no good at this!" Just notice the thoughts and paint anyway. Paint until it's all mud, paint no matter what it looks like. Just paint. And at the end of the designated time, you are finished. No need to judge the painting exercise, but it can be fun to reflect on any mind tricks that may have come up.

One student who decided to try this had much difficulty. She got all ready the day before, started the exercise and then just stared at the blank painting surface. She told me she felt like a failure because she did nothing. First of all, she did a lot. She got ready and showed up. That's something! For the second day she was to remind herself the task has nothing to do with pre-planning for an idea. All that is required is to put paint on a page for twenty minutes, then optionally throw it away. The exercise is not about making a painting, only about breaking the spell of nonaction. Once you get back into the swing of painting, keep in mind that creative blocks can emerge if we push ourselves too hard or rush our process, moving too quickly into a critical phase. Take the time you need in the play phase as this is often where our inner voice can be as loud as it wants.

Hire a Creative Coach

Specialized counselors such as creative coaches or life coaches can help focus and analyze creative issues. A series of sessions may be of benefit. Shop around to find one who fits your style and budget. Ask for a free preliminary consultation to test your comfort level with this person. If personalities don't mesh and you feel unable to speak freely about yourself, keep looking. If possible, find someone local so you can have in-person sessions. Online coaching may not be personalized enough. If you have an unresolved issue not related to your creative work, but one that interferes with it, then a general therapist or counselor may help resolve the issue and free up your energy.

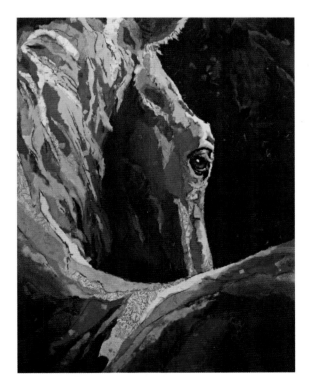

MIDNIGHT / Michaelin Otis / Mixed media and acrylic on canvas / 40" × 30" (102cm × 76cm)

Be Your Own Therapist

This is one of my favorites. Find some time in your schedule where you can be alone in a quiet place for ten to fifteen minutes. Place two chairs five feet (1.5m) apart, facing each other. One chair is designated as "the client" (right brain), and the other chair represents "the analyst" (left brain). Start by sitting in the analyst chair and ask a question out loud. Ask the first question that comes to mind. Here are some suggestions, but always go with your first thought. "Why am I feeling down?" "What would I rather be doing?" "What's bothering me?" "How am I feeling?" Pick one question and voice it out loud. Move immediately to the other chair then answer with your first thought, again out loud. Alternate by going back and forth between chairs, continuing to use the analyst chair to ask a question and the other chair for the answer. Don't think too hard. You may surprise yourself at the honesty of the answers as you create a dialogue between your inner and outer selves. This can be as satisfying as a session with your therapist, but costs nothing except ten minutes or more of your time and can often be more revealing, healing and insightful.

An alternative to this do-it-yourself method of therapy is writing instead of asking questions out loud, and by switching hands instead of chairs. Take pencil and paper and write the analyst question with your main hand. Then switch the pencil into your nondominant hand to write your answer. Writing with your less dominant hand may be illegible, but that is not important as you will "hear" your answer while you scribble. Continue alternating hands to further the dialogue as necessary.

Take a Break

Sometimes we're just simply tired! If you've just finished an extensive project such as a solo show or commission, you may have what I call "post-project-downer," a mild depression and lack of enthusiasm immediately following a project's completion. Do something else for an afternoon, weekend or week. A break could be a simple activity you enjoy or something more expansive such as taking a trip. It can be art related or not. Watch a movie, make an ice cream sundae or get into bed early with a good book. When our mind is completely off duty, we get our best inspiration. There's a myth that to be a good painter we need to be painting all day every day, so taking any breaks can cause guilt. Artists need time

to gather resources, let life soak in, think about things. In general we have about four good painting hours each day. Continuing to paint after that often destroys any previous progress made. If you are tired after painting for a few hours but want to remain in your studio, don't force yourself to paint. Instead put on some fun music, stretch and prime surfaces, clean brushes or reorder your paint shelves. Just being in your studio can keep your creative thread alive and still feel like a break.

Make a Routine and Stick to It

Sometimes we just need a structure. Write down a plan for yourself that involves which days and times you will paint. This way you can mentally plan ahead. If you don't have enough energy while painting, are you picking the best time of day to paint? If you feel paralyzed by freedom, introduce even more structure and order to your routine. When routines feel too constraining, make room for improvisation. Life's daily requirement of "stuff management" can be overwhelming. Gallery exhibitions require preparation, commissions have deadlines and day jobs have schedules. Identify those things that are energy draining and unnecessary and eliminate them from your life. Then give yourself a realistic goal towards balancing obligations with creative needs. Turn off your phone and computer for a specified painting session. Let the world wait while you focus on your work.

Some priorities such as caring for ill family or friends may require taking time off from painting. If the obligation requires extensive time frames, schedule smaller amounts of painting time. Even one hour of painting every two or three days each week can keep your creative juices alive without adding stress.

Sometimes we let "stuff management" become a priority in order to avoid painting. In that case, push yourself to get to the studio and paint even if you don't want to, enduring any pain and fear you may have about your work. Change old habits and patterns of avoidance. When you do have a productive day, observe and keep a journal of what worked to improve your routine.

Find Support

Join a supportive art community or start your own. Get you and your work out in public, look at art and find new ways to exhibit and participate in local art events like studio tours. These activities can add incentive and get

you back into your work rhythm. Or apply for an artist's residency to mingle with other artists, changing your environment and routine altogether.

Know Your Limits

Physical issues such as health problems or injuries can affect our physical body, energy and capability to work. Be as kind to yourself as you would be to a close friend. Physical suffering is not valuable to the creative process.

Improve Your Workspace

A dysfunctional work environment can cause frustration and lack of motivation, and keep you from working productively. Clear your work space so you have enough room to work. Visit other artists' studios for ideas on organizing and other space-saving, efficient setups.

Don't Skimp on Supplies

Being stingy with materials may feel like you're saving money, but it doesn't pay off in the long run. Low-quality materials can put a damper on creativity and rarely offer satisfactory results. Insufficient supplies may result in a lack of surface quality and a weak voice for your medium. When finances are a concern, save costs elsewhere.

Soothe Your Fears

Our mind plays tricks, generating negative thoughts based on fears to keep us from our work:

"Will my work be adored or ridiculed?"
"Sales aren't happening so why bother making art?"
"I don't have enough technique to paint well."

Perhaps you have experienced negative criticism in the past about yourself or your work. Revisit the "Meet Your Audience" section on page 20 about finding appropriate audiences for your work. You'll never please all the people all the time. There are times when painting is a battle making us doubt our abilities. These doubts usually occur when we are ready to go deeper into our work or are bravely trying something new. As van Gogh once said, "If you hear a voice within you say you cannot

paint, then by all means paint, and that voice will be silenced." Realize that tough spots and creative blocks happen to everyone. Don't allow fears to keep you from doing your work. Grab a paintbrush and paint anything—it doesn't matter what. The act of painting changes the old fear-based program to a new healthier one.

Keep It Simple

Sometimes we fear not having enough ideas. Yet too many ideas can be overwhelming. It's okay to trash some, as not all our ideas are worth bringing to fruition even if they seem exciting at the time. Some ideas are merely stepping-stones toward other ideas more akin to our intentions. I write down my ideas as they come yet am inspired to paint only one out of every thirty or forty ideas. Too many techniques can get in our way as well. The Old Masters didn't have the variety of tools and materials we have today, yet they made masterpieces with a smaller range of paint colors using good old-fashioned traditional painting techniques.

"IF YOU HEAR A VOICE WITHIN YOU SAY YOU CANNOT PAINT, THEN BY ALL MEANS PAINT, AND THAT VOICE WILL BE SILENCED."

Vincent

Practice Positive Thinking

When your mind thinks negative thoughts to keep you from painting, override them with new positive thoughts. Verbalize the opposite approach out loud to any excuse your mind invents. For example, if you find yourself thinking your work isn't good enough, state loud and clear, "My work is great and I am a great artist." Even if you don't believe it now, it will redirect you on a more positive path, one that encourages you to work rather than to avoid it. We are empowered beings with the ability to control our lives more than we realize. We have a say in what happens to us through our thinking.

Don't Obsess About Perfection

Strive to make each painting your best rather than a perfect masterpiece. Do the best you can, then let it go at some point and move on to your next painting. Knowing when to let go is one of the benefits of using The Viewing Game to analyze your work. Make your painting right for you, not to fit someone else's ideal of perfection.

TOPIC 3: DISCOVERING NEW IDEAS

As painters we experience peaks of high production as well as dips and valleys when ideas have run their course. The dips are perfect times to seek new ideas. New ideas mean taking risks. Albert Einstein once said, "A person who never made a mistake never tried anything new." Here are suggestions to think in a new way and do something different.

Let Your Ideas Evolve

Think of your first idea as a seed. By the time it has taken root and developed leaves, the seed itself no longer exists. Our first idea gets something started on the canvas, but at some point it may need to disappear. Letting go of our initial vision can often shift the work into a deeper version. When it's time for this shift, put all previous reference material out of sight, allow liberal changes to be made by overpainting as needed.

Create Something Different

Galleries often encourage artists to keep creating the same thing over and over again. Repetition like this enables the gallery to use consistent marketing. However, artists in general need freedom with their creativity to stay motivated and inspired, both consistency and variety are necessary for an artist's evolution. Consistency in the work allows us to keep experimenting with one particular idea to take it further. Chuck Close is a good example of this with his consistent theme of portraits and evolving them into even more amazing images. But when it's time to change your process, find new reference materials, try unusual tools/applications/ materials, try new styles or mediums, or switch to your nondominant hand to paint.

Relish Alone Time

Even though it can be helpful to take an art workshop to learn a new technique, it is important to savor working alone. Being alone is when our greatest fears, hopes and desires make themselves known but also when we invent our own techniques. When you work without outside influences, you can discover your true intent. There are some artists who feel they can be productive only in a workshop environment, and in this way workshops can be an addiction. If you find yourself in this situation, plan a full year with no instruction, painting on your own to allow more of your intent to develop into the work, with less distraction and other people's opinions to influence you. Once this goal is achieved, then take a one-day, one-week or weekend workshop during the following year to add something new and get reinspired. Know when a workshop can be helpful and when it is instead encouraging avoidance. We often have enough skills to paint what we want to paint without continually having to add new techniques.

Ask a Question

A question can get new ideas rolling. Try completing the open-ended phrase, *What would happen if* ... using spontaneous answers such as:

- "... I used colors I have never used before?"

- "... I paint whatever comes to my mind while painting?"

SELF-PORTRAITS IN OIL (DETAILS) / From left to right, Vincent van Gogh, Francisco Goya and Judith Leyster

SELF-PORTRAITS

Throughout history painters have been conveniently using themselves as models. When in doubt paint yourself! These self-portraits dating from the eighteenth to twentieth centuries are the original selfies!

- "... I let music inspire the colors and forms I choose?"
- "... I combine several images in my head into one painting?"

Work Within a Series

A series can be as simple as painting on three or more surfaces during the same painting session or in succession. Images in a series usually share one or more aspects such as color scheme, figurative elements or size. A series can allow a single idea to expand in scope. As an idea, start with several small surfaces. Arrange them so they are all accessible on your worktable at the same time so you can paint on all of the surfaces at least once during the same painting session. Start painting on one surface, until you feel like switching to the next. Keep time intervals short. Set a timer if you prefer. Switching from one surface to the next encourages working fast and more spontaneously. This process gets your creative juices flowing to work through many ideas quickly.

Recycle Your Work

Cut up unfinished work or failed sketches into small pieces. Reassemble the pieces together in a new way for new ideas or glue them down as a collage. Destroying unwanted, unfinished work can be a powerful ritual of letting go and nonattachment.

Use Reference Photos

Photographs can be of great assistance to launch new work or assist a work in process. Your personal photography, art books, postcards or magazines can help to inspire new ideas. Working too closely from a photographic reference, however, can have some negative repercussions. A camera's lens is curved, which dramatically changes spatial qualities in a photographic image. Central forms get pushed back, while forms on the side come forward. A painted image copied directly from a photograph can lose spatial depth and focal interest.

To keep your painting fresh and original while using photographs, pick out at least three photographs to use as reference for a painting, instead of just one. Each photograph can contribute a different aspect to the work. For instance, one image can inspire your color palette, a second image may have an interesting composition, while a third offers ideas for forms or shapes. Use and combine all three in one painting. This way your imagination stays active, free to add, edit and transform the images into something original. This may result in a final painting with a complete surprise, veering dramatically from any of your original references. See other examples of using photographs as reference in "Flexible Processes" on page 35.

MANTRA 1 /
28" × 22"
(71cm × 56cm)

MANTRA 2 /
28" × 22"
(71cm × 56cm)

MANTRA 3 /
22" × 16"
(56cm × 41cm)

MANTRA 5 /
22" × 16"
(56cm × 41cm)

MANTRA 6 /
60" × 48"
(152cm × 122cm)

MANTRA 7 /
60" × 48"
(152cm × 122cm)

PAINT IN A SERIES

Gottwald created a series of seven paintings, each sharing a similar concept of color field and horizontal bands. Six are presented here. The seventh is pictured full page on page 120 at the start of this section. Gottwald continuously chanted a specific sacred mantra (either Tibetan, Buddhist, Hindu or Sanskrit) for each painting during its creation.

All images by Vezna Gottwald, oil on canvas.

TOPIC 4: CRITIQUE EXAMPLES

Three paintings are documented here as they progress in stages using The Viewing Game's critique process to complete them.

Critique #1

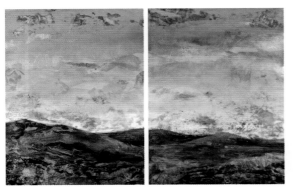 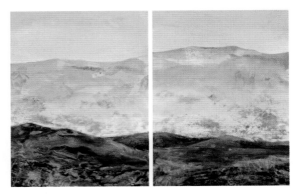

1 ANALYSIS

The diptych painting pictured here is at an appropriate point for critique. Here are the issues I discovered during the first round of analysis using the ten inquiries:

- Inquiry 1 (see page 50) revealed that all the lightest values are confined to the horizon line. Inquiry 1 also showed that the complementary pair red and green are too equally presented in a boring 50:50 ratio.

- The Flip 4 exercise in Inquiry 3 (page 62) revealed that the top or sky area feels too heavy.

- Observing focal points in Inquiry 6 (page 74) revealed that the focal points running along the top edge are distracting and too repetitious.

- Viewing the spatial qualities in Inquiry 8 (page 84) revealed an insufficient quantity of only two spatial planes—ground and sky—creating an uninteresting space.

2 FIRST ADJUSTMENTS

Here is the improved painting after making the following corrections:

- Added a second mountain range, and therefore a new spatial plane in the middle ground.

- Made the sky lighter.

- Removed the distracting focal points along the top.

After making these adjustments and analyzing the painting again, I found a new issue. Using Inquiry 1, I found that the darks are all segregated at the bottom while the lights take over the top portion.

3 SECOND ADJUSTMENTS

This corrected version shows the addition of darks into the upper area along the middle mountain range. A third round of analysis found further issues:

- Still not enough spatial planes.

- Feels weak along the top edge.

- Top third doesn't balance or relate to the dramatically weighted bottom.

4 FINISHED PAINTING

Here is the final painting with the previous issues resolved. Remember, finding problems and working through their solutions is part analytical and part personal. Some painters might have been satisfied with the first version as a finished painting. Others might have made different decisions along the way.

LAND PATTERNS / Nancy Reyner / Acrylic and gold leaf on two panels (diptych) / 16" × 24" (41cm × 61cm)

Critique #2

1 ANALYSIS

At this point in the process, the artist felt the painting was finished. Though after some time spent viewing it, she could feel that something wasn't right, that it wasn't as good as it could be. Her motto is "Never accept mediocrity. If you can make it better, do it. The point is to feel good." After contemplating the painting, she realized she didn't like the way the eye moves quickly to the bottom, with nothing to bring the eye back into the image. She noted the following causes of this issue:

- The woman in the painting needed to be lighter.
- More angles were needed in the bottom chaise.
- The forms felt disconnected to each other.
- The upper right and lower right quadrants were dead zones.
- The overuse of pale neutral colors with a lack of brights and lights gave no contrast and minimal focal points.

2 FINISHED PAINTING

After corrections, the image now contains an over-riding triangular shape connecting the woman's legs with the guitar and chaise legs. More contrast is added with stronger darks and lights, which also create focal points and movement within the image. Adding the portrait in the upper right helps balance the strong forms on the left.

INTERIOR WITH CHAISE / Gigi Mills / Oil, crayon, graphite on paper / 30" × 43" (76cm × 109cm)

Critique #3

1 ANALYSIS

Here is a painting at a point where I felt stuck. I used The Viewing Game to identify issues so I could move forward.

- Inquiry 1 revealed all the lights are segregated on top with all the darks on bottom. It also showed mostly cool colors with barely enough warm ones (100:0 cool to warm ratio).

- Inquiry 6 showed no eye-catching focal points.

- Inquiry 8 revealed not enough spatial depth. The image needed more planes and forms.

2 ADJUSTMENTS POST-ANALYSIS

These first issues have been resolved by adding a middle mountain range, more warm colors and better integration of lights and darks. A second analysis revealed new issues:

- Bottom feels heavy.

- Top feels too weak.

- Darks and lights are better integrated but are now presented in a boring 50:50 ratio.

3 FINISHED PAINTING

Use The Viewing Game to keep your thinking sharp, avoid getting stuck and validate your intuition about the work. Double- or triple-check for possible improvements. Remember that personal preferences and intentions for the work play an important role in critique. The Viewing Game is not a set of painting rules but merely a reminder of the many aspects to analyze in a painting, which might otherwise go unnoticed.

HIDDEN RAINBOW / Nancy Reyner / Acrylic on panel / 26" × 34" (66cm × 86cm)

TOPIC 5: CRITIQUE GROUPS

Evaluating your work in solitude has many advantages. Problem solving can be handled on demand, and you avoid the possibility of too much input from others. We don't always want or need a committee to do our work. On the other hand, critiquing with others has benefits. Listening to other artists comment on your work can offer clarity, inspiration and a broader viewpoint. Another added benefit of group critique is that we end up "mirroring" our own individual creative needs through commenting on the work by others. When one painter from the group makes a comment on another painter's work, it almost always turns out to be a key issue in their own work.

The Viewing Game is a method of critique for painters to use anywhere, anytime, in a group or on your own. While in a group you will have the opportunity to speak about your work, defend your viewpoint or participate in related discussions, improving your ability to articulate about art. Consider gathering together a few painting friends and colleagues to start your own critique group, or see if there are any already established in your locale to join.

Selecting Members for Your Group

It's best to make sure the opinions you are getting for your work are helpful and not harmful. It's not important to choose members who paint similarly, use the same medium or work in the same style. In fact, it is more productive to have a variety of artwork represented. What is important is that members share similar goals and understand the concept about different levels of visual tension. Keep the group restricted to practicing painters. Professional critics, gallery owners, friends, family and other non-artists may not be skilled at seeing paintings that are in process in an unfinished state. Keep the max number of participants to six. Add new members only when needed to fill a vacancy. This allows the group to become familiar with each other's work and creates a safe environment to talk on a deeper, more personal level.

Where to Meet

Select a location that is appropriate for viewing work. It could be a member's studio or a public space avail-able during off hours, such as a church, art center or community room at a local college. The space should be uncluttered and have adequate light. If any member works in very large sizes the group can opt to meet at that artist's studio on occasion to give that artist a break from hauling large paintings to meetings. Having easels or wall space for hanging is helpful, but chairs can also work for propping up work to display.

Structure Your Sessions

For best results have an initial group discussion to agree on rules, schedules, goals and procedures ahead of time. This way all participants know what to expect and can come prepared.

With no system in place for how a session will be run, it can drag on too long, one person can dominate the discussion, or the time is taken up socializing. Structures help to ensure that the time is well spent, offering productive feedback for all involved. Start with meetings lasting three hours once a month and see how that feels. Meet more frequently if all members are producing enough new work to warrant more meetings. Start and end sessions on time. Adhering to a strict schedule respects those who have other time commitments and responsibilities. Decide who will go in what order by drawing straws or by arrival order.

What to Bring

Have new work to bring to each new session, whether finished or in process. If in process, make sure the piece is developed enough for critique. Avoid work that is just in its beginning stages. Bringing more than one piece is helpful so if you have only one new painting, optionally accompany it with one or two earlier pieces for comparison.

The Group Critique Process

Clear space of all distractions, especially paintings and other images not being analyzed at that moment. Turn all paintings around so images are hidden from view until their time for display and discussion.

Each presenter takes their turn displaying only one of their pieces at a time while the rest of the group act as reviewers. After a full analysis of that one piece, the

same presenter continues with their other work until all they have brought has been analyzed before moving on to the next presenter. If an artist has several pieces to show, each piece is seen separately unless part of a series.

Once the presenter puts a painting up for display and before anyone speaks, a timer is set for one minute of silence. Reviewers will then have time to look at the painting without any outside influences or commentary from others. Most importantly, the artist stays silent during this viewing time. The artist doesn't need to tell their story. See if your work can speak for you. For best feedback on your painting, listen to what others think without your influence. At the end of the discussion for that particular artwork, the presenter can then add comments or answer questions if appropriate.

Reviewing Other's Work

Take the time to look! How does it make you feel? What is your first impression? If you feel joy, then why? If you feel repulsed, then why? What is the level of visual tension? Go through the ten inquiries in your mind while viewing the work, noticing prominent pairs of opposites or any lack of important pairs of opposites. Notice focal points, quadrants, spatial and design movement. What is the overall aesthetic experience? What is the artist's story revealed to you in the work (without asking the artist)?

What to Say

It's best for all members to share an aesthetic vocabulary. The Viewing Game and its ten inquiries can come in handy for these purposes and can be used as a template. Avoid unhelpful comments or purely personal opinions such as "I like it" or "I don't like it." Also avoid offering knee-jerk solutions such as "It needs some red

over there." Remember, solutions are your way of resolving perceived issues, and the best advice is in the form of problem discovery, not solutions. Each person has vastly different work than the next, and it doesn't matter whether you prefer that type of work or not. It only matters whether you think that artist has succeeded in doing what they set out to do.

Some people say it as it is and inflict pain. Others say it as it is and create growth. It's not the words that make the difference. It's the compassion that is behind those same words.

Helpful comments often include three parts:

1. How it makes you feel

2. Related design issues

3. Appropriate solutions

For example, "The upper left quadrant feels boring and is all muddy or a dead zone, and could use some brights and focal points." Or "I keep looking at the form on the right and feel stuck, am not encouraged to move anywhere else, and feel it could use a buddy." Also helpful is to use the phrase: "It's too (*your adjective here*)."

As the presenter, avoid any negative self-effacing talk ("I only just ... this is just a ... I can't paint ... I'm only a beginner," etc.). As a group you can remind each other whenever someone goes into negative talk by ringing a bell or using a symbolic word.

How to Handle Criticism

As presenters, if we want shallow compliments, we show it to relatives. On the other hand, if we want to be scorned or derided we also show our work to relatives. Hopefully, though, you have created a safe environment

Practice Makes Perfect

Increase your critique skills by viewing art more often. Read articles by art critics in national and international art magazines. Art history books can also offer new viewpoints for critique as well as art criticism books by articulate art critics such as Dave Hickey, Thomas McEvilley and Dore Ashton.

in your critique group by choosing members carefully and creating a set of rules to allow the best possible feedback.

While your work is being presented, be aware of your immediate reactions to what is being said. You will either feel a big inner yes, agreeing with that reviewer's comments, or a big inner no. The inner yes recognizes that comment is valid for you and the work, while the inner no can push your buttons, get you riled up and even make you angry at times. Recognize both reactions as gifts for growth. You can't make everyone happy. Remember, visual tension is not fixed and varies with each person. Evaluate any comments about tension to determine whether the tension level in your work adds to your intent or keeps the viewer from getting your message. See the

group's criticism as a collection of information for you to choose from. It is up to you to determine what information is valid for you and what isn't. Use the information to make changes to enhance your work, to feel justified in not making changes, or for an idea on how others see the work. Group critique can give you that objectivity that's so important for analyzing your work.

Clarify whether the person is giving you their solution instead of what they perceive as a problem. This is important! Most people agree on the problems, but for each problem there are many solutions. It is your solution that makes it your piece.

SONORAN MORNING / Michaelin Otis / Acrylic and mixed media on canvas / 36" × 48" (91cm × 122cm)

PAINTING AS A CAREER

As a painter, making a career from your painting is a choice. It is not a requirement and is not always in your best interest for your creativity. Sam Scott has made a lifelong career from his paintings but prefers the phrase *walk of life* when referring to his profession, since for him, the word *career* conjures up a vulgar and aggressive use of one's dedication to the arts. A career in painting can bring financial profit, offer more exposure and help justify the time and effort expended. There are plenty of books already published that focus on this aspect. These books are continually updated as art-world resources and methods shift constantly. They offer information on how to get representation in galleries, museums and other art venues, and list a variety of resources for exhibitions, grant money, artist websites and more. In this topic I'd like to instead share some thoughts I have on those common issues that occur for artists around the tricky notion of balancing business with making our art.

1. **Make the best paintings you can.**

 Strive to make your work the best it can be. Put your best foot forward in all your efforts, not only with painting but business aspects as well, such as your website, writing, your portfolio, showing up on time for appointments, following through with commitments, etc.

2. **Develop a clear vision.**

 It's important to clearly understand what you paint and why. Equally important is to envision how you want a career to relate to your painting. The book *The Answer* by John Assaraf offers great ideas to create a life vision.

3. **Stay open and positive.**

 This is more work than it sounds. It takes a lot of effort to keep from whining, complaining, getting stressed and being negative. But once you create a habit of positive thinking, it releases an enormous amount of energy and adds confidence.

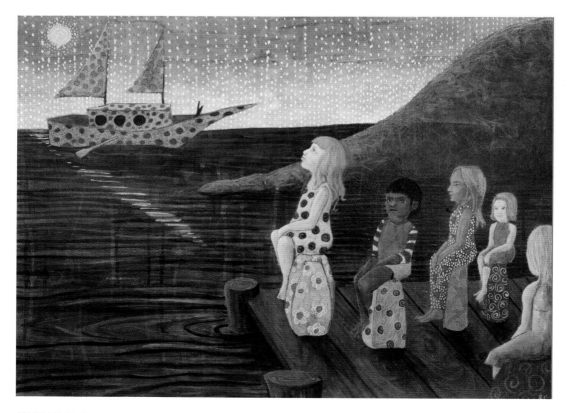

ONCE UPON THE DEEP BLUE SEA 2 / Diana Ingalls Leyba / Mixed media and acrylic on watercolor paper / 22" × 30" (56cm × 76cm)

4. Show your work.

Online self-publishing sites allow you to create a small, professional-looking portfolio for very little cost. One of many options is mypublisher.com. Make one and carry it everywhere as you never know what opportunities will come up. Find ways to exhibit your work. Have an exhibition in your studio. Invite friends and put a posting in the local paper. Ask your local restaurants, banks and other public venues if you can hang your work on their walls. Donate work to public institutions like colleges and hospitals.

5. Continually seek new venues.

Always be on the lookout for better galleries, dealers and agents to sell your work. Find artists online whose work is compatible to yours or in galleries you may visit, and read their bios to find out where they show. Research galleries, agents, grants and any other information you feel an affinity with to see if you can use these in your own search.

6. Seek advice from experts.

To allow more time for you to paint, use specialists to do the work you don't want. Use coaches for guidance, financial advisors for budgets, photographers for professional shots of your work, lawyers for contracts, tech experts to keep your website running and a social media team for publicity assistance.

7. Stay connected with your team.

Stay in touch with anyone who helps you in your career, especially your venues and dealers. Make a list of all those who help you, both friends and business associates. This is your team. Stay in touch regularly. Online correspondence is not enough. Add occasional team get-togethers such as a cocktail party in your studio or a fun night out.

8. Protect your time.

Be aware and protective of how your time is spent. Eliminating one unnecessary activity in your day, such as watching television, can increase time for business tasks, or even better, more studio painting time.

THE COMIC BOOK LOVER'S ROAD GUIDE TO CONSCIOUSNESS / Nancy Reyner / Acrylic on canvas / 52" × 68" (132cm × 173cm) / Private collection

INDEX

ABOUT THE AUTHOR

Buying her first set of oil pastels with allowance money when she was nine, Nancy Reyner has been on the art path ever since. Born and raised on the east coast in the USA, Nancy received a BFA from the Rhode Island School of Design and an MFA from Columbia University. From creating costumes and sets for theater and film to coordinating public arts programs for the state of New York, she has had a wide-ranging career in the arts, all of which inform her work. She now lives in Santa Fe, New Mexico, and has been painting for more than thirty years, exhibiting and teaching both nationally and internationally. Her books, *Acrylic Revolution* (2007), *Acrylic Innovation* (2010) and *Acrylic Illuminations* (2013) offer a multitude of techniques and ideas to inspire artists everywhere. Visit nancyreyner.com to view Nancy's paintings, blog, articles, videos, and for information on coaching sessions and workshops.

Photo by Jane Bernard

ACKNOWLEDGMENTS

It takes a village to get anything achieved especially in today's high-tech world. And what a village I have to thank! Thank you to my partner, Jim O'Hara; my son, Jacob Cohen; friends and colleagues Bonnie Teitelbaum, Jennie McGee, Mary and Alex Ross, Laura McClure, Sara Novenson, Destiny Allison and Patti Brady. This book would not have happened without the skillful and artistic input from photographer Wendy McEahern who worked with me for unending hours on almost every image. Thank you Jane Bernard for photographing my studio and portraits. Gems of ideas were gifted to me while writing this book from artist friends Sam Scott, Todd Defoe and Pat Bailey. Thanks to the design genius of Edy Keeler, my studio got a facelift with clear space to write and prepare the book. Thanks to early proofers Nancy Zimmerman and Hank Roberts. Every book I write owes much gratitude to Mark and Barbara Golden, the staff at Golden Artist Colors, Ampersand and New Wave Art. Thank you to my publisher F+W Media for believing in me for yet another round. Special thanks to the ever so creative and charming publishing director, Jamie Markle, and his incredible North Light Books team. Extra special thanks to my fabulous editor, Sarah Laichas, designer Jamie DeAnne for the "perfect" cover and book design, and Jennifer Lepore for coordinating the book's accompanying videos.

DEDICATION

To painters everywhere who persevere with creativity and energy, who continue to believe in the positive power of images, and by expanding their work, also push the current boundaries of painting.

a content + ecommerce company

Other fine North Light Books are available from your favorite bookstore, art supply store or online supplier. Visit our website at fwcommunity.com

21 20 19 18 17 5 4 3 2 1

DISTRIBUTED IN CANADA BY FRASER DIRECT
100 Armstrong Avenue
Georgetown, ON, Canada L7G 5S4
Tel: (905) 877-4411

DISTRIBUTED IN THE U.K. AND EUROPE
BY F&W MEDIA INTERNATIONAL LTD
Pynes Hill Court, Pynes Hill, Rydon Lane, Exeter, EX2 5AZ, UK
Tel: (+44) 1392 797680
Email: enquiries@fwmedia.com

ISBN 13: 978-1-4403-4419-0

Edited by Sarah Laichas
Designed by Jamie DeAnne
Production coordinated by Jennifer Bass

Front cover background: Nancy Reyner

Front cover images (left to right):
Celia Drake, Pat Bailey, Rick Garcia, Pat Bailey

Back cover images (left to right):
Vezna Gottwald, Cesare Auguste Detti, Nancy Reyner

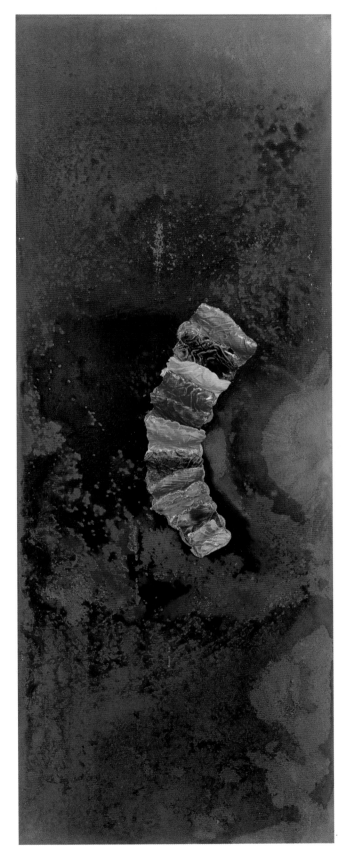

SONORAN PROCESS #6 / Deborah Lewis / Ceramic tile and cement on steel / 32" × 12" (81cm × 30cm)

Ideas. Instruction. Inspiration.

These and other fine North Light products are available at your favorite art & craft retailer, bookstore or online supplier. Visit our websites at artistsnetwork.com and artistsnetwork.tv.

Get your art in print!

Visit artistsnetwork.com/competitions for up-to-date information North Light's book and magazine competitions.

DISCARD